IMAGES
of America

TWIN LIGHTS OF THACHER ISLAND, CAPE ANN

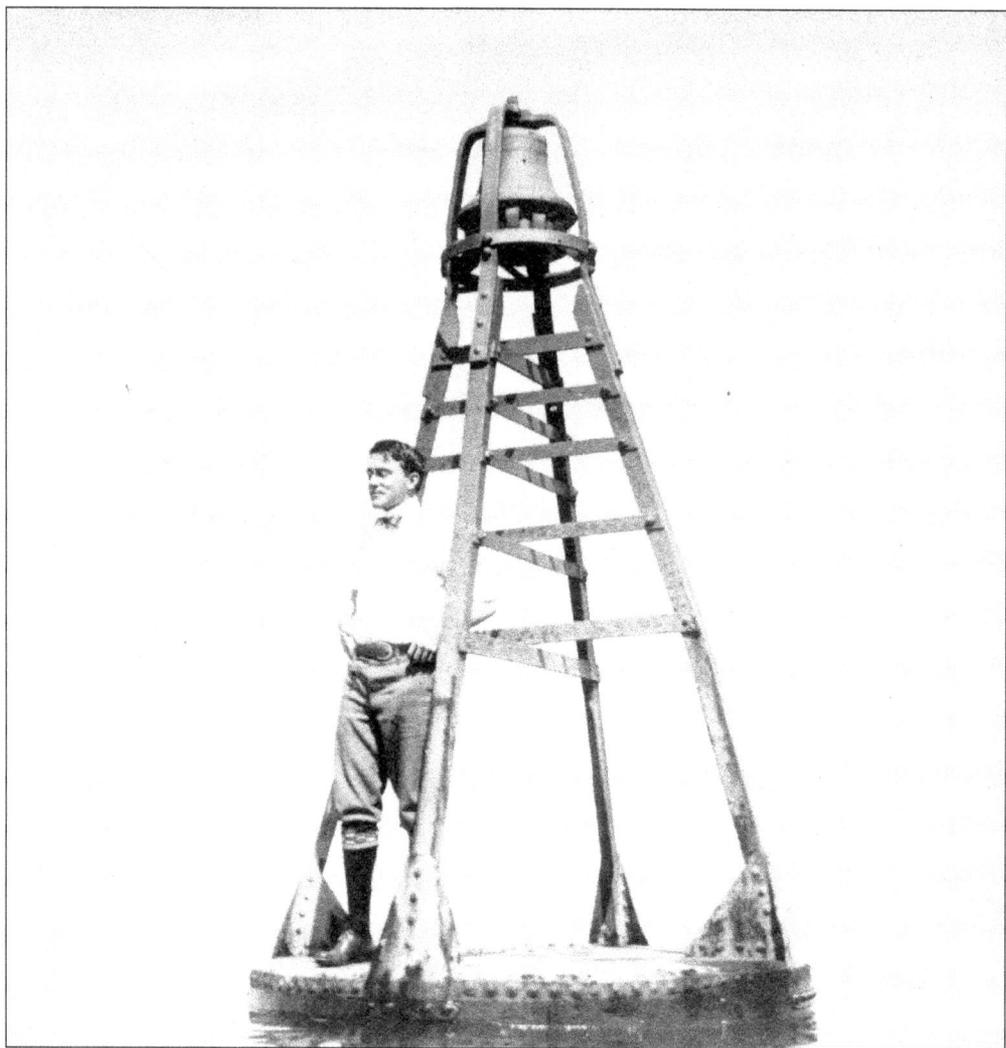

Charles Cleaves (1877–1937), a prominent Rockport businessman, had a lifelong interest in photography. In 1906, he established the Rockport Photo Bureau, which produced thousands of postcards celebrating the Rockport and Cape Ann area. His glass-plate negative collection resides at the Sandy Bay Historical Society museum. Many of his photographs are featured in this book. Cleaves is shown standing on the red U.S. Coast Guard bell buoy, located near the reef at Avery's Ledge at the entrance to Rockport Harbor. (Courtesy Sandy Bay Historical Society.)

On the cover: Please see page 57. (Courtesy Sandy Bay Historical Society.)

IMAGES
of America

TWIN LIGHTS OF THACHER ISLAND, CAPE ANN

Paul St. Germain

ARCADIA
PUBLISHING

Published by Arcadia Publishing
Charleston, South Carolina

Library of Congress Control Number: 2009931547

For all general information contact Arcadia Publishing at:
Telephone 843-853-2070
Fax 843-853-0044
E-mail sales@arcadiapublishing.com
For customer service and orders:
Toll-Free 1-888-313-2665

Visit us on the Internet at www.arcadiapublishing.com

*To my grandchildren, Taylor, Olivia, Hunter, Luke,
Nate, and Shane, who are the bright shining lights of
my life and call Thacher "Papa's Island."*

CONTENTS

ACKNOWLEDGMENTS

As a first time author, I never realized how many people it took to write a book. First, I must thank the Sandy Bay Historical Society and Cynthia Peckham, its renowned curator, and their board of directors for allowing me to have free rein over their collection, especially photographer Charles Cleaves's collection of glass-plate negatives. Les Bartlett helped digitally scan many of the best shots of the collection. Jeremy D' Entremont, lighthouse expert, helped edit and supplied photographs, information, and contacts. Candace Clifford, maritime historian, helped retrieve many documents from the National Archives and Records Administration during my writing of the National Historic Landmark nomination to the National Park Service for Cape Ann Light Station in 2001. Other contributors are Chad Kaiser of the U.S. Lighthouse Society; U.S. Coast Guard historian Chris Havern; lighting apparatus expert Thomas Tag, who helped locate photographs and drawings of lighting equipment; and Jim Claflin, whose vast collection of lighthouse artifacts, literature, and documents was invaluable. Phil Bissell, cartoonist and former board member of the Thacher Island Association, provided drawings.

Thanks to all those who provided photographs and information about family members that were a part of the keeper community on Thacher, including Dorothy Snow Bicknell, daughter of famed marine writer Edward Rowe Snow; Barbara Kezer, daughter of keeper George Kezer; David Cook, grandson of keeper John Cook; Leola Morse, daughter of keeper William Daggett; and Dina Hamilton, who gave me information on her father Eugene Larsen.

I especially want to thank Eleanor Parsons, author of the definitive history called *Thacher, The Island of the Twin Lights*. She was my inspiration to write this book before her passing. Her encouragement to do a book of vintage photographs of her favorite subject was kind and generous.

I thank my wife Betty Ann for her numerous readings, edits, suggestions, and patience while writing this book.

I wish to recognize John and Mary Bennett; George and Dottie Carroll; Dr. Syd Wedmore, chairman of the Thacher Island Town Committee; the late Ned Cameron; and former board members who were involved in the creation of the Thacher Island Association back in 1980. Their dedication to restore and maintain this treasure has inspired the current board and volunteer crews who work together for the betterment of this fascinating island.

INTRODUCTION

Cape Ann was named by Prince Charles (later King Charles I) in honor of his mother, Anne of Denmark, wife of James I.

Late on July 15, 1605, while sailing south from Cape Porpoise, Maine, Frenchman Samuel de Champlain sighted Cape Ann. Champlain, who was charting his journey, called the area "Cap aux Isles" (the cape with isles). The next day, he reached the peninsula and made notes of three islands, one of which was the yet-to-be-named Thacher Island.

More than a decade later in 1614, on reaching the cape in Massachusetts with its three isles, Capt. John Smith dubbed the islands the three "Turks Heads." Smith had been a captive of Turkish soldiers in prior years and had killed three of them. He was granted a patent for a coat of arms bearing three Turk's heads on a shield as a reward for his victories. The three islands were later to be named Straitsmouth, Milk, and the largest became Thacher Island. It was named for Anthony Thacher, an Englishman, whose vessel the *Watch and Wait* was wrecked in a ferocious storm near the island in 1635 on its way to Marblehead from Ipswich. Thacher called it "Thacher's Woe." He lost his four children as well as a cousin and seven nieces and nephews. A total of 21 souls were drowned; only Thacher and his wife survived. The Massachusetts Bay Colony awarded the island to Thacher for his losses. It remained in his family for 80 years until it was sold to a local Gloucester family. In 1771, Joseph Allan sold it back to the Colony of Massachusetts for 500 pounds, and it became permanently known as Thacher Island.

Colonial shipping interests were growing rapidly during this time. Many mariners petitioned the Massachusetts government to build a lighthouse on the island. John Hancock had a large shipping business in the area and was influential in convincing the Massachusetts colony to build two lights on Thacher. The new 45-foot towers were built in 1771 and first illuminated on December 2, 1771.

Once the American Revolution ended and a federal government was formed, Congress addressed many issues concerning trade. Pres. George Washington believed lighthouses were so important that the ninth act of the newly formed Congress in 1789 created the U.S. Lighthouse Establishment to build and maintain lighthouses along the East Coast.

Before 1789, all lighthouses were owned by their respective colonies. On June 10, 1790, the Commonwealth of Massachusetts approved an act that officially ceded to the United States all lighthouses along the Massachusetts coast, including "the two lighthouses situate on Thacher Island, so called in the County of Essex, together with the lands and tenements thereunto belonging, the property of this Commonwealth."

The secretary of the treasury was designated as the person responsible for all lighthouses now owned by the federal government. In 1792, Alexander Hamilton wrote and signed the actual appointment letter for the first lighthouse keeper at Cape Ann Light, Samuel Huston, after the appointment had been approved by Washington.

In 1771, there were only 10 so-called colonial lights on the East Coast. Boston Light, established on Little Brewster Island in Boston Harbor in 1716, was the first lighthouse built in North America. Succeeding lights were located at Brant Point on Nantucket (1746), Beavertail Light in Rhode Island's Narragansett Bay (1749), New London Light at the harbor entrance in Connecticut (1760), Sandy Hook at the entrance to New York Harbor (1764), Morris Island Light in South Carolina (1767), Cape Henlopen Light in Delaware Bay (1767), Plymouth Light on Gurnet Point (1769), Portsmouth Harbor Light in New Hampshire (1771), and finally the two Cape Ann lights on Thacher Island (1771).

The twin lights were particularly important at the time because Cape Ann sticks out into the Atlantic Ocean over eight miles along the Massachusetts coastline and Thacher Island is a mile offshore from the cape. It was the first sight ships arriving from Europe saw before working their way south to Boston Harbor. The island also guarded the extremely dangerous Londoner reef that sits a half-mile off its southeastern shore. Several English wrecks occurred in this area, which was why the reef was dubbed the Londoner. It was the first light station built to mark "a dangerous spot in the ocean"; all other stations at the time simply marked harbor entrances. The twin lights of Thacher Island were one of only eight twin light stations ever built in America. Five of them were in Massachusetts: Plymouth, Baker's Island, Chatham, and the Three Sisters Lights (triple lights) at Nauset Beach on Cape Cod. The others were Matinicus Rock in Maine, Cape Elizabeth in Maine, and Navesink in New Jersey. Today there are still twin towers at Navesink, Matinicus Rock, Cape Elizabeth, and the Three Sisters, but only single lights are visible at each. However, both lights are in operation at Cape Ann Light Station on Thacher Island.

In 1858, it was decided that Cape Ann needed new towers. The existing 45-foot towers were not high enough to be seen well at sea and were nearly 100 years old. The lighthouses at Boston Light and at Cape Ann were both considered by the lighthouse establishment and mariners to be first-class light stations and deserved replacement because of their importance to shipping and the dangerous ledges and rocks off the Salvages and the Londoner. It was estimated in the early 1800s that as many as 70,000 vessels passed by Thacher Island annually. A survey done in 1884 by the navy indicated that 147 wrecks and 560 partial disasters had occurred between 1874 and 1894. This was 100 years after the first twin lights were erected.

New 124-foot towers were approved by Congress, which appropriated $68,751 for the project. It took two years to build them for a final cost of $81,417. In 1860, Rockporters helped elect Abraham Lincoln as president of the United States, and then in April 1861, the Civil War broke out. On the evening of October 1, 1861, the first order, fixed twin lights of Cape Ann Light Station on Thacher Island were illuminated for the first time.

Cape Ann Light Station on Thacher Island remains the last fully operational twin light in America. The south tower is still an official aid to navigation operated by the Coast Guard, and the north tower is operated by the Thacher Island Association as a courtesy aid using a modern, solar-powered LED light system that can be seen by mariners at a distance of six miles.

In 2001, Cape Ann Light Station was designated a National Historic Landmark by the National Park Service, 1 of only 10 light stations so designated.

Today the island is owned by the Town of Rockport (the southern 29 acres) and the U.S. Fish and Wildlife Service (the northern 22 acres).

One

THACHER'S WOE

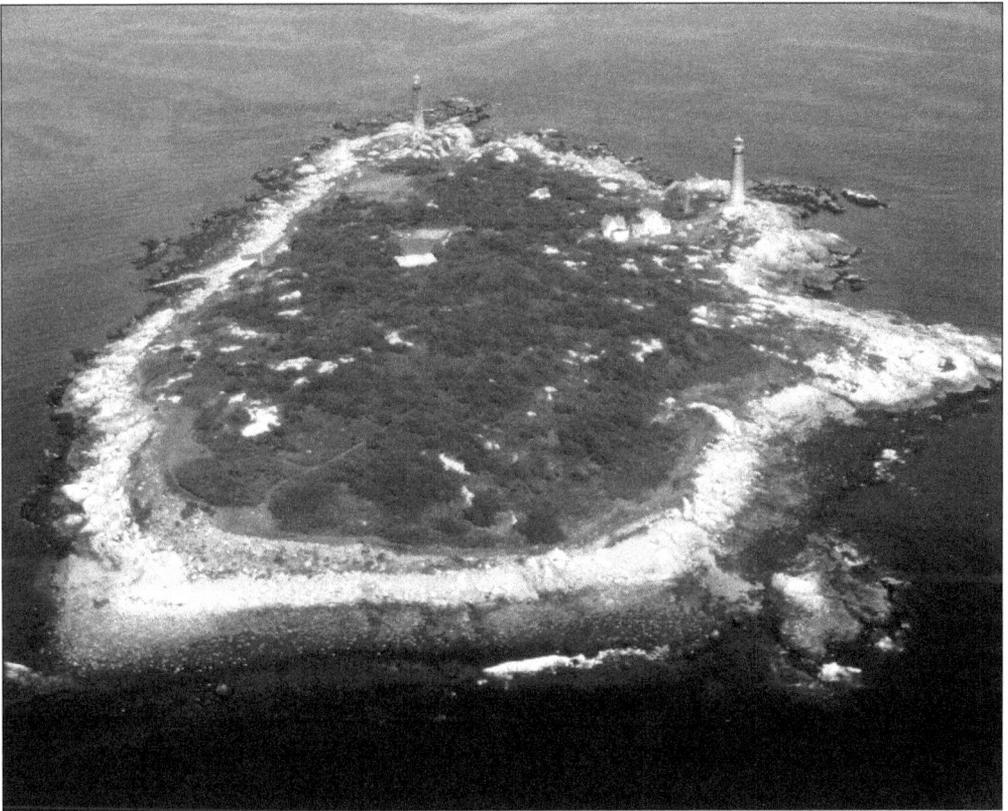

Thacher Island is located on the eastern shore of Rockport, one-half mile off shore and about three miles from Rockport Harbor at longitude 70 34' 45.3" latitude 42 38' 19." Milk Island is located to the south, Straitsmouth Island is to the northwest, the Londoner reef is to the east, and Dry and Little Salvages reefs are to the north. (Courtesy Thacher Island Association.)

Thacher Island

A National Historic Landmark

Cape Ann Light Station
Rockport, Massachusetts

P. O. Box 73
Rockport, MA 01966

E-mail
info@thacherisland.org
www.thacherisland.org

Longitude 70° 34' 45.3"
Latitude 42° 38' 19"

America's
Twin Lights
Since 1771

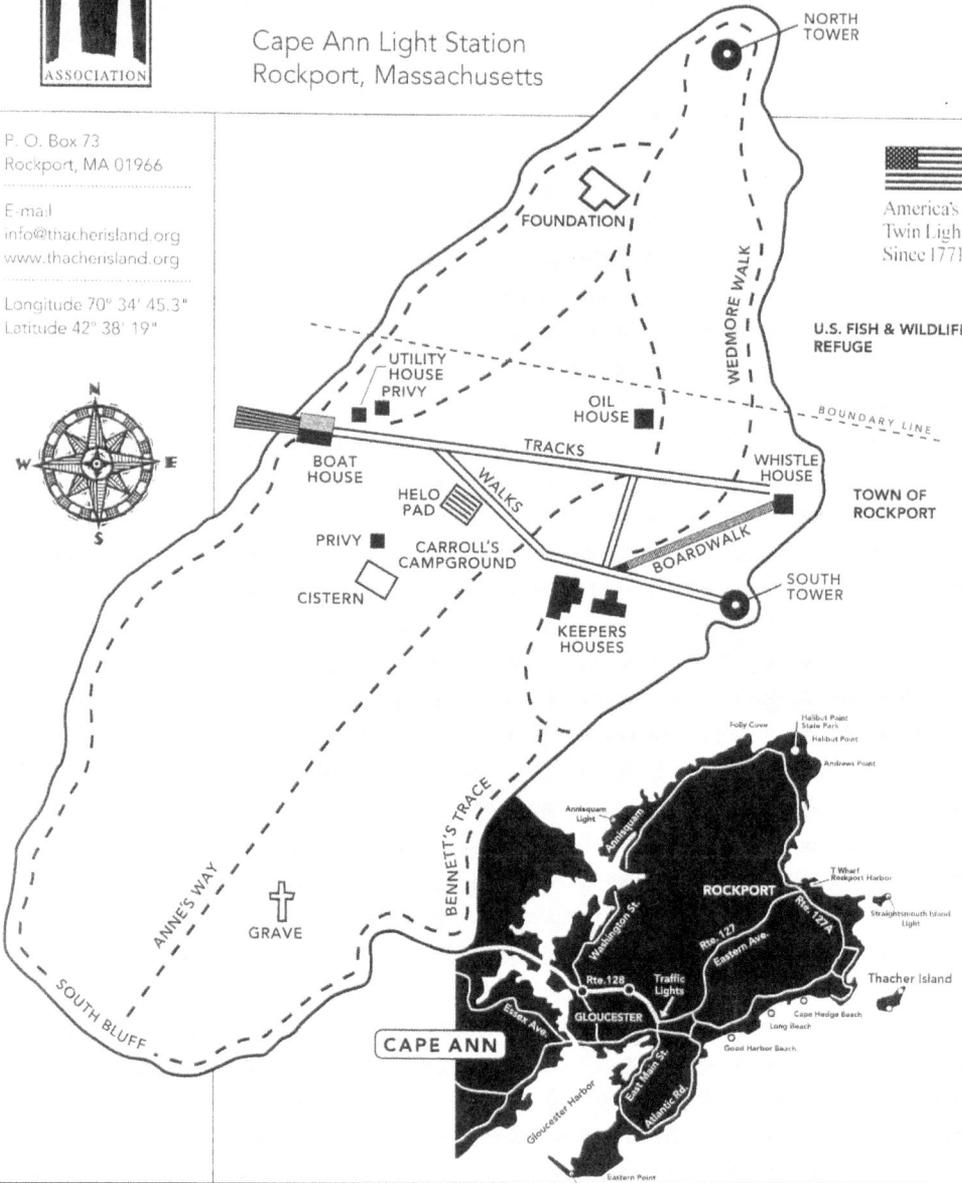

The island is approximately 52 acres. In 2002, the U.S. Coast Guard gave the southern 29 acres of the island to the Town of Rockport. The northern 22 acres are owned by the U.S. Fish and Wildlife Service, which also owns the north tower. The Thacher Island Association was formed in 1980 as a nonprofit organization to provide funding for the restoration of the structures and facilities. (Courtesy Thacher Island Association.)

The northern end of the island (22 acres) was given to the U.S. Fish and Wildlife Service in 1970 and is used as a National Wildlife Refuge. (Courtesy Thacher Island Association.)

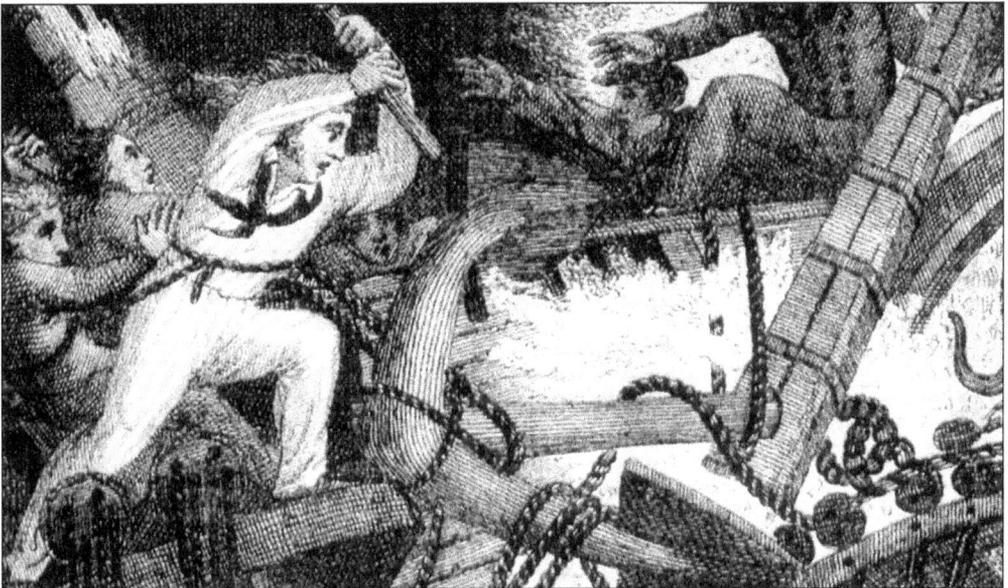

This engraving of the pinnace *Watch and Wait* captures the desperate crew cutting away the anchor as they were shipwrecked near the island on Avery's Ledge in 1635. Only Anthony Thacher and his wife, Elizabeth, survived. Twenty-one people perished, including the crew, Thacher's cousin the Reverend John Avery and his family, and Thacher's four children. The island was later named for Thacher. This uncredited illustration is from Edward Rowe Snow's *True Tales of Terrible Shipwrecks*. (Courtesy Dorothy Snow Bicknell.)

Anthony Thacher was awarded 40 marks by the General Court of Massachusetts "towards his great losses." In 1636, Gov. John Winthrop and the court granted Thacher "the small island at the head of Cape Ann, upon which he was preserved from shipwreck as his proper inheritance." The island was subsequently sold in 1714 to the Reverend John White of Gloucester, who paid 100 pounds. In a letter to his brother Rev. Peter Thacher in Salisbury, England, recounting the August 15, 1635, tragedy, Thacher wrote "we went off that desolate island, which I named after my name 'Thacher's Woe' and the rock 'Avery, his fall', to the end that their fall and

loss and mine own, might be in perpetual remembrance." Anthony Thacher never lived on Thacher Island. He and his wife Elizabeth moved to Yarmouth, Massachusetts, and was one of the original grantees of the town. In 1639, he became town clerk and treasurer of Yarmouth and remained in that capacity until his death in 1667 and was buried on his own land. He and Elizabeth went on the have three more children, John, Judah, and Berthia. (Courtesy Thacher Island Association.)

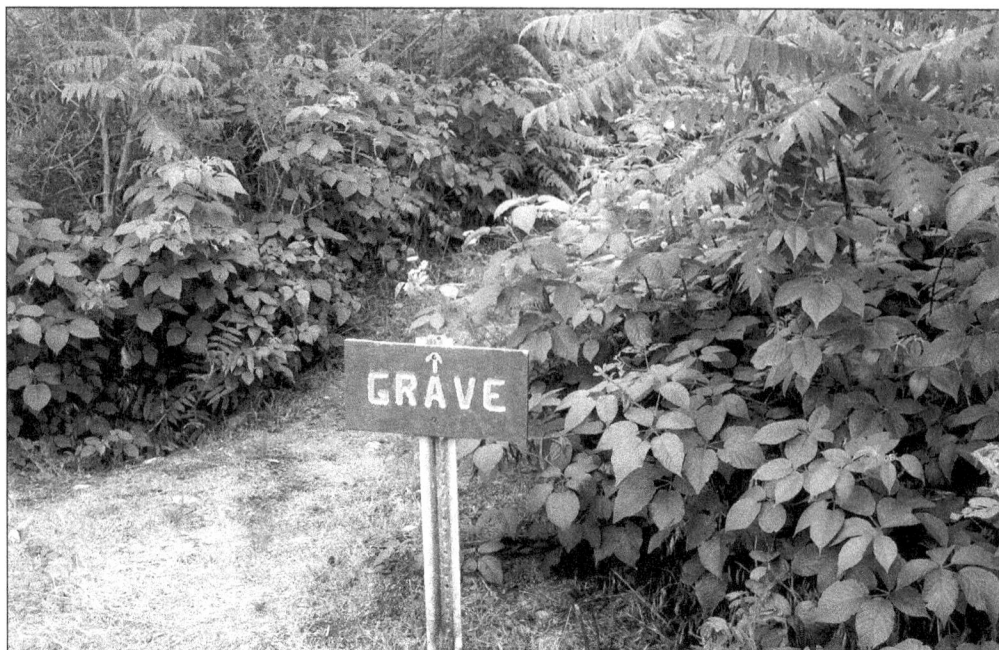

A grave is located on the south end in the center of the island surrounded by heavy vegetation just off Anne's Way trail. The area was described by Anthony Thacher in a letter he wrote to his brother soon after about the shipwreck and burying his 12-year-old niece. (Courtesy Thacher Island Association.)

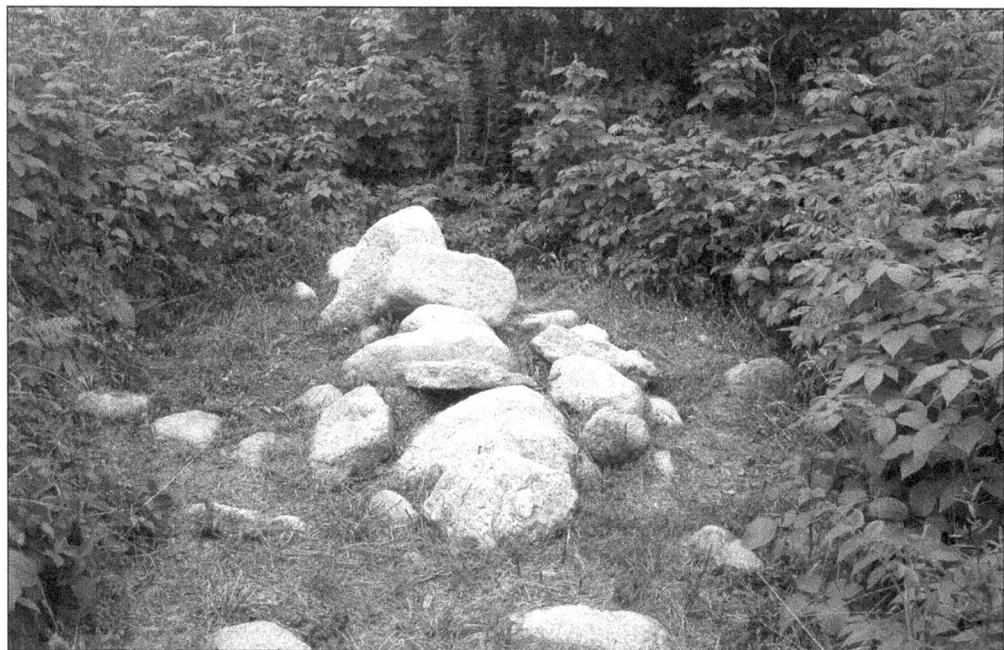

These boulders may be a grave marker where Thacher buried his niece. The boulders are piled in an unusual way. They are far from any other ledge on the island's interior and look as if they were arranged by hand. The cairn looks to be about the length of a typical 12-year-old child. (Courtesy Thacher Island Association.)

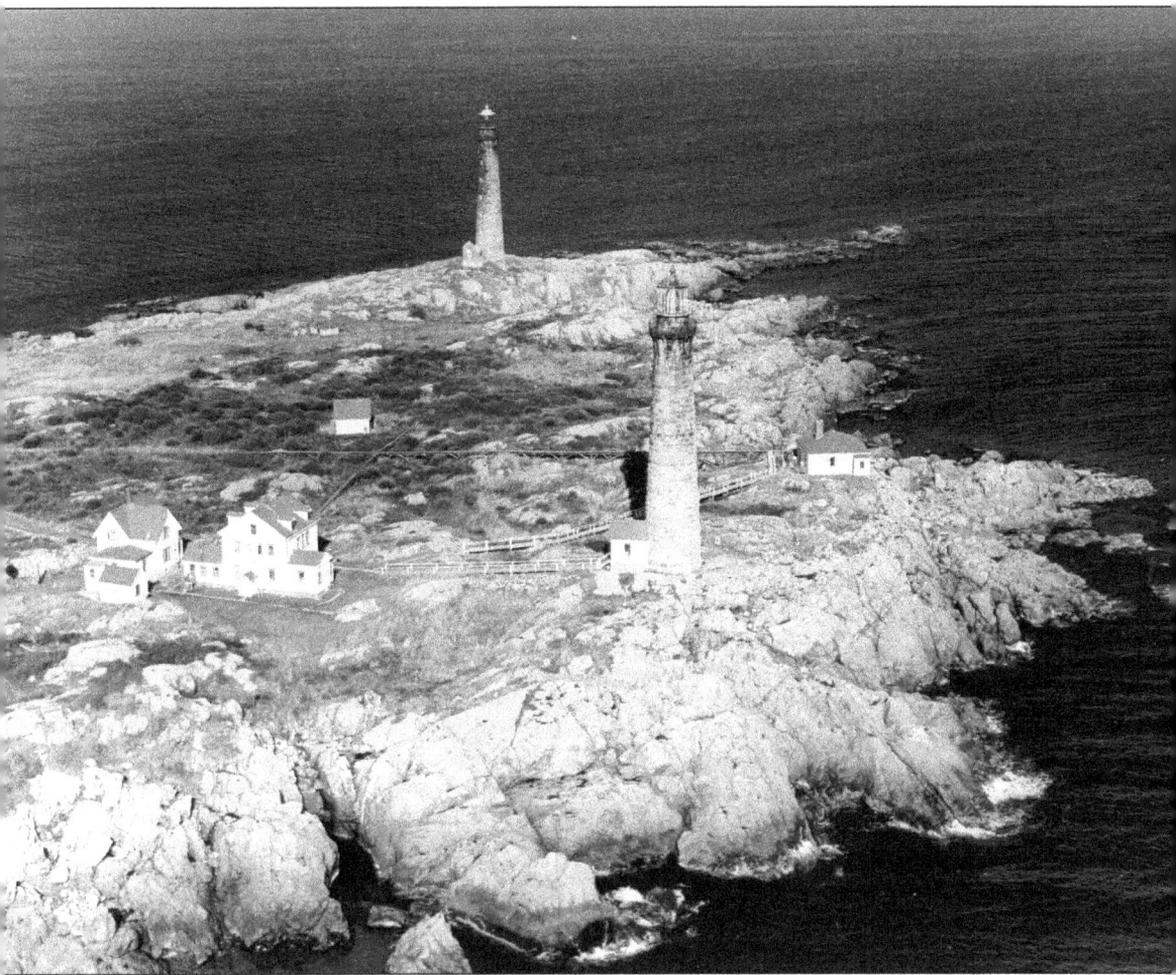

The island has changed dramatically since Thacher's wreck in 1635. It is dominated by a number of structures built since 1771. Today the island has 11 structures, including the twin lighthouses, two keeper dwellings, a whistle house (fog signal), an oil house, a boathouse and ramp, a cistern, a utility house, a railway, a campground, a helicopter pad, and about three miles of walking trails. (Courtesy U.S. Coast Guard.)

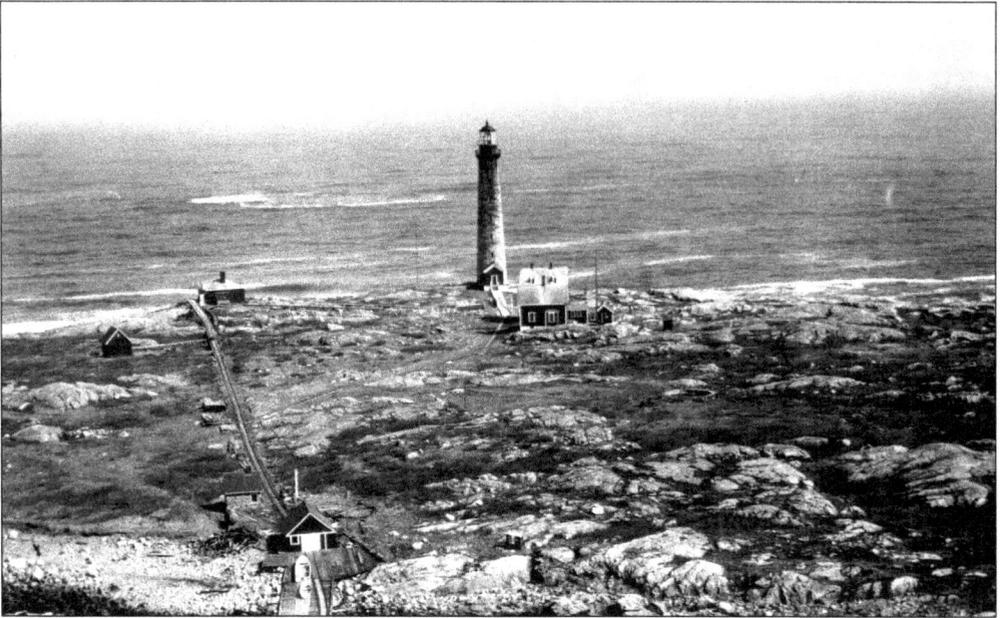

The Londoner reef is located just off the northeastern shore of Thacher Island and is known to have claimed several ships, including many from London, England, thus the name Londoner. At one time, an iron pole (spindle) was erected to warn mariners but was soon proved to be ineffectual. It was decided that two lighthouses were needed instead. Note the iron pole at the upper left in the white water. (Courtesy U.S. Coast Guard.)

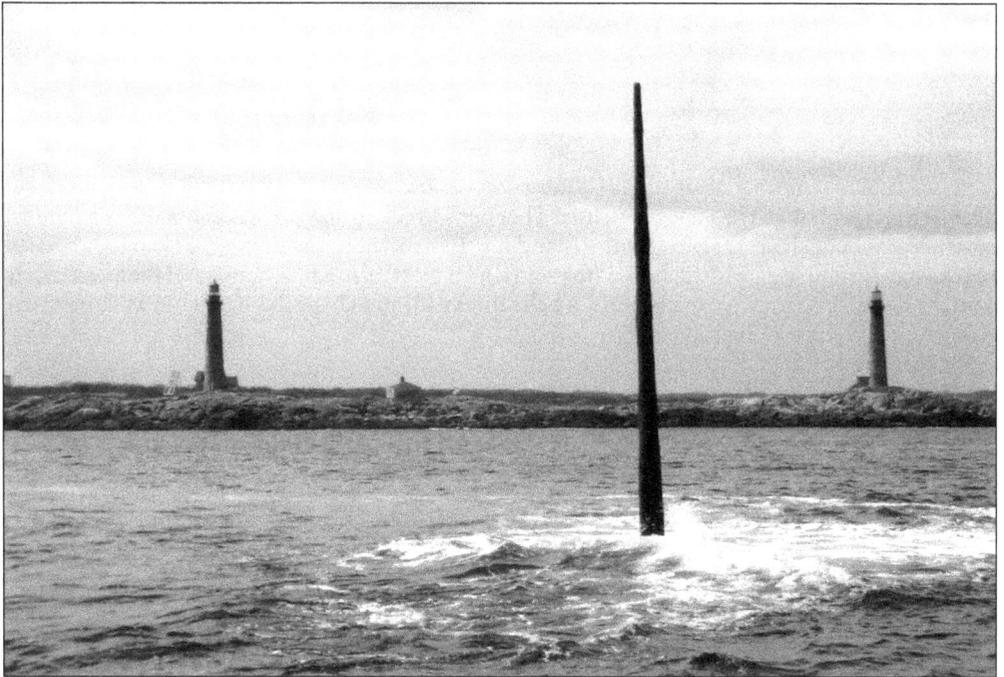

Remnants of the iron pole can still be seen today, located between the twin lighthouses about 500 yards off the eastern shore. The Londoner reef is partially submerged at high tide. (Courtesy Thacher Island Association.)

Capt. Josiah Sturgis, aboard the U.S. Revenue Cutter Service schooner *Hamilton*, surveyed the reef on June 28, 1845. His chart shows the reef to be 90 feet long and 57 feet wide and particularly dangerous for ship traffic. As a result of his report, a spindle beacon day-mark was erected. Sixty-five shipwrecks had been reported on the Londoner since 1775. (Courtesy State Library of Massachusetts, Alexander Parris Digital Archive.)

This "Notice to Mariners" appeared on September 18, 1855, announcing, a "forty foot high day mark surmounted by an octagonal latticework seven feet high and five feet in diameter" built on the Londoner rock. (Courtesy National Archive and Records Administration.)

NOTICE TO MARINERS.

BEACON ON LONDONER ROCK,

OFF

THATCHER'S ISLAND, CAPE ANN,

MASSACHUSETTS.

A wrought iron shaft, forty feet high, surmounted by an octagonal lattice or open-work cast iron day-mark, seven feet high and five feet in diameter, painted black, has been erected upon the Londoner Rock, off Thatcher's island, Cape Ann, Massachusetts.

The following are magnetic bearings from the beacon, viz:

To Dry Salvages	N ½ E.
" Straitsmouth Island light-house . . .	N. N. W.
" Northern light-house, Thatcher's island	N. W. ½ N.
" Southern " " "	N. W. by W. ½ W.
" Eastern Point light-house	S. W. by W. ½ W.

By order of the Light-House Board :

C. A. OGDEN,

Major Corps of Engineers.

BOSTON, MASS., *Sept.* 18, 1855.

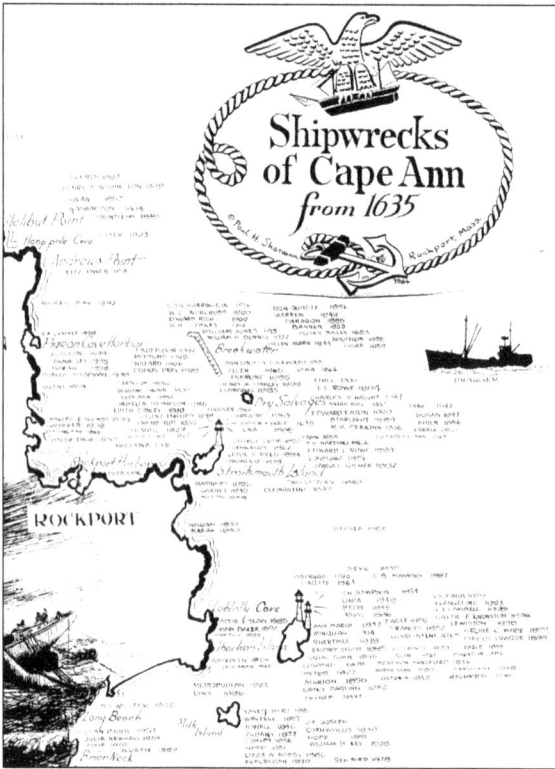

Hundreds of shipwrecks have occurred near Thacher Island. This is a portion of a map done by Paul H. Sherman in 1964 on "Shipwrecks of Cape Ann from 1635," indicating some of the wrecks and approximately where and when they occurred around Thacher Island. (Courtesy Sandy Bay Historical Society.)

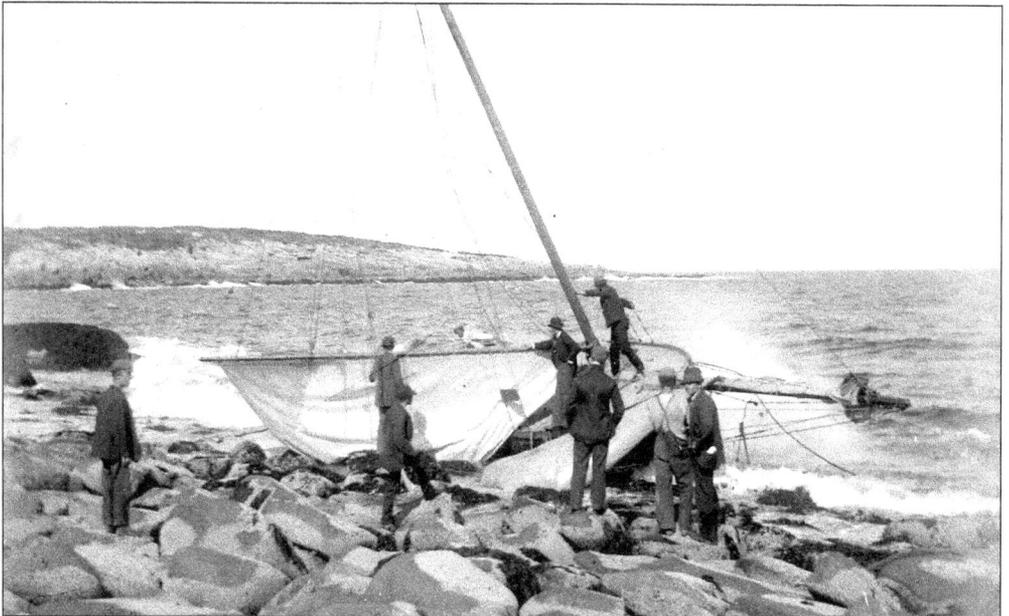

The schooner *Harriet* is fetched up on the beach in Folly Cove, Rockport, on March 28, 1895. It was 71 feet long with a 23-foot beam and built in Bath, Maine, in 1870. *Harriet* was carrying stone, and its homeport was Gloucester. Folly Cove is located to the north of Thacher Island on Cape Ann. This area is particularly susceptible to the severe northeast storms that blow through each year. (Courtesy Sandy Bay Historical Society.)

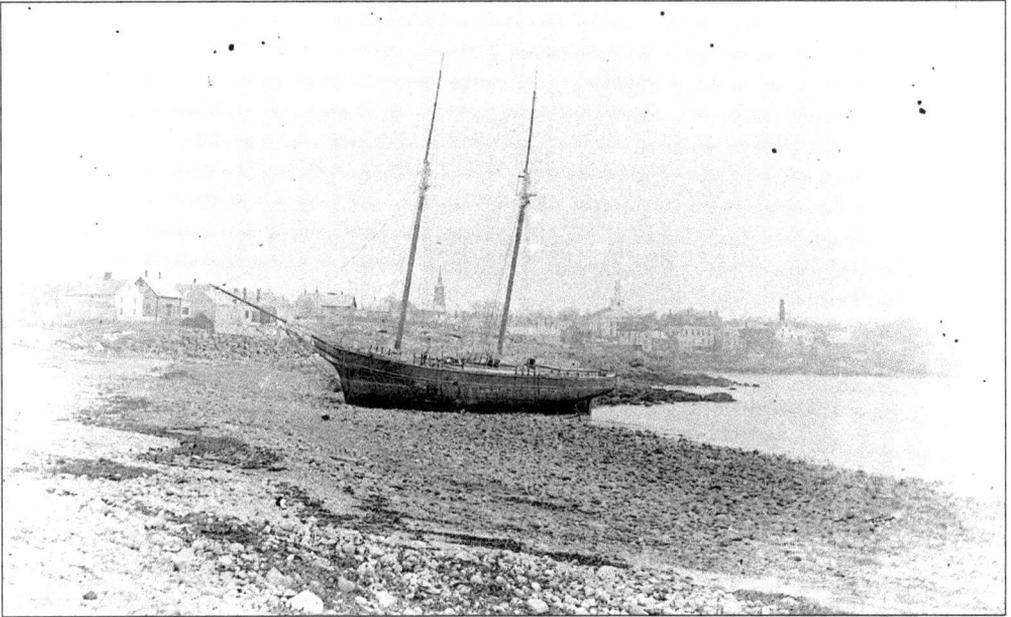

An unidentified schooner is on the rocks at Old Harbor, Rockport. In June 1876, the steam-screw freighter *Leopard* went up on the northeast end of the Londoner with a cargo of 800 tons of coal. Cape Ann residents lost no time in helping to salvage the valuable cargo. By the Fourth of July, thrifty residents had carried off 500 tons of coal for their winter fuel supply. (Courtesy Sandy Bay Historical Society.)

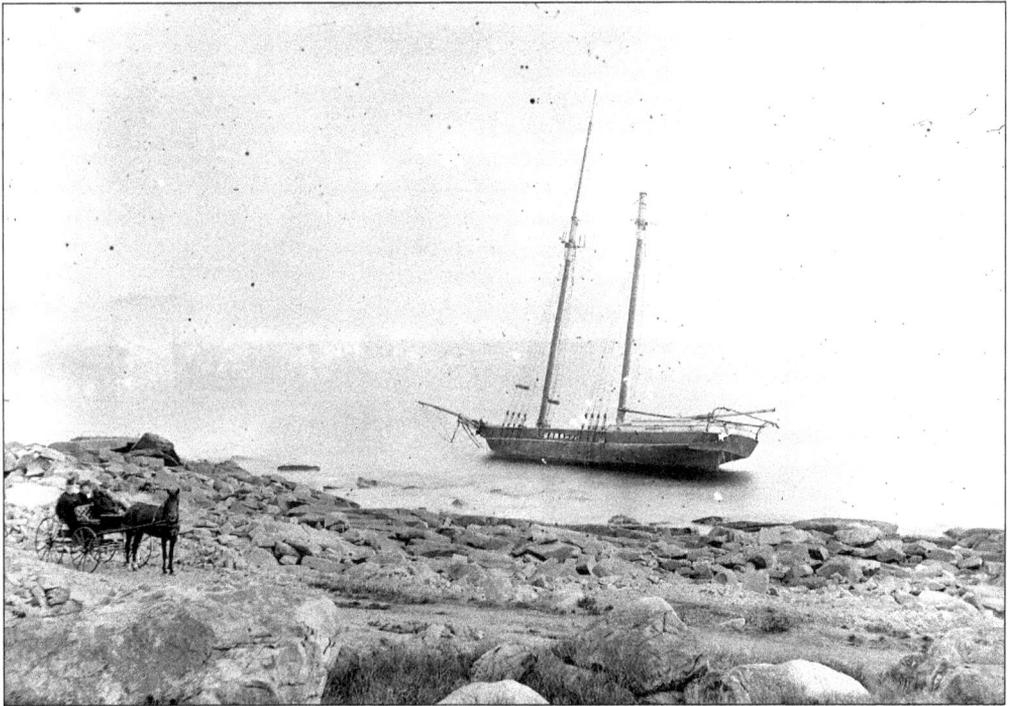

The fishing schooner *Babson Farm* is beached at Halibut Point, Rockport. Note the wagon with curiosity seekers. (Courtesy Sandy Bay Historical Society.)

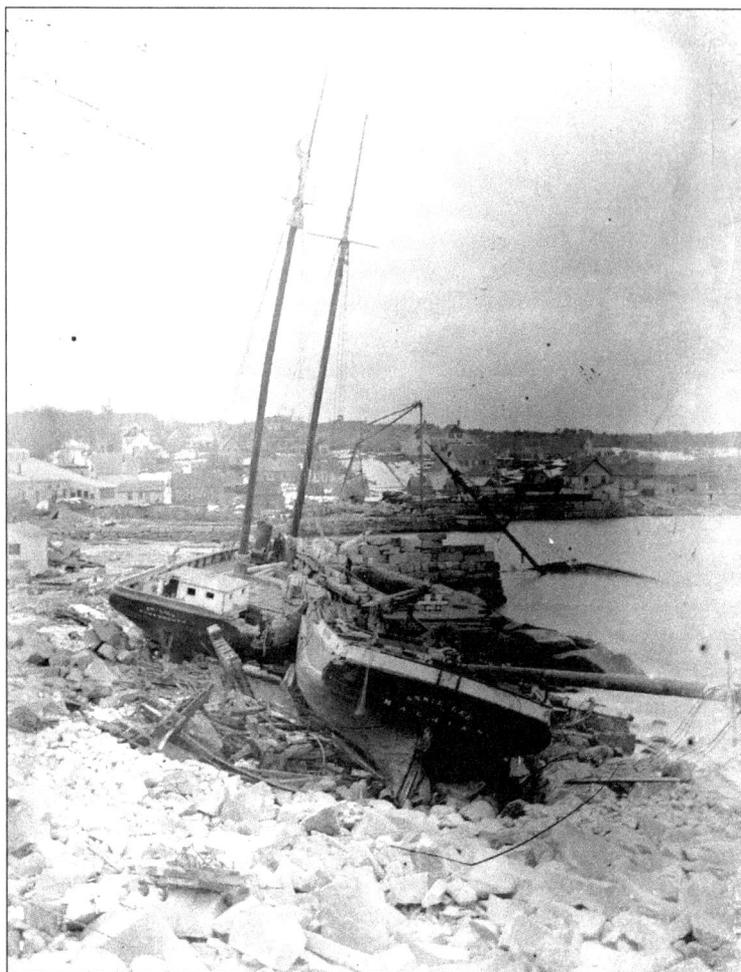

The schooners *Annie Lee* of Machias, Maine, and *Chillion* of Portsmouth, New Hampshire, are shown wrecked in Pigeon Cove, Rockport, after the great Portland gale of 1898. (Courtesy Sandy Bay Historical Society.)

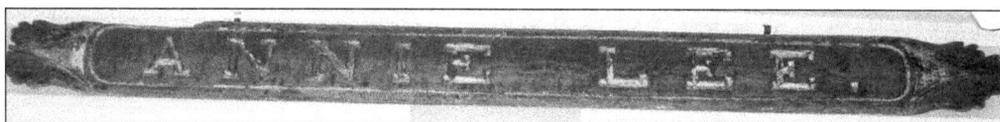

This is the quarter board from the *Annie Lee*, on display at the Sandy Bay Historical Society. Sailing ships in the 19th century displayed their names on decoratively carved and painted signs called quarter boards. When a sea captain retired and went ashore, he would acquire the quarter board and display it on his house for all to admire. (Courtesy Sandy Bay Historical Society.)

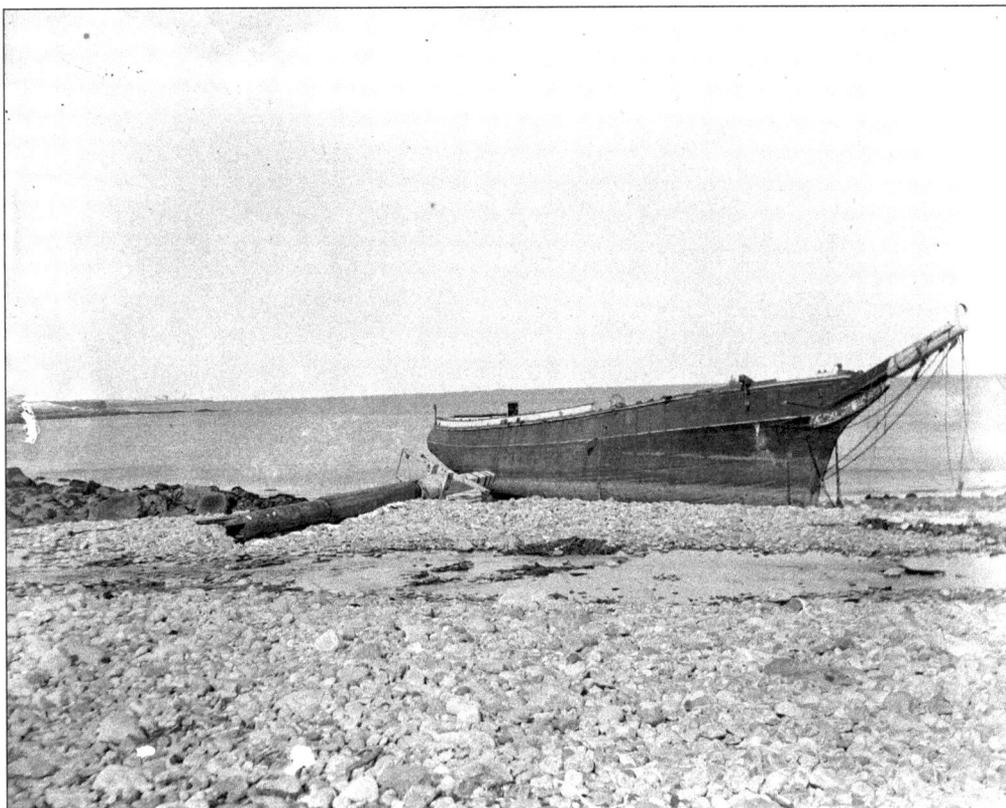

The *Hattie Paige* is shown washed ashore on Back Beach in a northwester on March 7, 1889, at 5:00 a.m. The crew was taken ashore in a breeches buoy. The vessel was captained by B. D. Kelly of Yarmouth. Its home port was Plymouth, and it was built in Bridgeton, New Jersey, in 1867. *Hattie Paige* was 115 feet long with a beam of 29 feet and was carrying stone at the time of the wreck. (Courtesy Sandy Bay Historical Society.)

The quarter board salvaged from the *Hattie Paige* is now exhibited at the Sandy Bay Historical Society museum. Many fishing schooners were built in Rockport by David Waddell, whose boatyard was located on Bearskin Neck on the inner harbor. Waddell built many small schooners and other watercraft for Rockport's shore fishermen, who inhabited fishing shacks along the neck and in Pigeon Cove. (Courtesy Sandy Bay Historical Society.)

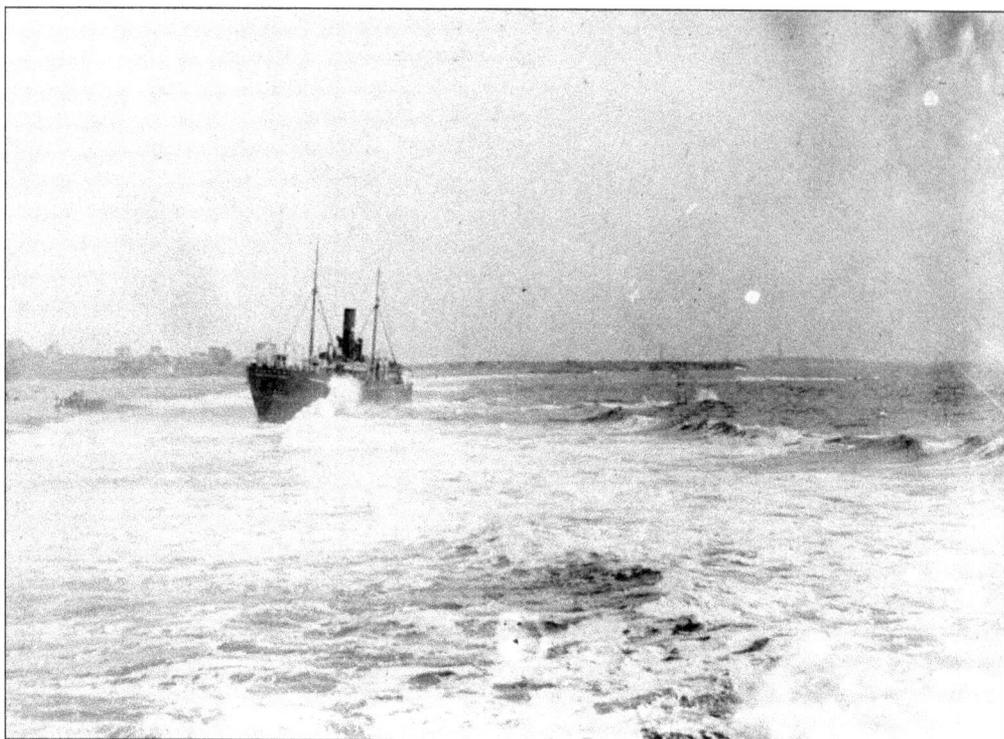

The *Wilster*, a British tramp steamer with a cargo of sugar, was forced onto Long Beach in Rockport opposite Thacher Island on February 28, 1902. Note the twin lighthouses of Thacher in the far distance to the right. (Courtesy Sandy Bay Historical Society.)

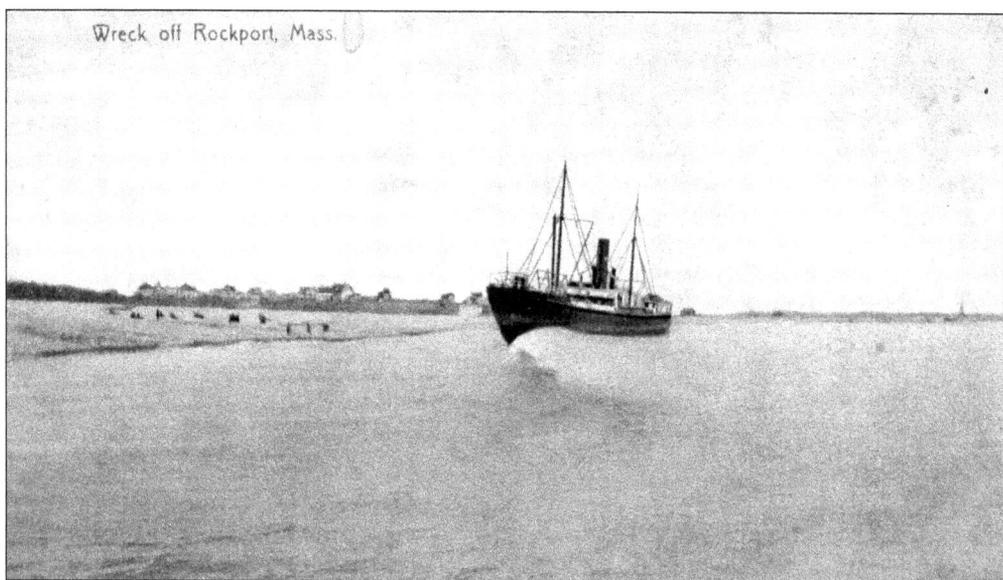

Wreck off Rockport, Mass.

The *Wilster* was later memorialized in this Charles Cleaves postcard in 1905. Cleaves did over 5,000 glass-plate negatives of a variety of seaside scenes in the Cape Ann area. This postcard was just one of hundreds he produced at his Rockport Photo Bureau in the early 1900s. (Courtesy Sandy Bay Historical Society.)

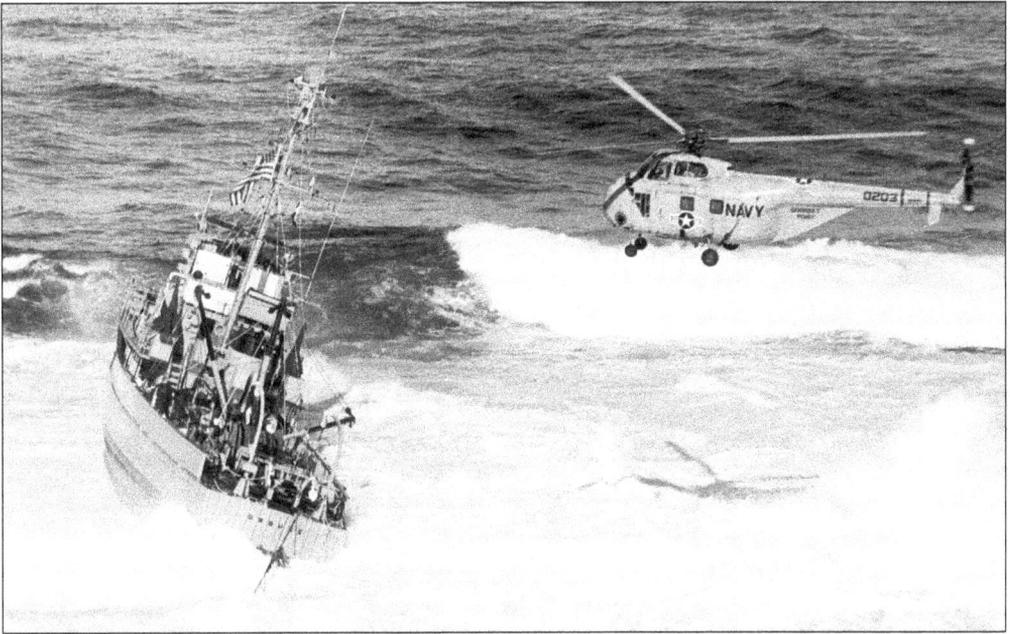

High seas break against the navy minesweeper USS *Grouse* on Little Salvages reef near Rockport Harbor in September 1963. A navy helicopter hovers at right. All crewmen were rescued from the 136-foot vessel, which piled up on the reef at the tip of Cape Ann about two miles from Thacher Island. (Courtesy Associated Press.)

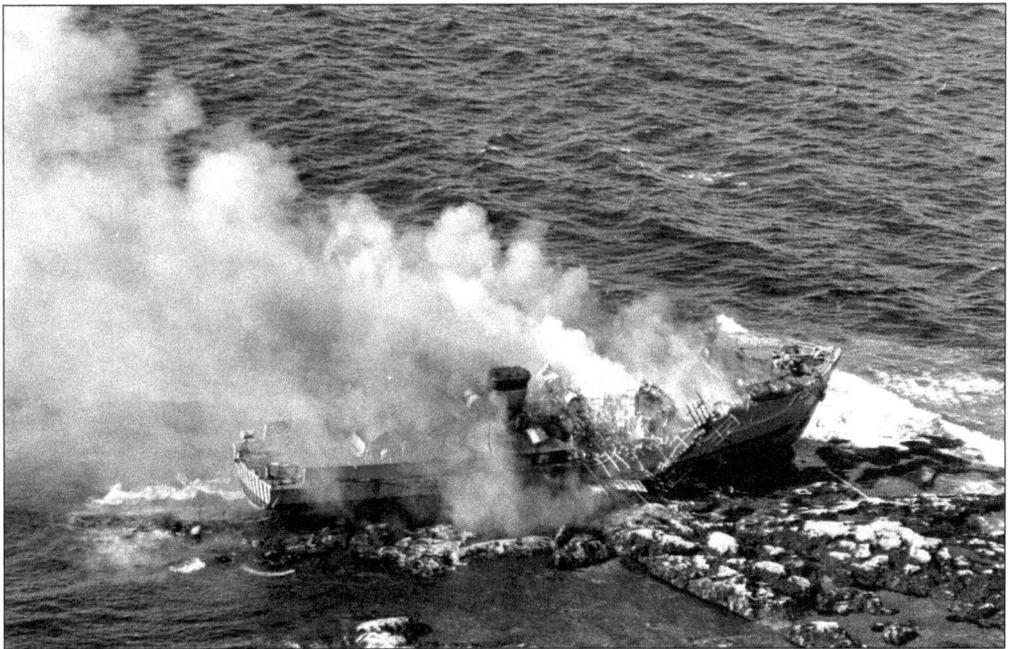

Several attempts were made to free the vessel by three navy tugs. Unable to free the stranded ship, the navy eventually doused her with gasoline and a flare was fired into the ship. Billows of black smoke rose, and within an hour, she was an inferno. Five officers and 30 crewmen aboard were removed with no injuries. (Courtesy Associated Press.)

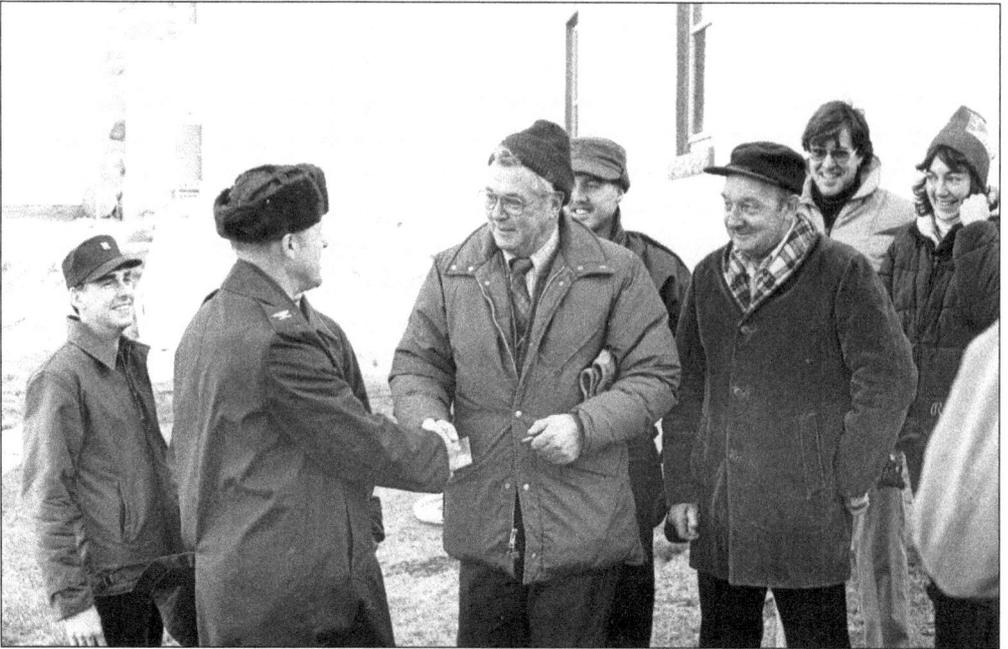

In 1980, the Town of Rockport leased the southern end of the island from the Coast Guard after they automated the light and fog signal and abandoned the island. The first president of the Thacher Island Association, Ned Cameron (center) is shaking hands with Capt. David Flanagan (second from left) of the Coast Guard. The newly appointed civilian keeper, Russell Grubb, is pictured fifth from the left. (Courtesy Thacher Island Association.)

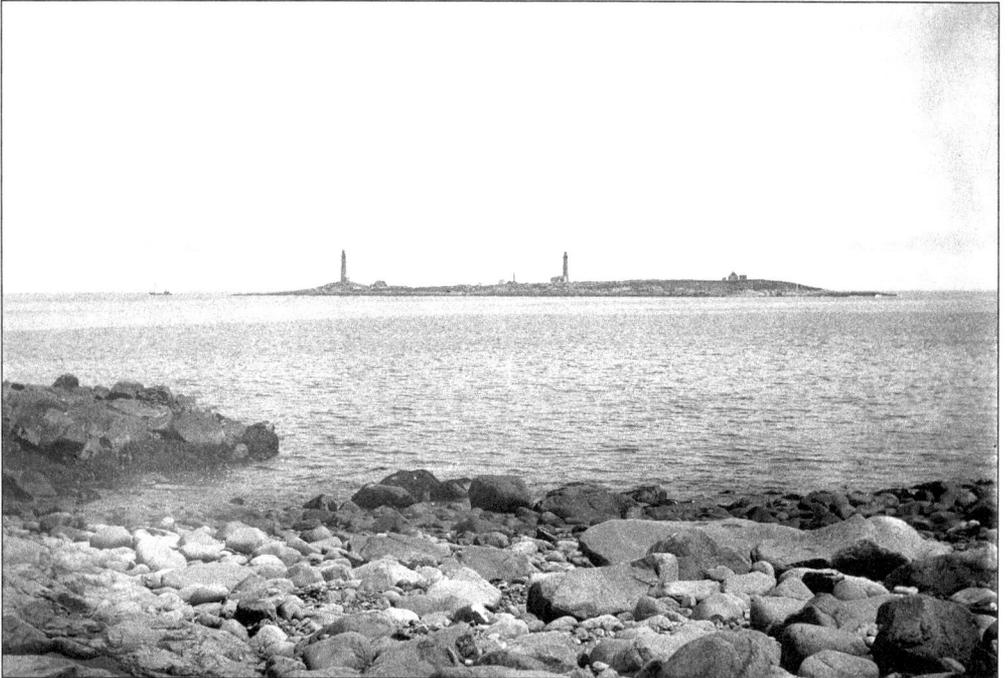

Today the island is open to the public free of charge. It attracts over 3,000 visitors annually and is enjoyed by all ages. (Courtesy Thacher Island Association.)

Two

ANNE'S EYES

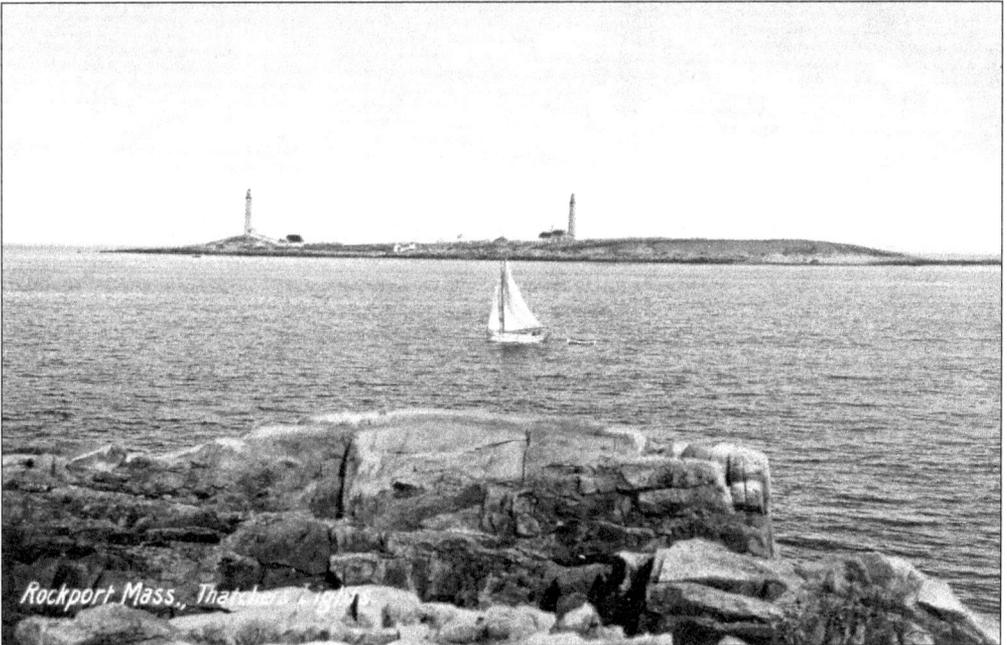

The first lighthouse towers on Thacher Island were built in 1771 by the Massachusetts Bay Colony while still under British rule. They were requested by the mariners of Marblehead and Boston. John Hancock, who had significant shipping interests in the area, presented his petition to the general court and proposed to tax Boston shipowners for "light money" to cover the costs of building and maintaining the lighthouses. (Courtesy Sandy Bay Historical Society.)

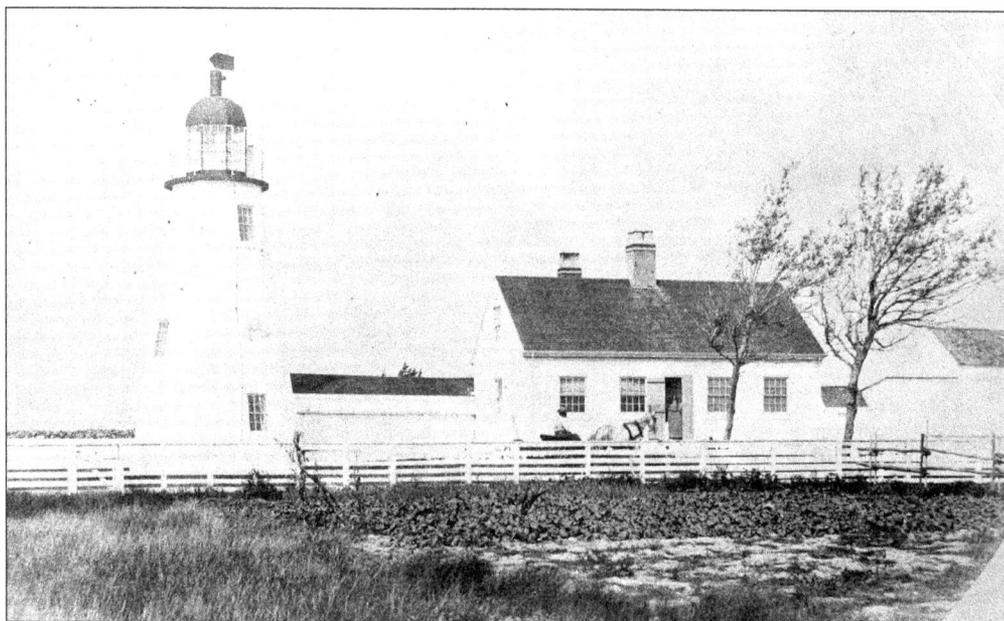

Ned's Point Lighthouse, built in 1838 in Mattapoisett is very similar to the first towers built on Thacher Island in 1771. They were built of rubble stone and wood and stood 45 feet high. On December 21, 1771, Forefathers' Day (a holiday observed in honor of the Pilgrims), the twin lighthouses shone with their candle flame for the first time. (Courtesy Jeremy D'Entremont.)

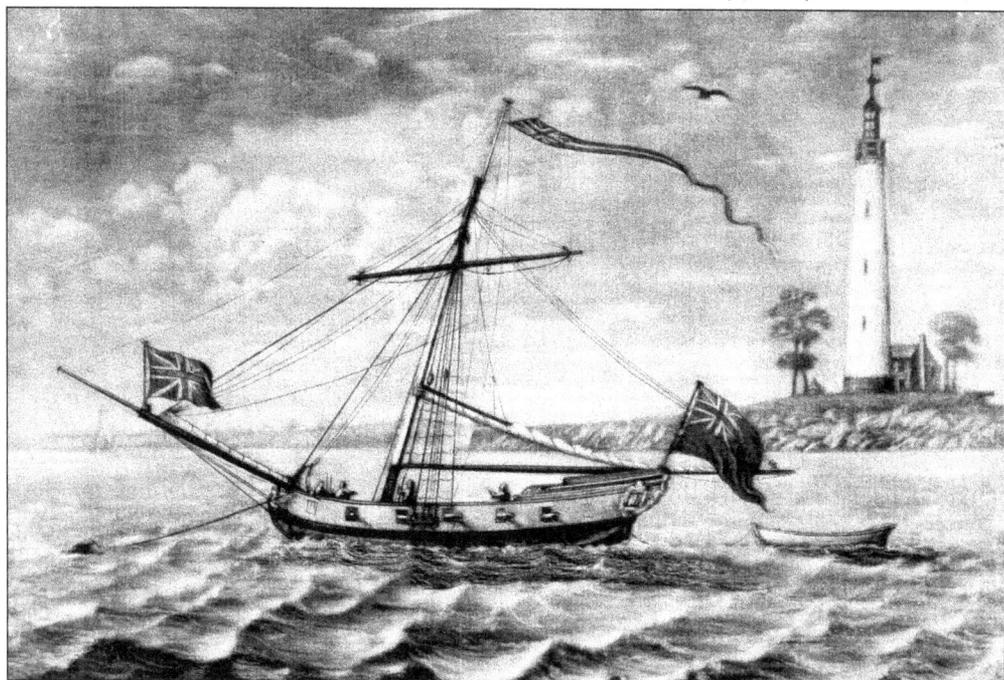

Boston Light was the first lighthouse built in the colonies in 1716 by the British. This print recalls what it looked like. It is thought to be similar to the first Thacher Island towers. At the time, only nine lighthouses were in operation in North America. North of Cape Cod there were only three locations for lights: Boston, Plymouth, and Portsmouth. (Courtesy Mariner's Museum.)

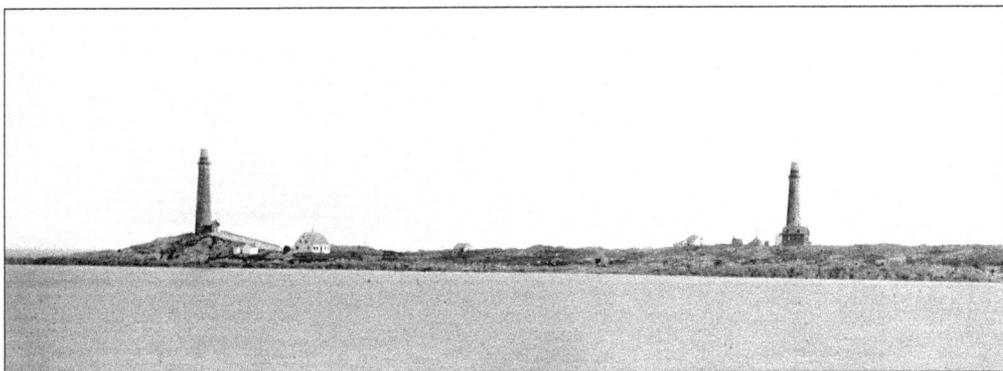

This panorama of the island was taken in 1870 before the principal keeper's house was built near the assistant keeper's house. The towers were located approximately 300 yards apart in an exact north-to-south alignment, enabling mariners to use them as range lights to determine their ship's exact location. These lights were among the first 10 so-called "Colonial lights" that existed at the time from North Carolina to Massachusetts. (Courtesy Thacher Island Association.)

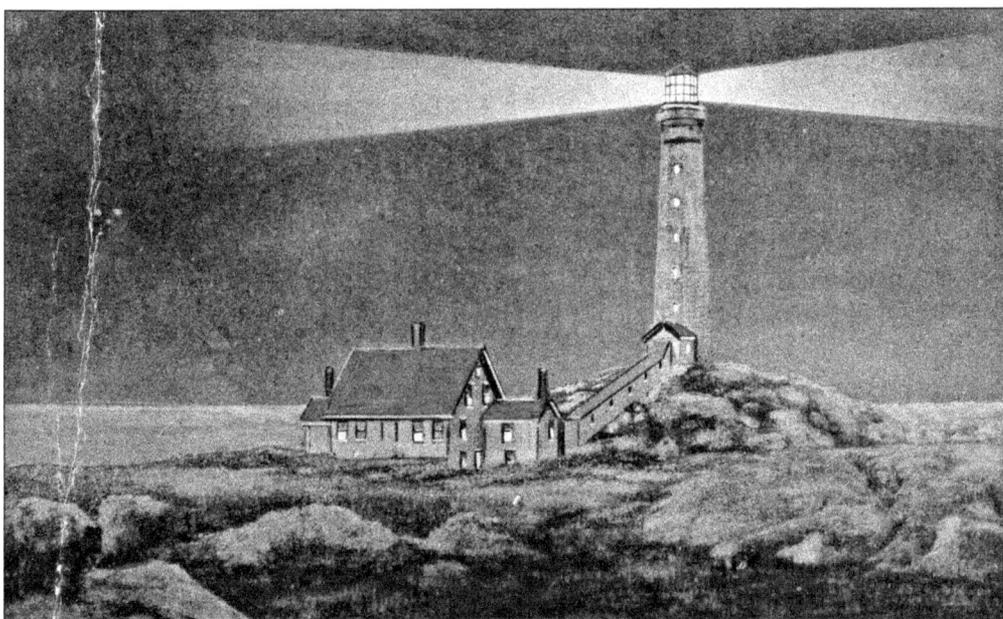

18 THATCHER'S ISLAND BY NIGHT ROCKPORT, MASS. THE NORTHERN LIGHTHOUSE

This postcard view of the north tower and keeper dwelling appeared around 1911 and was published by C.T. American Art Company of Chicago from a photograph by Charles Cleaves. It is a unique photograph which was hand painted in color to show the light at night with its bright beam expanding across the ocean. The actual photograph which was used is featured on the top of page 57. (Courtesy Thacher Island Association.)

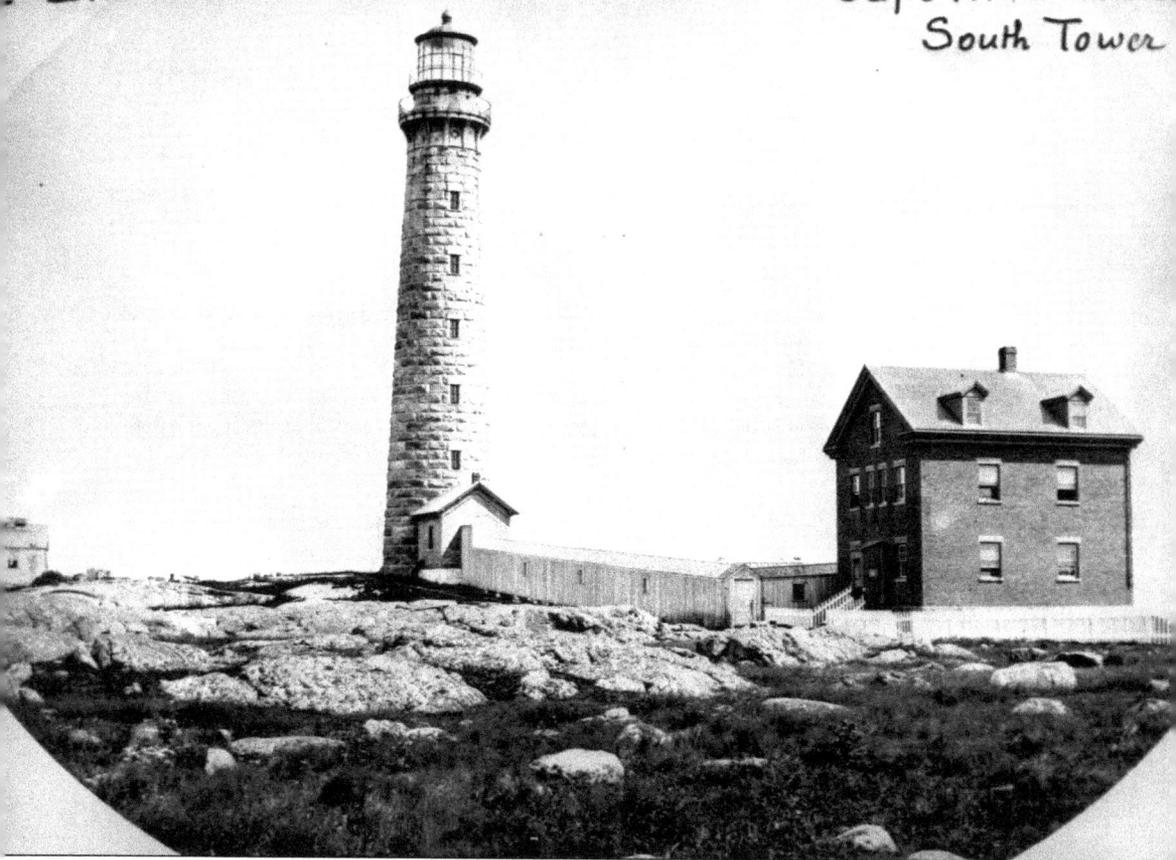

Two new towers and a brick keeper dwelling were built in 1861. The south tower is shown here with a covered walkway and the fog signal building. Ironically Rockport, known for its many granite quarries, did not supply the granite for these towers, due to political pressure. New Hampshire granite was used instead. The towers' locations on Cape Ann spawned the nickname "Anne's Eyes" by the locals. (Courtesy National Archives and Records Administration.)

This illustration of the south tower from *Harper's New Monthly Magazine*, March 1874, appeared in an article written by Charles Nordhoff titled, "The Light-Houses of the United States." Note the original fog signal building on the left and the covered walkway to the house. (Courtesy Thacher Island Association.)

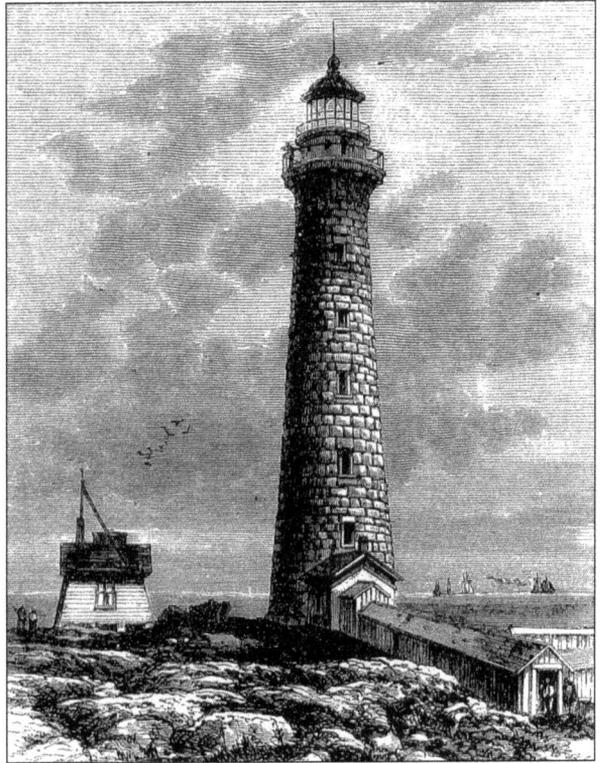

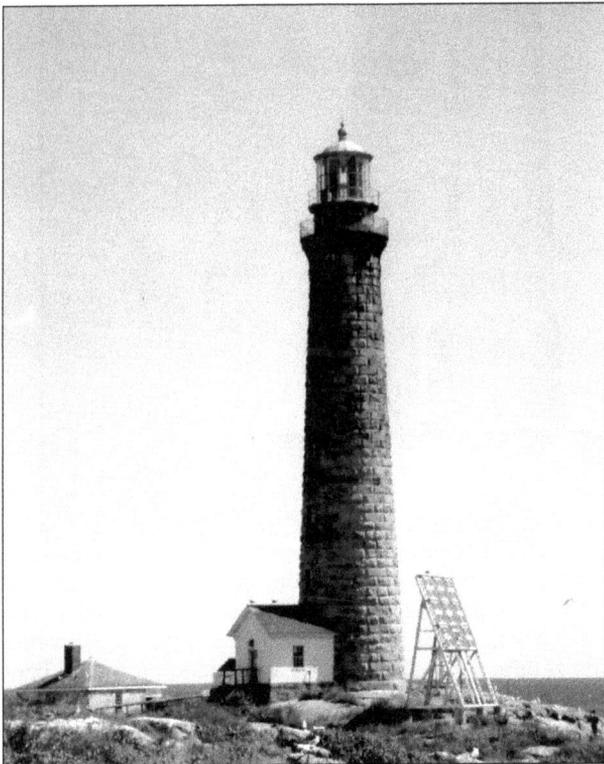

Contrast this photograph of the south tower today with the illustration above. It was totally restored in 2008. Note the solar panels used to power the red beacon light and the foghorns. (Courtesy Thacher Island Association.)

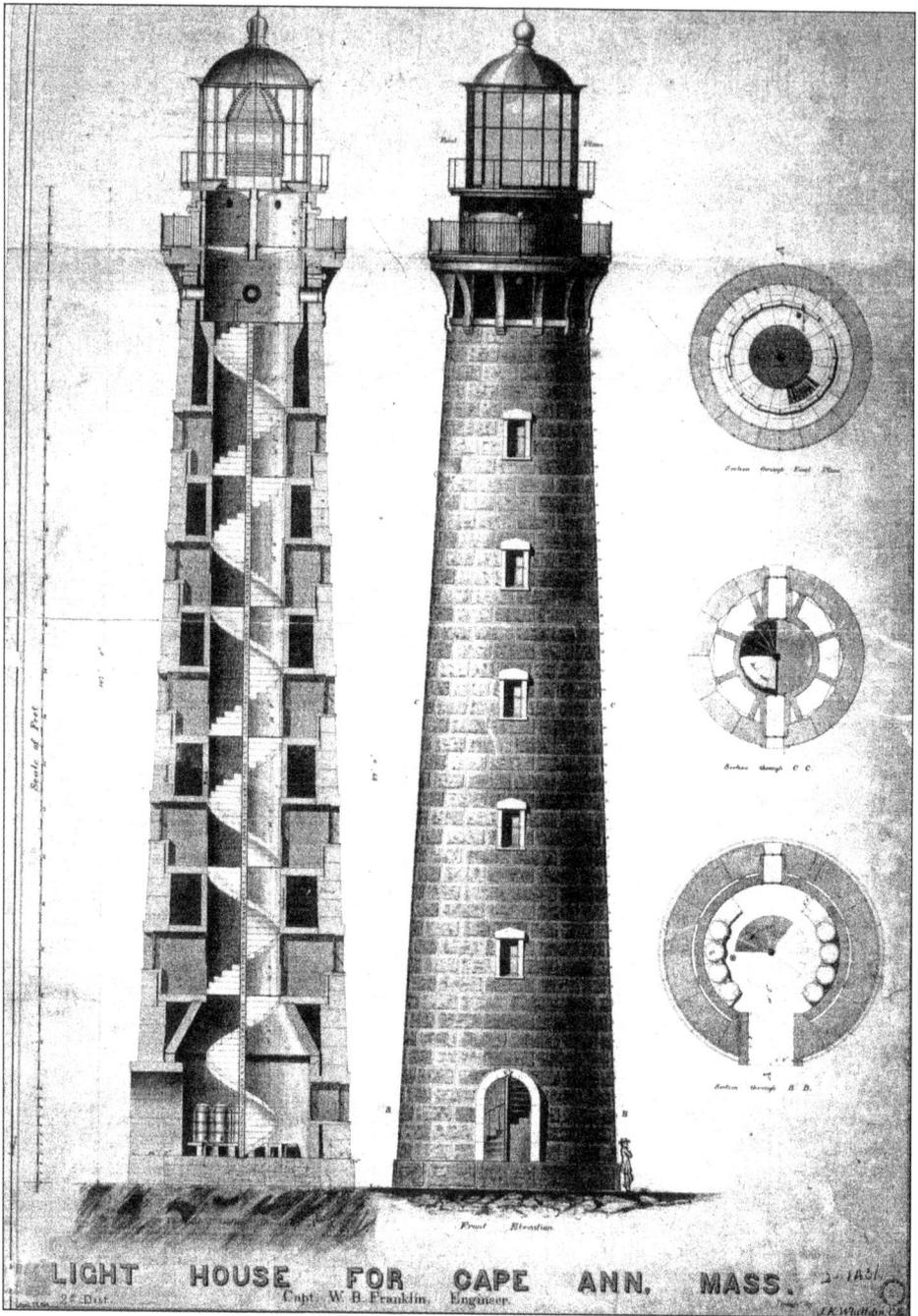

LIGHT HOUSE FOR CAPE ANN, MASS.
Capt. W. B. Franklin, Engineer

These are the original construction drawings of the towers. Each one stands 124 feet tall and 166 feet above mean high tide; they are 30 feet in diameter at the base and 18 feet at the lantern. There are five decks as one climbs the 156-step spiral staircase, and two stages of balconies encircle the upper tower. Five slit windows appear on the east and west sides, providing light to the staircase. The granite exterior is lined inside by brick with a space of 18 inches in between, and the walls of the tower are four to five feet thick. (Courtesy National Archives and Records Administration.)

30

This original construction drawing shows there are four porthole windows in the watch room. Above the watch room is the service room, where the keepers maintained a workshop and a place to store the oil used in the lamp. (Courtesy National Archives and Records Administration.)

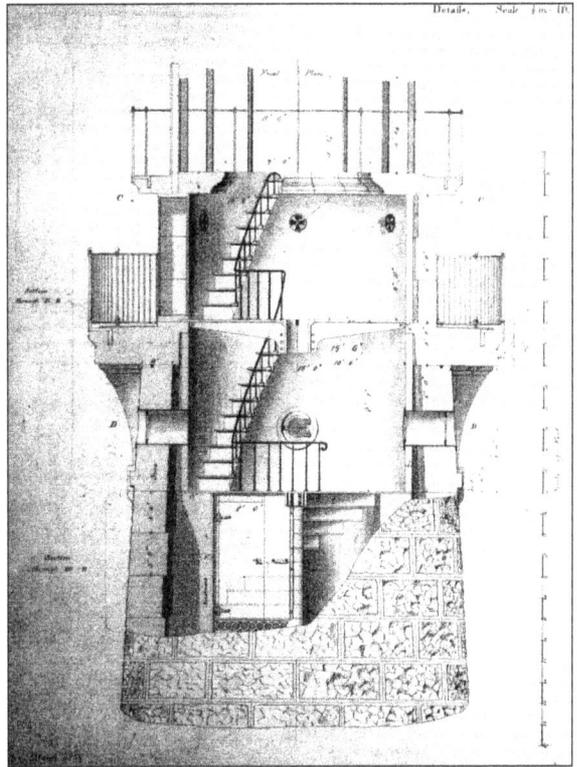

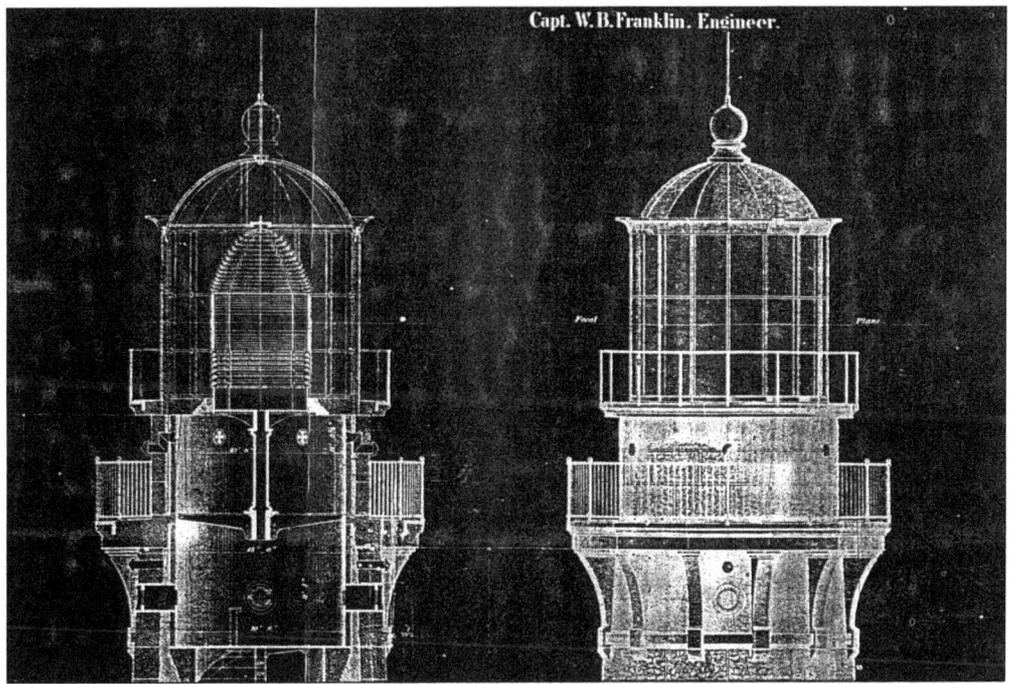

Capt. W. B. Franklin. Engineer.

The lantern is constructed of iron, bronze, and glass, with a roof made from copper topped by a ventilating ball and lightning rod. It is polygonal (16 sided) and about 10 feet high. (Courtesy National Archives and Records Administration.)

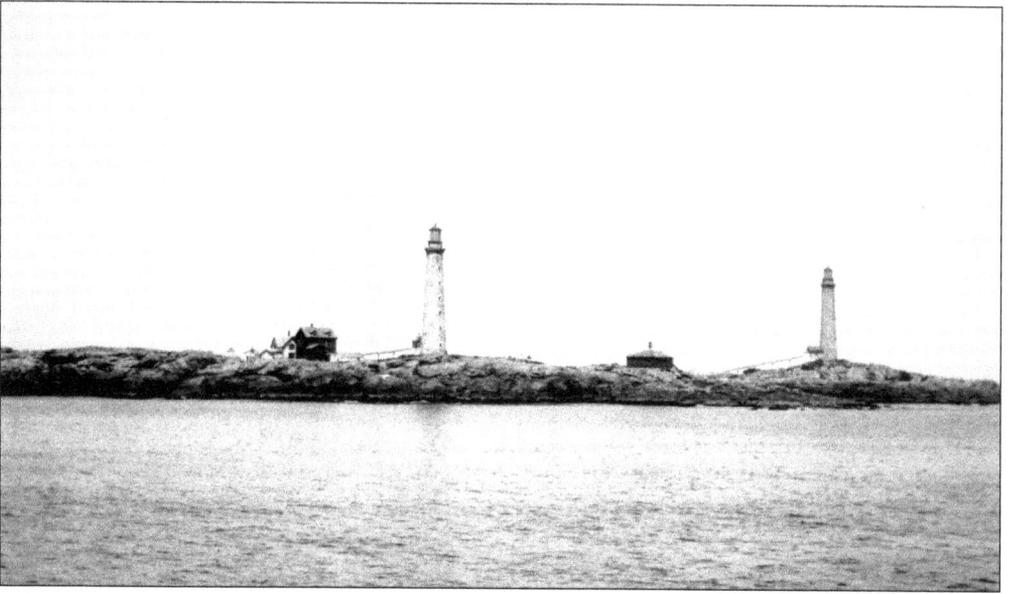

Why two lighthouses? Lighthouses today have distinctive flashing patterns known as characteristics, enabling mariners to differentiate one from another. At the time the towers were built, flashing technology was unavailable. In order to distinguish Thacher Island from Boston Light, 24 miles to the south, and Portsmouth Harbor Light, 30 miles to the north, two lighthouses where built. Standing 300 yards apart, they also mark the boundaries of the Londoner reef, about a half-mile off the island. (Courtesy National Archives and Records Administration.)

Only seven twin lights and one triple light have ever been built in the United States. They were constructed between 1769 (Plymouth Light) and 1838 (the Three Sisters at Nauset Beach on Cape Cod.) Twin light construction ended as technology allowing for characteristics was developed using rotating lenses. Cape Ann Light Station is the first light seen by mariners coming from Europe. (Courtesy U.S. Coast Guard.)

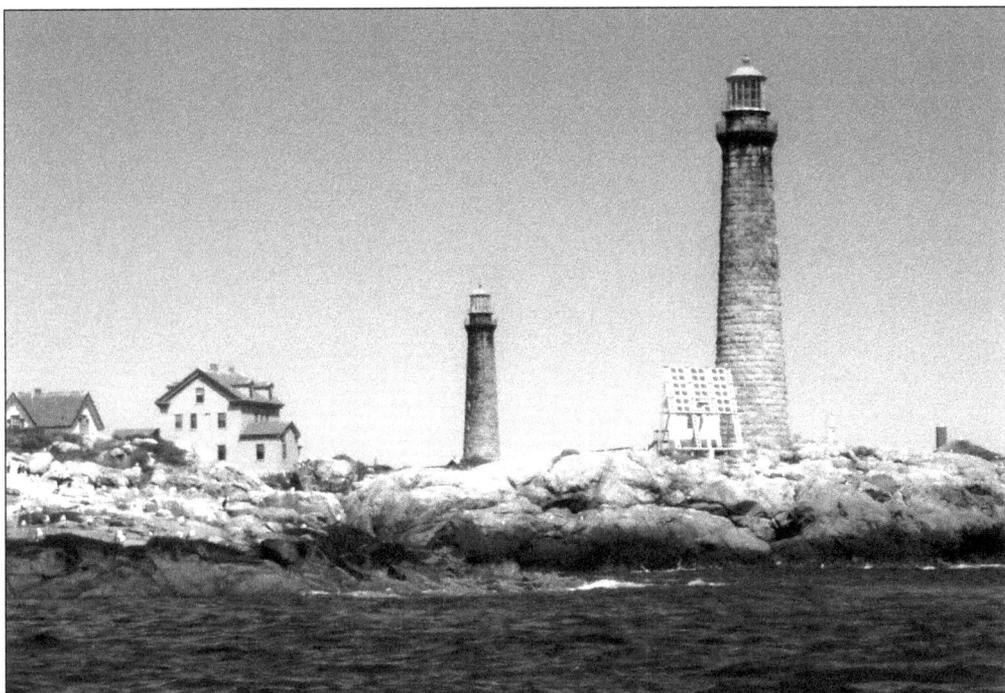

These are the twin lights as they appear today. The two keeper's houses are on the left, and solar panels and the fog signals are seen on the far right next to the tower. The roof of the former fog signal house can be seen on the far right. The Thacher twins are the last fully operational twin lights in the United States. (Courtesy Thacher Island Association.)

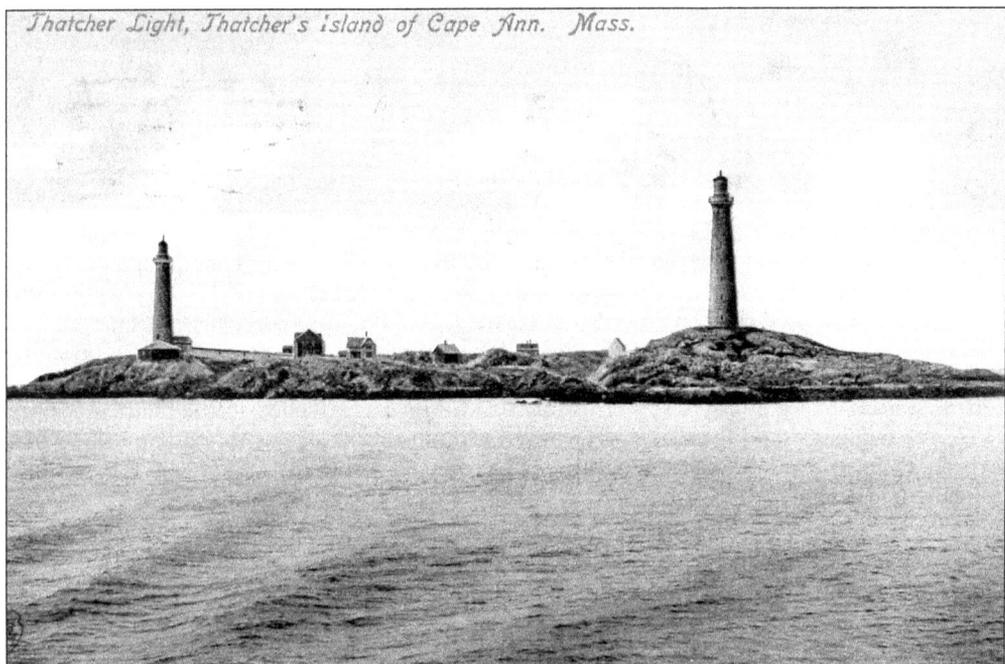

Thatcher Light, Thatcher's Island of Cape Ann. Mass.

This postcard, featuring the twin towers of Thacher Island, was one of several versions printed in the early 1900s. (Courtesy Thacher Island Association.)

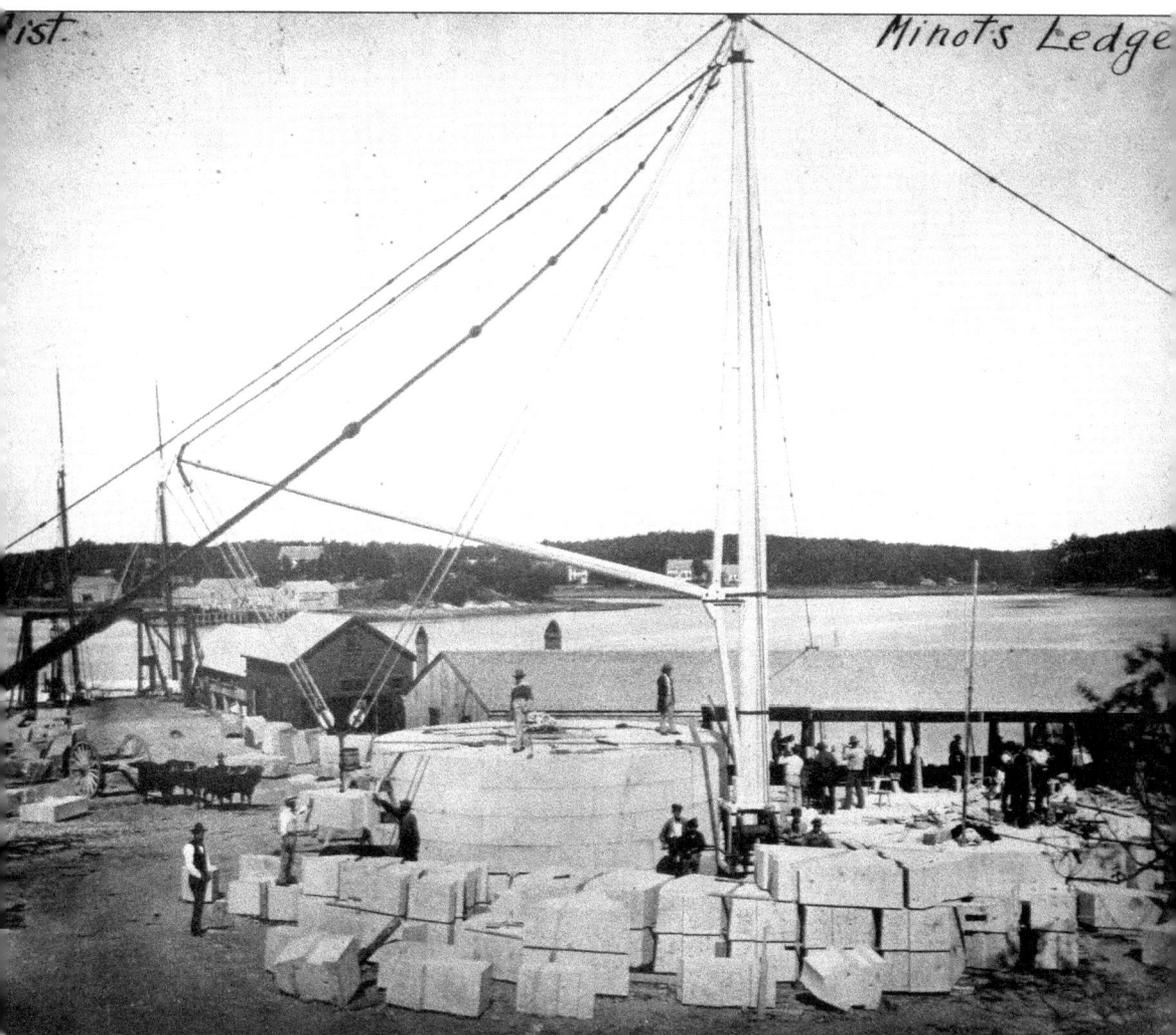

Minots Ledge

A year before Thacher Island's twin towers were built, Minot's Ledge Light was completed, using the same technology and believed to be designed by the same engineers. Gen. Joseph G. Totten of the lighthouse board designed the tower, and Lt. Barton S. Alexander of the U.S. Army Corps of Engineers supervised the construction. After the loss of the original, spidery 70-foot-tall iron pile tower, work on a new stone tower began in 1855. Each block of granite was precut on shore, as shown in this October 1857 U.S. Lighthouse Establishment second district photograph. The cutting was done at Cohasset's Government Island, which is attached to the mainland. Each block was numbered and fitted, and a team of oxen moved the blocks to a granite sloop that brought them to the work site on Cohasset Rocks about a mile off shore near Cohasset and Scituate. (Courtesy U.S. Coast Guard.)

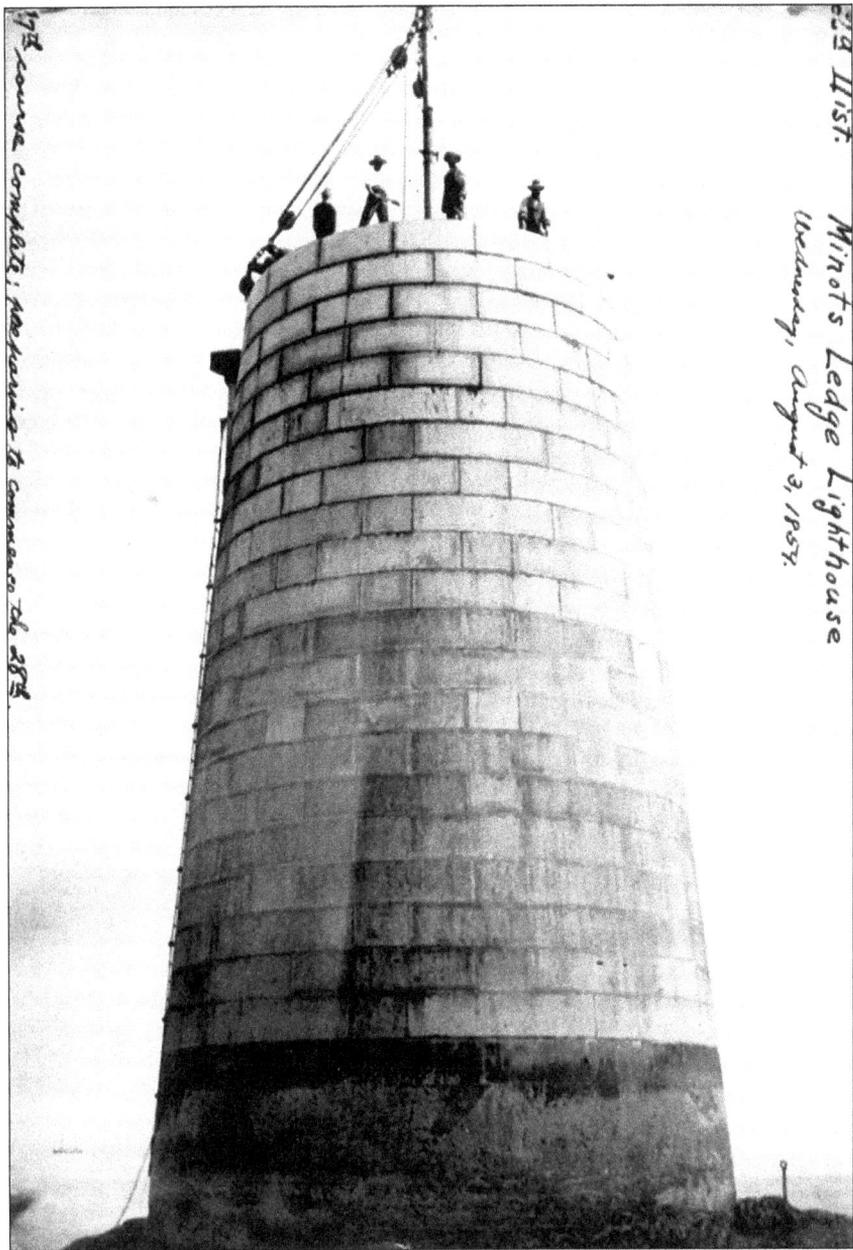

Shown here is the 27th course of granite being set in place at Minot's Ledge Light on August 3, 1859. The granite was lifted into place using a newly designed machine called a Holmes Hoist. At sunrise on Sunday, August 11, 1858, men "laid the lowest stone in the structure." Work had to be done at extreme low tide, and only certain weeks and times were available due to the position of the moon and its effect on the tides. Small coffer dams were built at low tide to enable workers to set the foundation stones into the rock ledge, which was covered at high tide. The building of the tower took about five years. At the ledge, the blocks were dovetailed to each other and doweled together with iron pins. The final cost was $244,000. The light has a distinctive one-four-three flash that stands for "I love you." It is often called "Lover's Light." (Courtesy U.S. Coast Guard historian.)

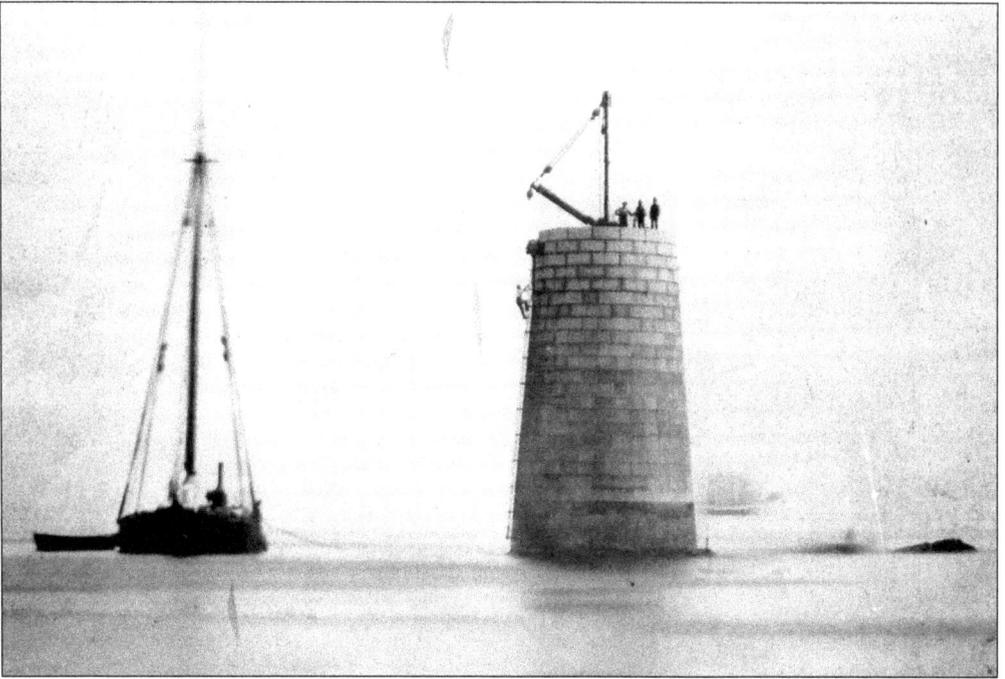

A rock sloop approaches the partially completed tower to supply more stone. The final stone was laid on June 29, 1860, having taken five years and close to $300,000 to complete. Built of 1,079 blocks of Quincy granite, the tower still stands today. (Courtesy U.S. Coast Guard historian.)

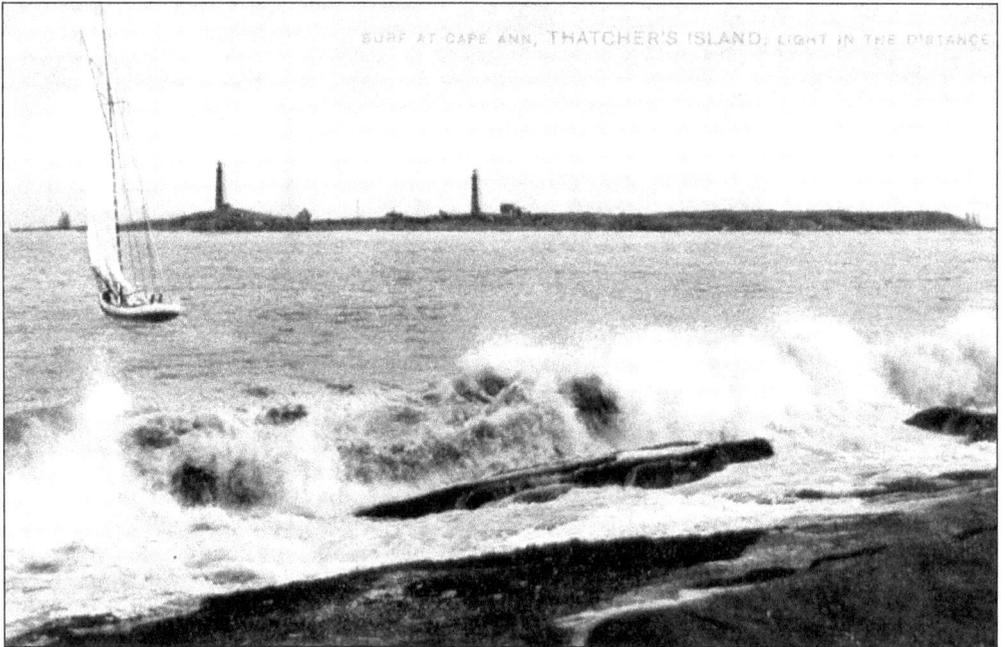

Thacher Island was located on the very busy commercial route between Canada, Europe, Boston, and the West Indies. It was once estimated that over 70,000 ships passed the island annually. The lights were the first to mark "a dangerous spot in the ocean." All others simply marked the entrance to harbors. (Courtesy Thacher Island Association.)

This photograph shows a man smoking a cigar while gazing at Thacher Island from Loblolly Cove. It was taken around 1872 or 1873 based on the fact that the principal keeper house is not visible, having not been built until 1875. This photograph was part of a series of stereopticon slides popular at the time. The slide was comprised of side-by-side duplicate photographs, and seen through the viewer, they gave one the illusion of greater depth and detail. These stereopticon slides were produced by Proctor Brothers and E. G. Rollins, both of Gloucester. Stereopticon viewers, as a special entertainment device, could be found in most middle- and upper-class parlors in the mid-1800s, allowing people to tour the world via these slides in their own home. Hundreds of stereopticon slides were produced by these companies covering the Cape Ann area, with many showing scenes of Thacher Island. Other slides in the series included picnickers on the rocks of Emerson Point across from Thacher Island. Another showed where keepers often landed to walk to town from Loblolly Cove beach, with Thacher Island in the background. (Courtesy Sandy Bay Historical Society.)

This is the official "Notice to Mariners," issued by the lighthouse board engineer Charles N. Turnbull, announcing that the twin lights would "first be exhibited at Cape Ann, Massachusetts on Thatcher's Island on October 1, 1861. The two fixed first-order catadioptric Fresnel lenses will be able to be seen at a distance of twenty nautical miles." (Courtesy National Archives and Records Administration.)

The town of Rockport realized the importance of the Thacher Island lighthouses. In 1888, the town voted "to adopt a corporate seal, grant money for the same." It was described by the town clerk: "The seal to be circular in form, one and one half inches in diameter, to have a representation of Thacher's Island lighthouses, and the inscription (Town of Rockport, Massachusetts, Incorporated February 27, 1840)." (Courtesy Town of Rockport.)

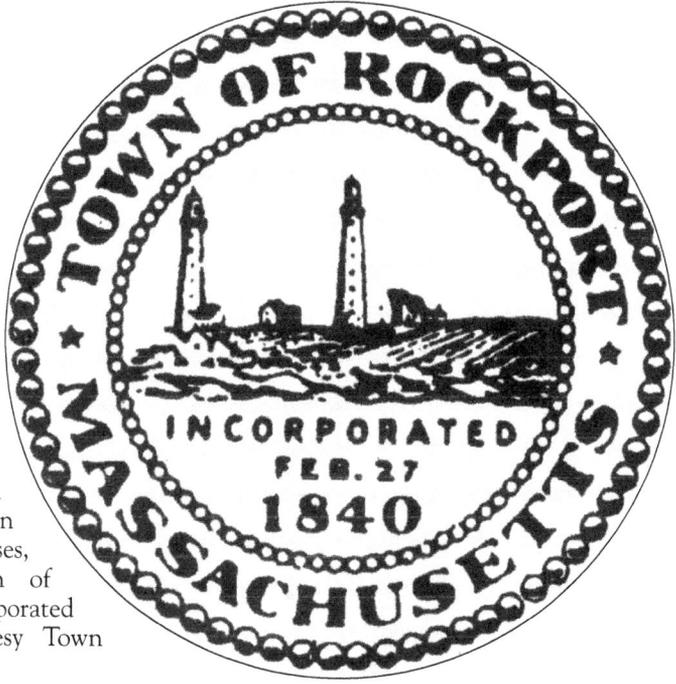

TOWN OF ROCKPORT MASSACHUSETTS
INCORPORATED FEB. 27 1840

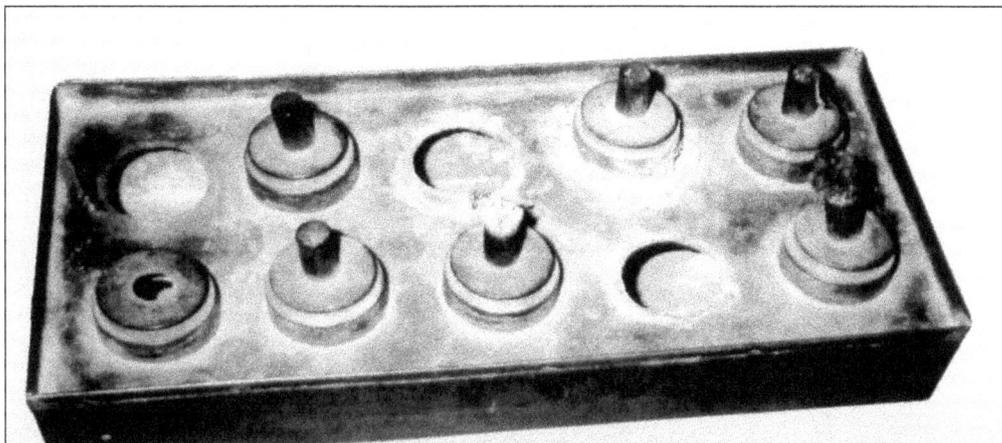

In 1800, spider lamps were being used as the beacon light in the towers. A spider lamp was a flat tray filled with whale oil and 10 lighted wicks suspended in the pan. (Courtesy U.S. Lighthouse Society.)

Winslow Lewis, a former sea captain, observed the poor quality of lighthouses during his years at sea. Eventually Lewis became the principal builder of lighthouses in the nation. He built the first keeper's house on Thacher Island in 1816 at a cost of $1,415. He later renovated both towers in 1828, using white-washed rubble stone and brick and added copper domes to the towers. (Courtesy U.S. Lighthouse Society.)

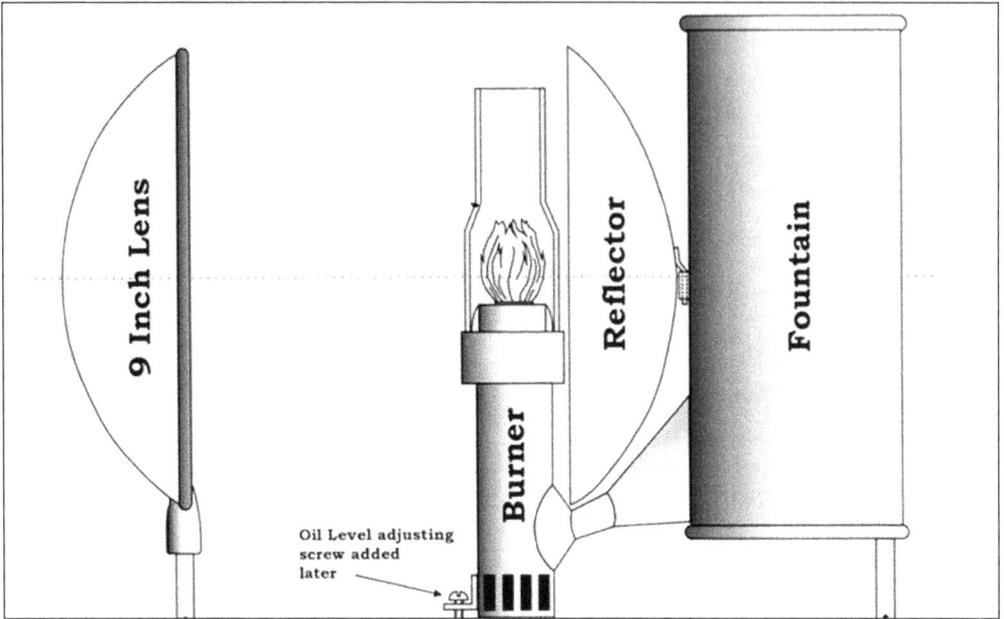

9 Inch Lens

Burner

Reflector

Fountain

Oil Level adjusting screw added later

In 1810, Winslow Lewis invented an improved lighting apparatus, combining an Argand oil lamp with a parabolic reflector and lens system to enhance the light beacon's intensity. He tested his device in the south tower. It proved to be brighter and used less whale oil than the spider lamp in the north tower. His system was soon used in all lighthouses in the United States. (Courtesy Thomas Tag collection.)

In 1841, Lewis completed a government contract to refit and replace all lights. According to the lighthouse establishment records, "each light house [was] to be fitted up with ten lamps and 20-inch reflectors on two tiers. The reflectors to be formed on a die, each to be plated with fifteen ounces of pure silver, furnished with brass rims, two spare lamps, stove and funnel and the lamps fitted with oil heaters." (Courtesy U.S. Lighthouse Society.)

Augustin-Jean Fresnel, a French physicist, designed one of the greatest inventions in the history of lighthouses—the lens named after him. (Courtesy U.S. Lighthouse Society.)

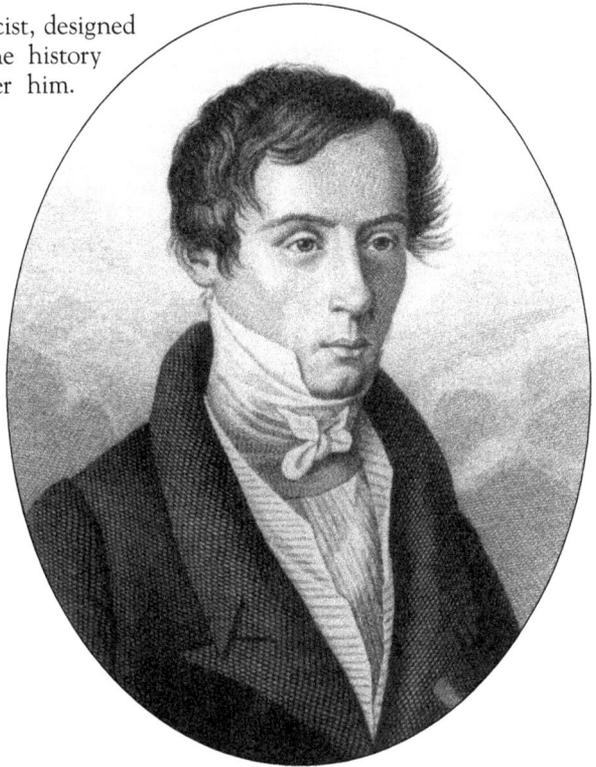

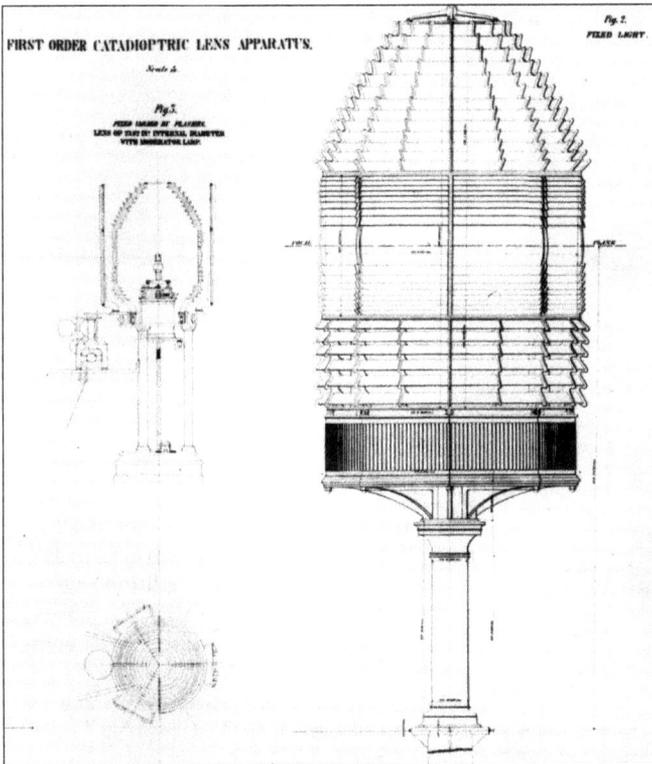

FIRST ORDER CATADIOPTRIC LENS APPARATUS.

First-order Fresnel lenses (the largest of the six orders or sizes) were installed in both towers in 1861. The Fresnel lens used the principal of light refraction to form a single concentrated shaft of light traveling in one direction, making the light visible 22 miles away. The first-order lenses each weighed three tons, stood 12 feet high, and were six feet in diameter with more than 1,000 crystal glass prisms mounted in a bronze framework. (Courtesy U.S. Lighthouse Society.)

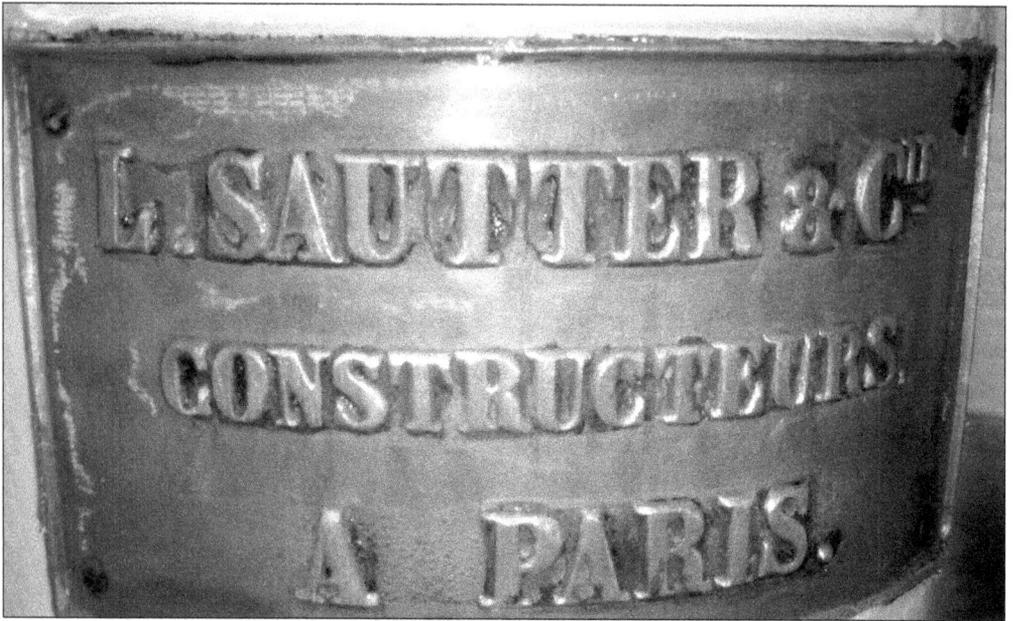

The lighthouse board split its lens purchases between two lighthouse equipment manufacturers during the main conversion to Fresnel lenses between 1853 and 1861. The lenses in the north tower were made by Henry-Lepaute, while the lens in the south tower was made by L. Sautter. Both companies were in Paris. This plate remains in the south tower lantern room. (Courtesy Thacher Island Association.)

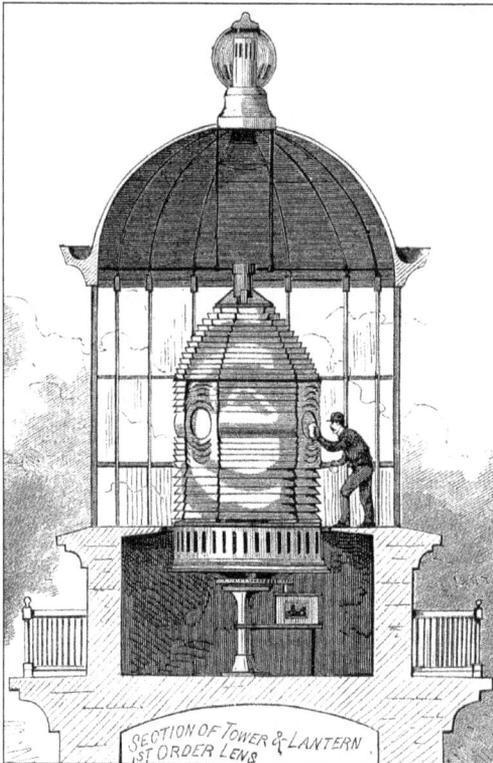

An illustration from *Scientific American* on June 11, 1892, demonstrates the size relationship of a first-order Fresnel lens to a man. When this lens was electrified in 1932, it was reported in the July 1 edition of the *Lighthouse Service Bulletin* "that the master of the steamship *Falmouth* has reported seeing the new light at Cape Ann, Mass, a distance of 44 miles." This observation was made on the night of May 3, 1932. (Courtesy Thacher Island Association.)

Don Terras, director of Grosse Pointe Lighthouse National Landmark, stands inside a second-order Fresnel lens at Grosse Point, indicating the enormous size of the Fresnel lenses. (Courtesy U.S. Lighthouse Society and Don Terras.)

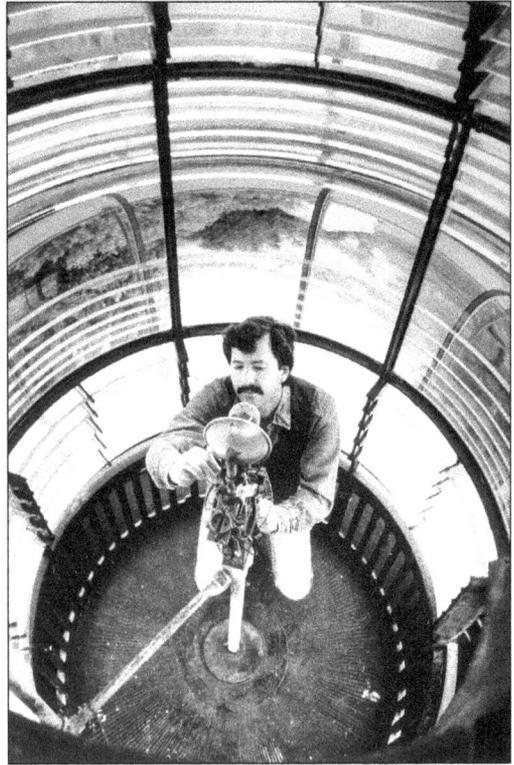

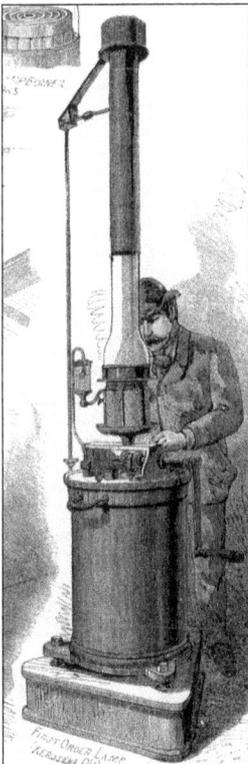

Various types of lamps were used in lighthouses. The Funck lamp used at Thacher Island had five concentric wicks and was fed by kerosene in later years. It is made of brass, and the reservoir tank below holds the fuel that is pumped into the lamp above. Pictured here is an illustration from the June 11, 1892 issue of *Scientific American*, showing the keeper preparing the first-order kerosene oil lamp. (Courtesy Sandy Bay Historical Society.)

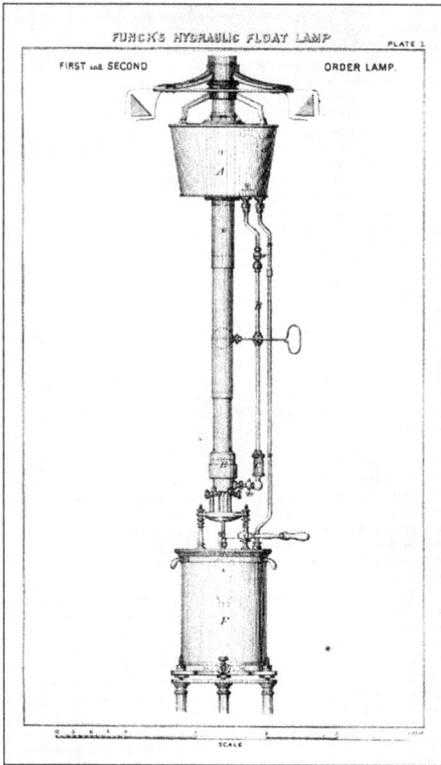

FUNCK'S HYDRAULIC FLOAT LAMP PLATE 1

FIRST and SECOND ORDER LAMP.

SCALE

This is an original U.S. Lighthouse Service drawing of the Funck Hydraulic Float Lamp for first-order lenses once used at Thacher Island. This entire apparatus was placed in the center of the Fresnel lens. (Courtesy Thomas Tag collection.)

This original lamp is on display in the Thacher museum. Whale or sperm oil was discontinued in 1850 due to its cost and scarcity. Lard oil was substituted until the 1870s, when kerosene (also known as mineral oil) became the illuminant. The lamp used a five-ring wick. An early lighthouse service annual report noted that a typical first-order lamp such as this burned 2,282 gallons of oil a year. (Courtesy Thacher Island Association.)

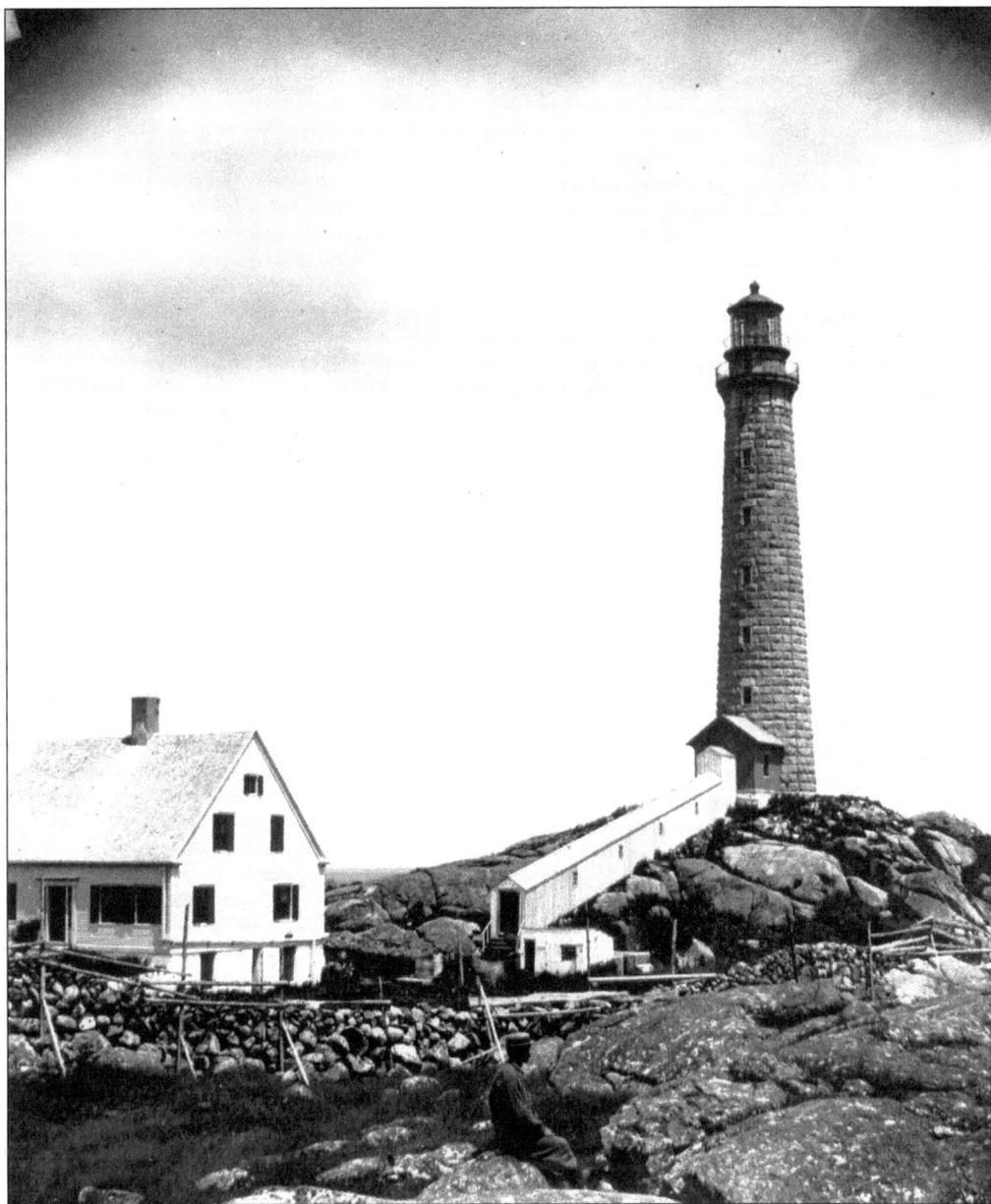

This *c.* 1890 photograph shows the north tower, which is an exact duplicate of the south tower, 298 yards away. The north tower stands on a high promontory on the northern end of the island. It was attended to by men who lived in the north keeper's dwelling. The tower stands 112.5 feet tall to the focal point of the light and 166 feet above the mean high tide mark of the ocean. When it was first electrified, it used four 250 watt bulbs surrounded by the huge Fresnel lens, with over 1,000 crystal glass prisms to intensify the light. This light was magnified to 70,000 candlepower. Lights had to be checked every four hours. A stopwatch was used to check the flash timing at five flashes every 20 seconds, and it had to be corrected if the keepers found an error of 1/100 of a second. Pres. Franklin D. Roosevelt ordered this light extinguished in 1932 as a cost savings effort during the depression. (Courtesy National Archives and Records Administration.)

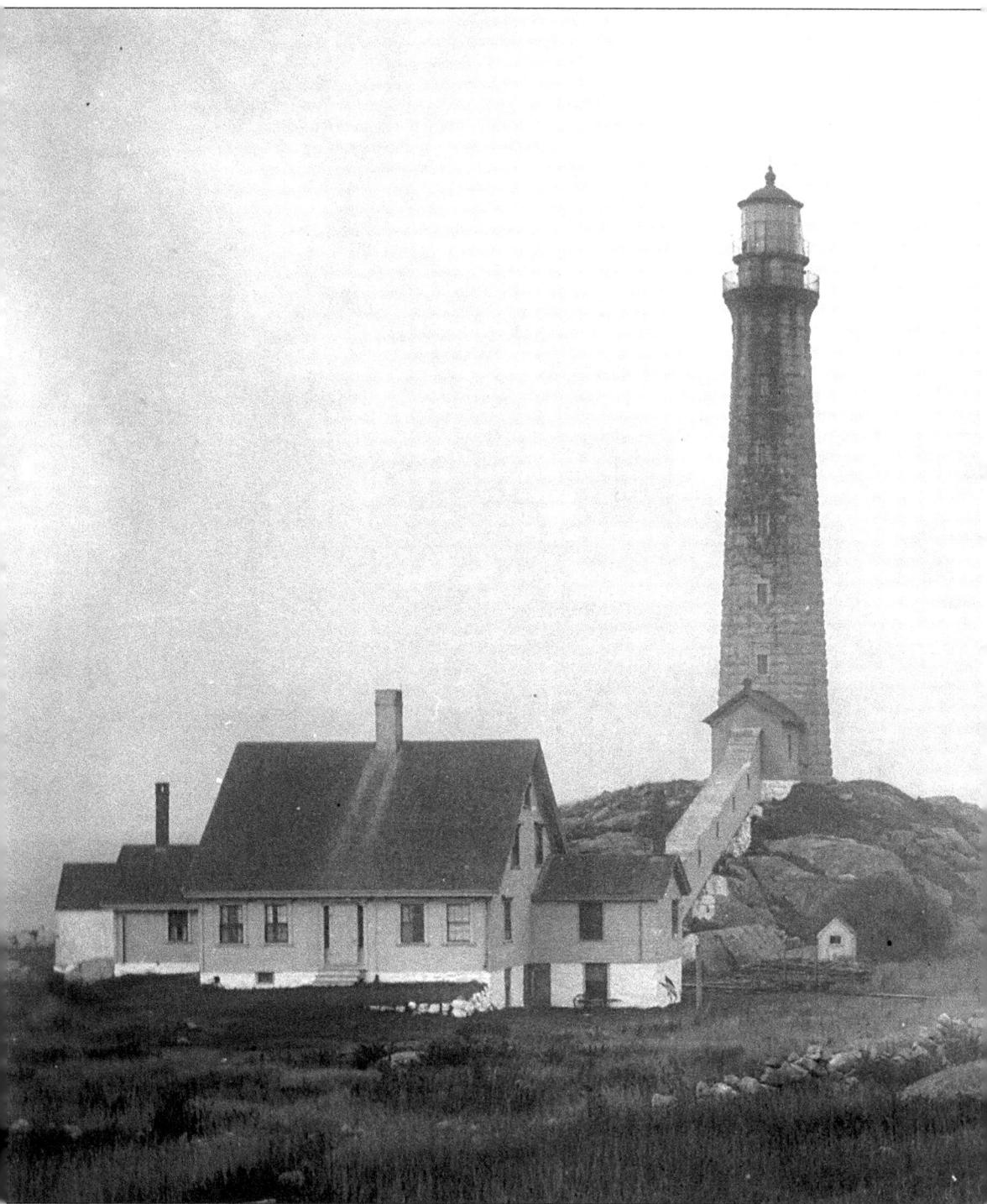

This Charles Cleaves photograph, taken around 1910, shows the addition of two kitchen wings on the north keeper's house. Note the fishing schooner sailing by in the background. In the foreground is a stone wall built by Aaron Wheeler, who was keeper from 1814 to 1834. It was used to surround a large vegetable garden maintained by the keepers. Joseph Sayward served as

keeper for over 20 years, from 1792 to 1814. Once in 1814, British sailors came on to the island to steal potatoes from the garden to restock their ship. The aging Sayward was helpless to defend his garden. (Courtesy Sandy Bay Historical Society.)

47

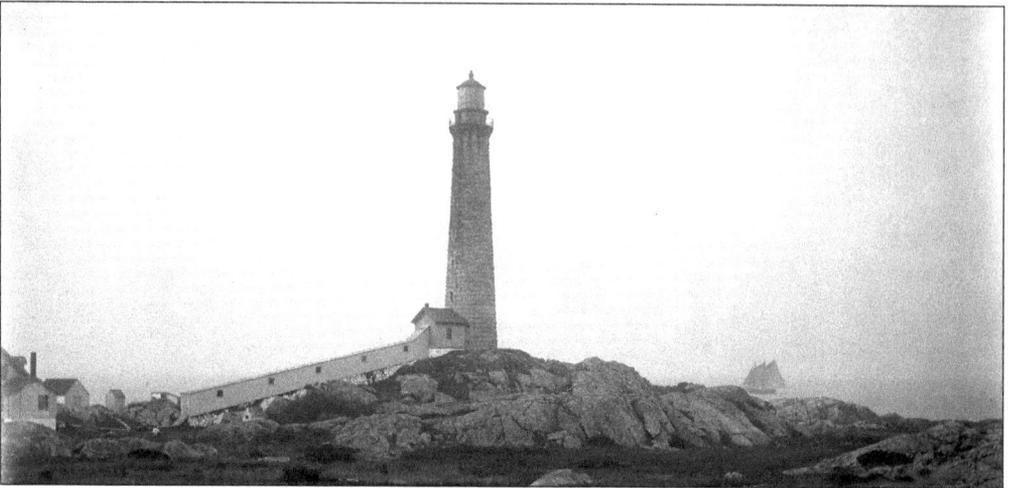

The outhouse can be seen on the far left near the covered walkway. This walkway came in handy during the severe snow and rain storms that frequently came out of the northeast. (Courtesy Sandy Bay Historical Society.)

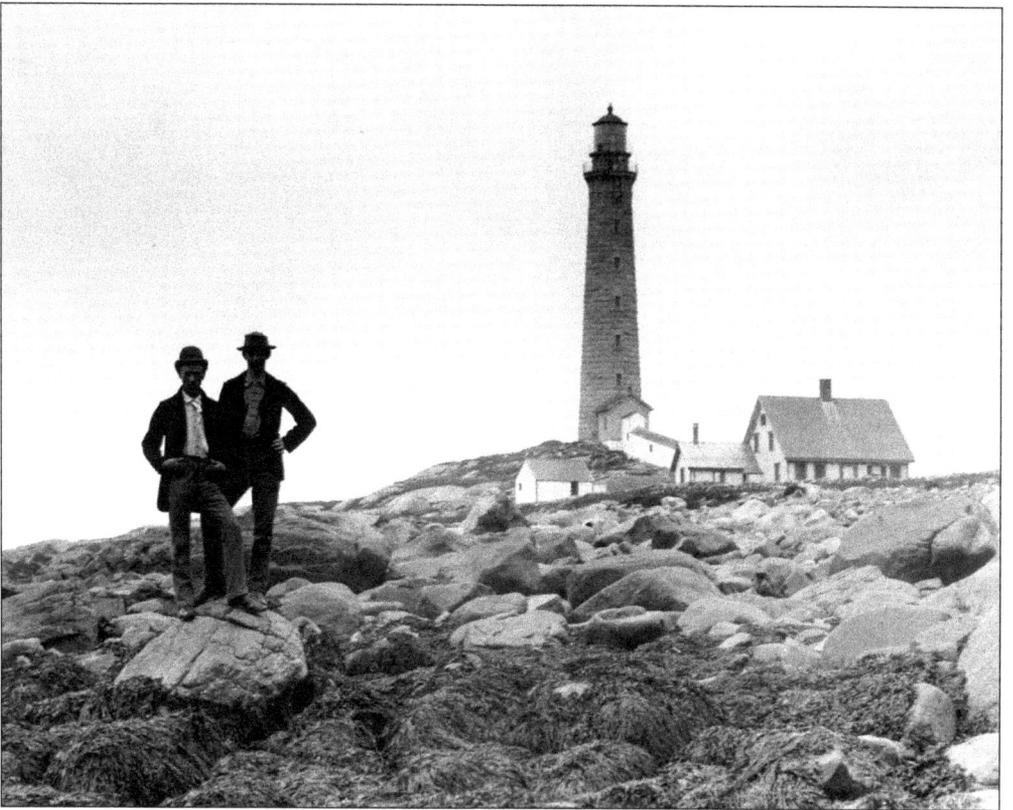

Unidentified keepers are standing near the north tower around 1890, before the second kitchen wing was added to the north keeper's dwelling. (Courtesy Thacher Island Association.)

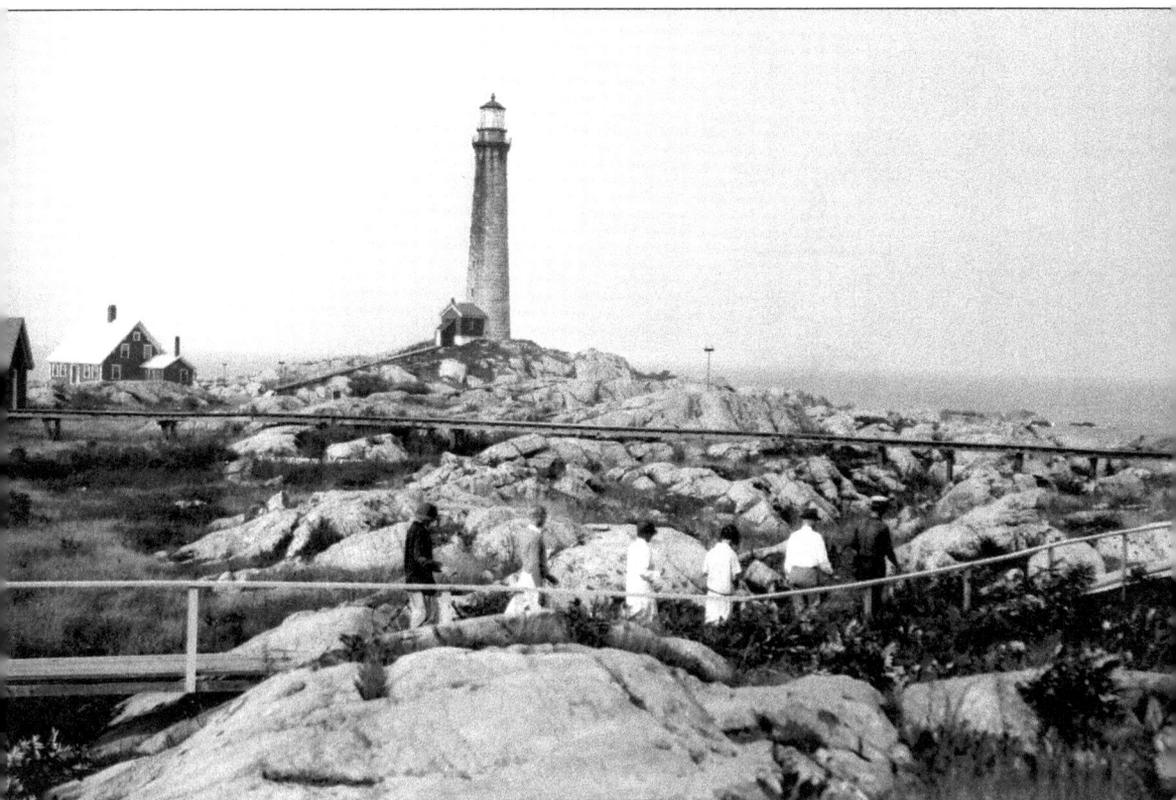

The head keeper is showing visitors around the island in 1920. Notice the covered walkway is gone, and the trestle to the railway going toward the whistle house is evident. The island was first electrified in 1902 when a submarine cable, also containing a telephone line, was laid by the lighthouse service from Loblolly Cove. Note the telephone pole to the right of the tower. (Courtesy Sandy Bay Historical Society.)

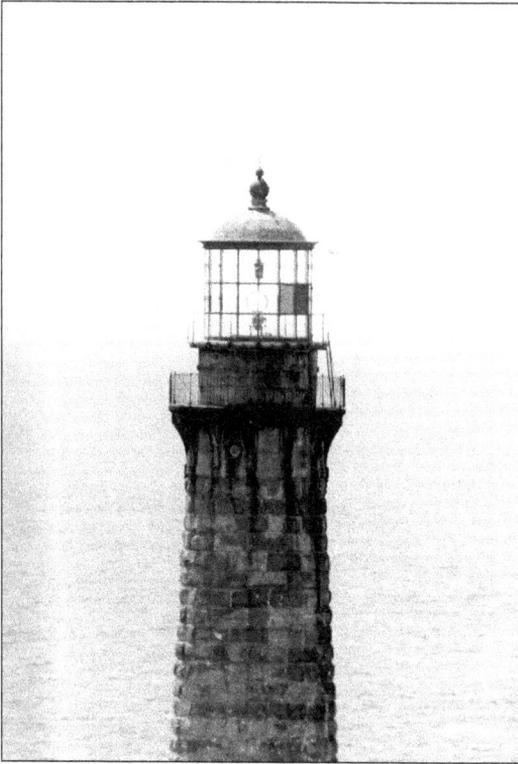

After the Fresnel lens was removed from the south tower and sent to the U.S. Coast Guard Museum in New London, Connecticut, it was replaced in 1980 by a DCB-224 aero-beacon using 1,000-watt metal halide bulbs. This new light had an automatic bulb-changing system. (Courtesy Thacher Island Association.)

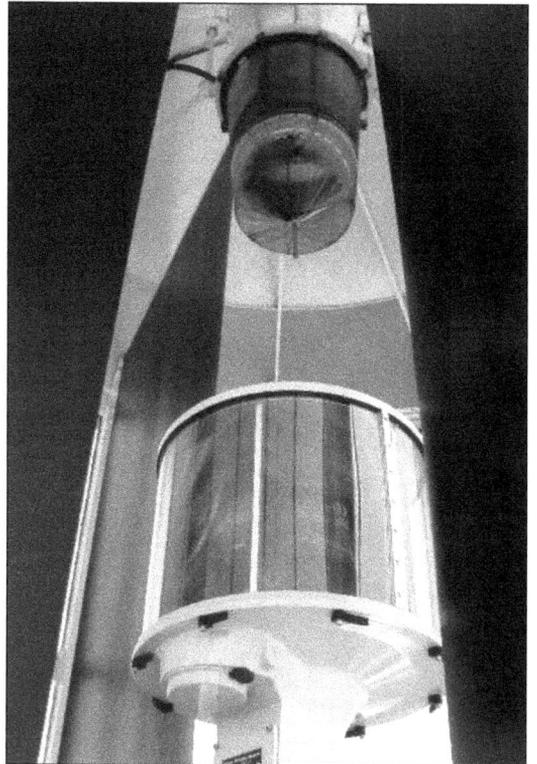

The Coast Guard automated the south tower with solar panels and batteries and a new Vega VRB-25 optic light with a red flashing beacon in 1990. It is still in use today. (Courtesy Thacher Island Association.)

This is the first-order Fresnel lens that was removed from the south tower in 1980 and is now exhibited at the U.S. Coast Guard Museum in New London, Connecticut. (Courtesy Thacher Island Association.)

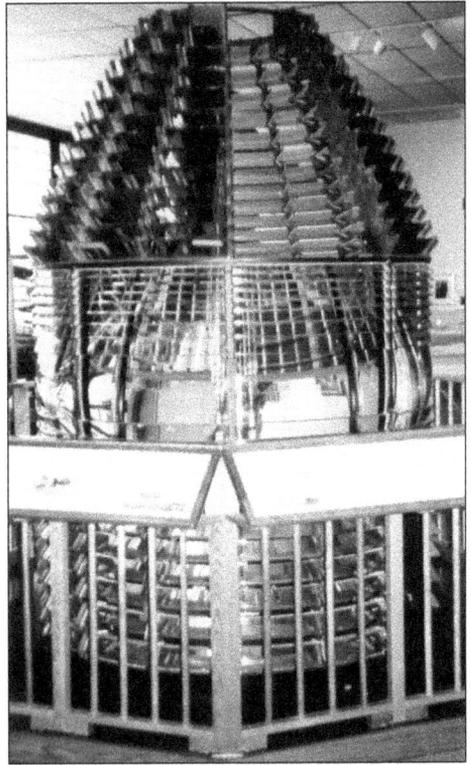

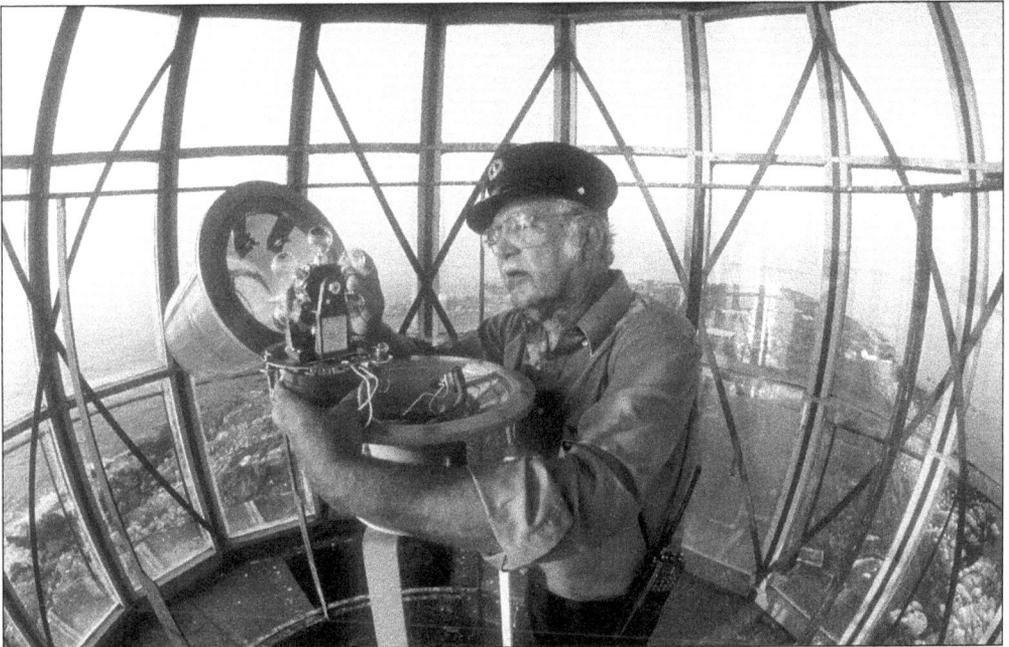

In 1989, the Coast Guard installed a small amber light with a six-light automatic changer in the north tower. Each bulb was only 15 watts. Shown is keeper George Carroll adding a new bulb to the changer. Today it is designated as a courtesy light and serves as a memorial to mariners. It is operated by the Thacher Island Association. (Courtesy David Brownell.)

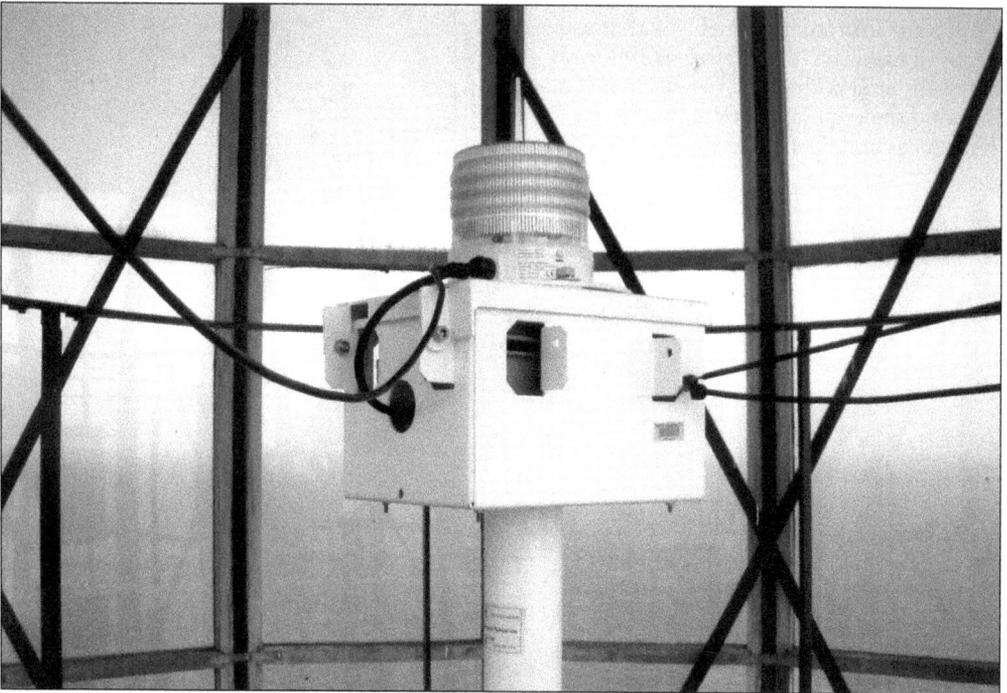

A solar-powered beacon replaced the six-light unit in 2003. It consists of 120 LED lights in a three-tier array that can be seen from six miles at sea. The box underneath contains the battery that is charged by the solar panels located on the gallery rail outside the lantern room. It is fully automated and has a sensor to turn it on and off at sunset and sunrise. (Courtesy Thacher Island Association.)

Here are postcard views from 1912, showing both north and south towers. They were produced by Charles Cleaves. (Courtesy Thacher Island Association.)

Three

THE KEEPERS DWELLINGS

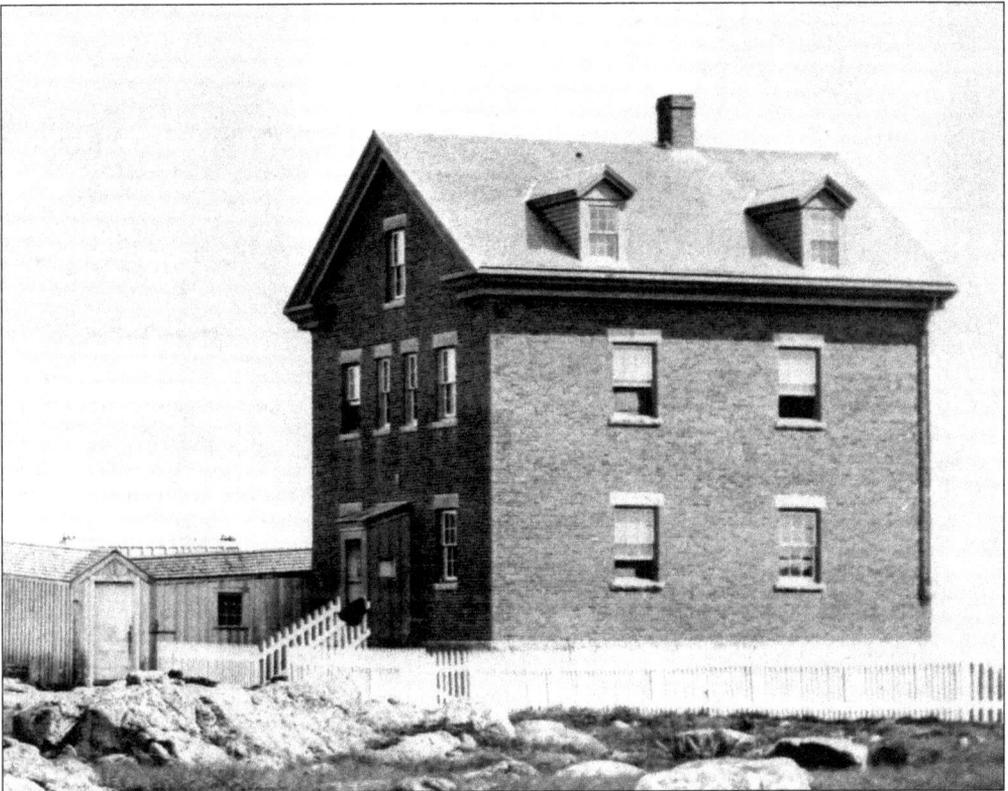

This three-story duplex, built in 1861, housed two keeper's families, living one above the other. It replaced the first keeper's house. The first keeper house contract, dated October 10, 1810, stated, "to build a stone dwelling house for use of the keeper on Thatcher [sp] Island Lighthouse of the following materials, dimensions, and description viz, thirty four feet long and twenty feet wide, one story of eight feet high, divided into two rooms sixteen feet by twelve each." (Courtesy National Archives and Records Administration.)

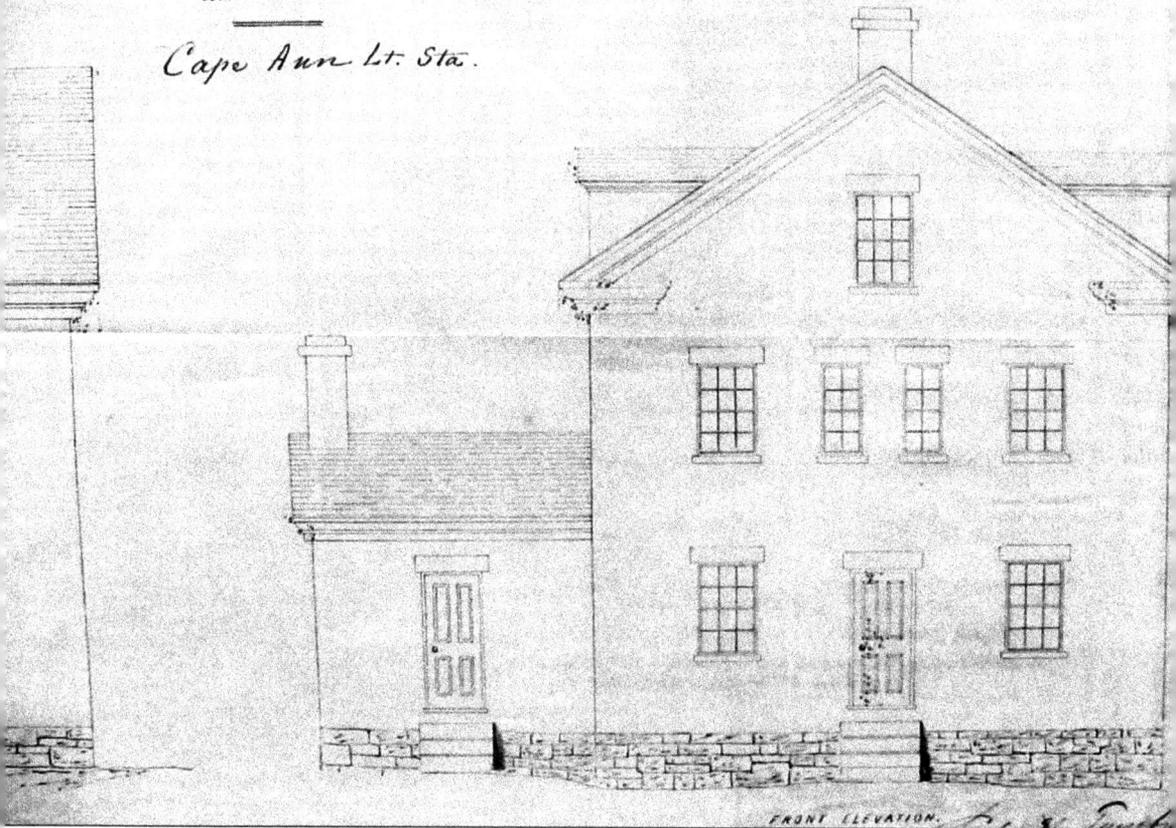

THATCHERS ISLAND.

scale four feet to an inch.

Cape Ann Lt. Sta.

FRONT ELEVATION.

This is the original plan drawing, dated April 19, 1860, of the current keeper house. The original entrance was at the northern end of the main building. There was only one kitchen located in the ell to the left shared by the two families. The keeper's log of August 1, 1860, stated, "86 thousand bricks landed for dwelling house and 3000 feet of lumber and cement." Work was completed on September 24, 1861. Note the spelling of Thatcher. The correct spelling is Thacher, but one branch of the family now spells their name Thatcher because of a clerical error. John Thacher (Thatcher) Sr. served in the Continental army with the Massachusetts troops from 1776 until 1780. When he applied for a pension, it was issued to John Thatcher. Although he had signed his enlistment papers as John Thacher, rather than delay payment of the pension, he added the letter *t* to his name so as to match his incorrectly spelled pension discharge papers. (Courtesy National Archives and Records Administration.)

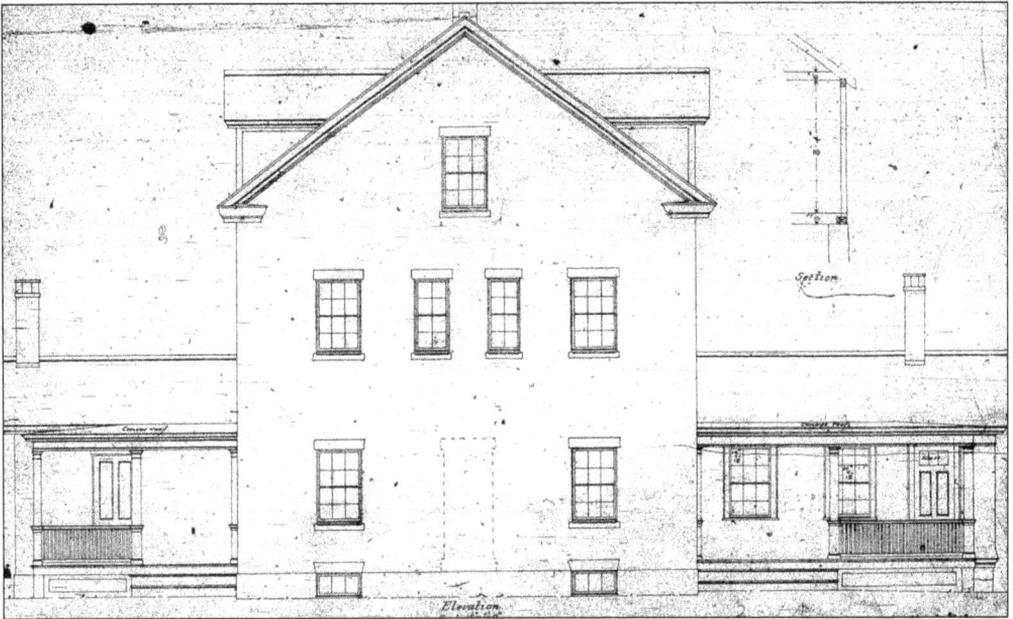

This front elevation drawing shows a second kitchen on the right, added in 1893. The original front door was bricked up, and entrances were created through the dual kitchens to allow privacy for each family. The house was split down the middle, allowing each family to have access to all three stories side by side. (Courtesy National Archives and Records Administration.)

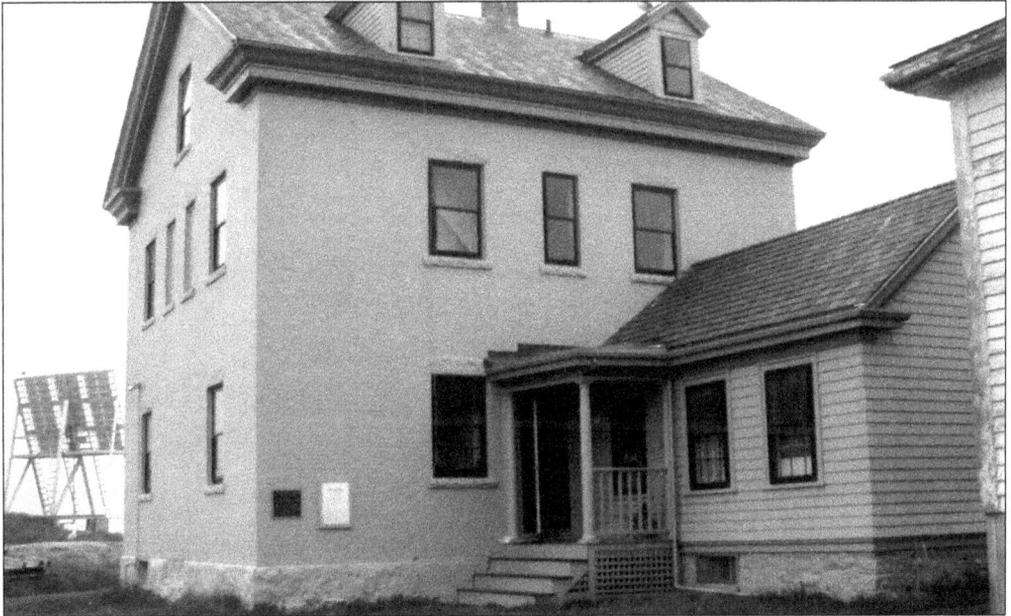

This duplex apartment building is used by volunteer keepers and interns who live on the island during the summer months. This assistant keeper's dwelling was totally restored by the Thacher Island Association in 2000. The house has six rooms on the first floor, two baths and three bedrooms on the second floor, and four bedrooms on the third floor. It also houses the new solar-electric equipment room, which provides power to the houses and the keeper's office and weather station. (Courtesy Thacher Island Association.)

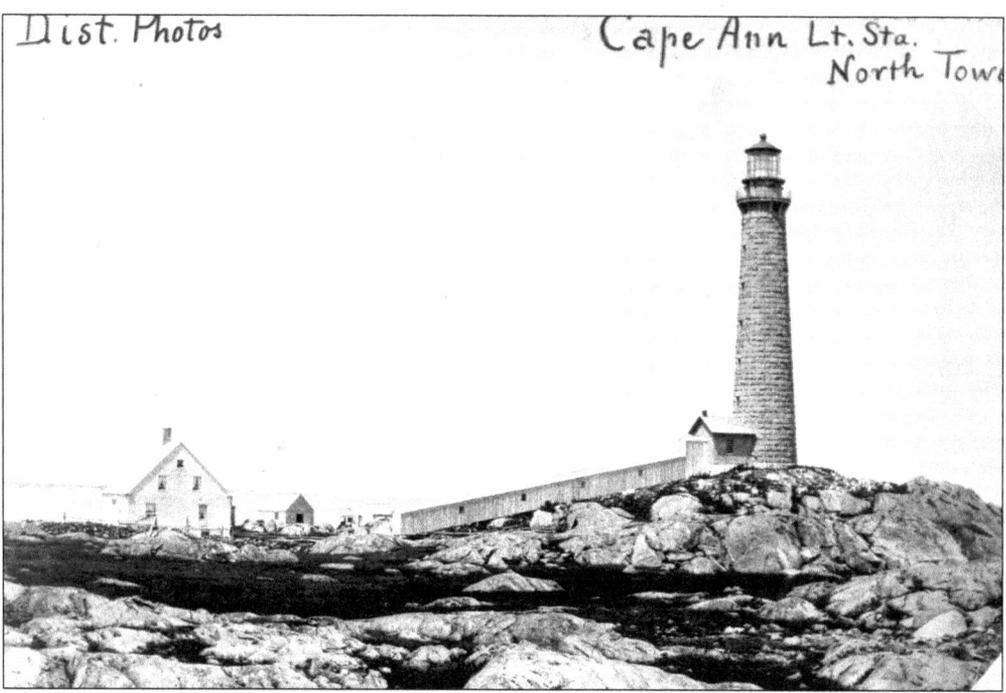

The north tower keeper's dwelling was built in 1869 and also housed two families. Originally it had one kitchen on the westerly side; a second kitchen was added to the east side around 1889. (Courtesy National Archives and Records Administration.)

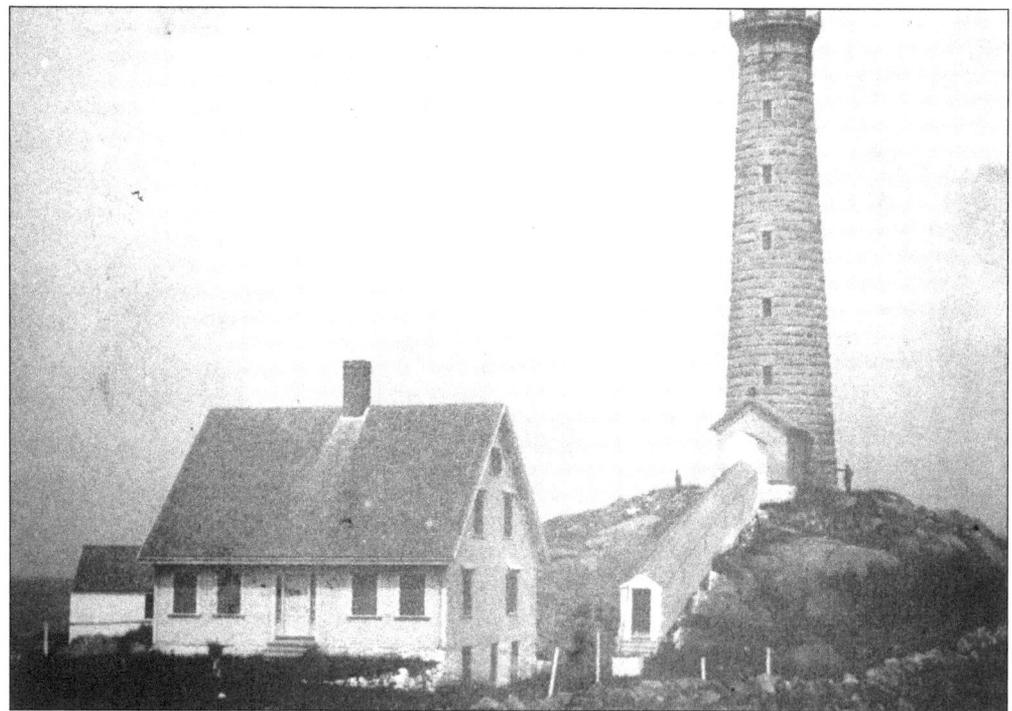

This is another view of the north tower dwelling before a second kitchen was added. Note the men standing near the tower. (Courtesy National Archives and Records Administration.)

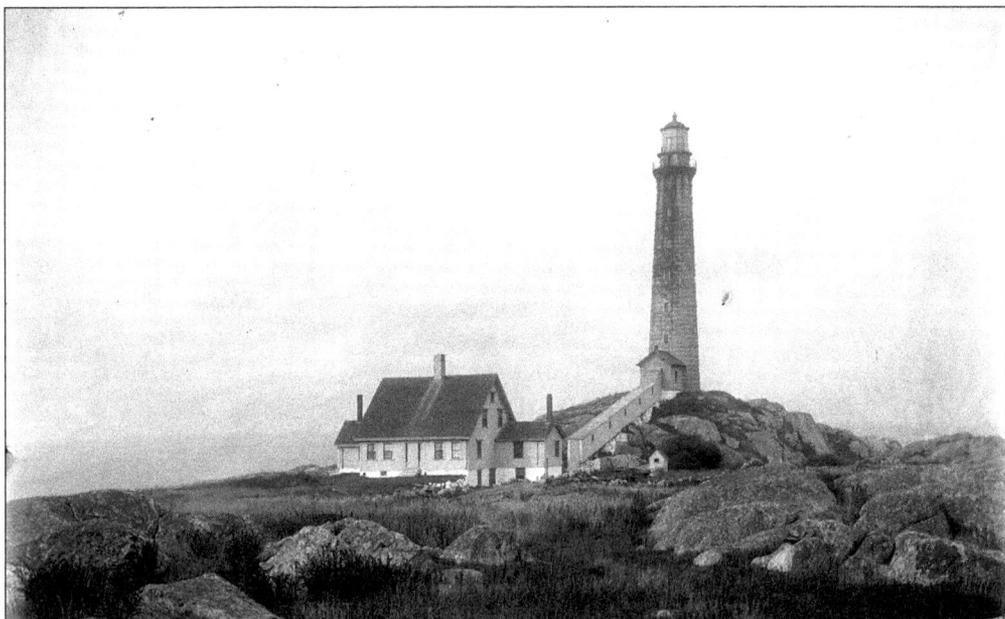

Here is the north tower dwelling after the second kitchen was added. Two families lived in the house, which was built in 1869. It was the second of three keeper houses on the island. This photograph was taken by Cleaves around 1920 and shows the two kitchen ells at either end of the home along with the covered walkway to the tower. Covered walkways were very helpful in winter snowstorms and summer rains during the early days, when keepers were required to tend the lights every four hours during the night. Over the years, as the lights required less tending due to electric power, the covered walkways were removed. In front of the house, the keepers created a garden and farmyard to raise vegetables, along with chickens, sheep, goats, and a cow. (Courtesy Sandy Bay Historical Society.)

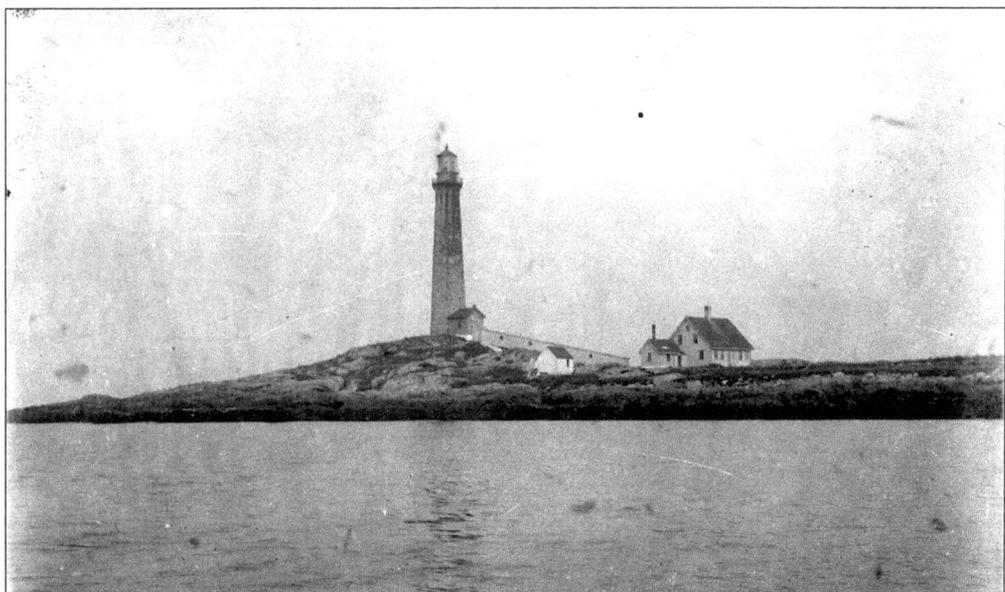

A water view of the north dwelling, taken around 1920, shows the outhouse and a barn. This was the milking barn for cows tended by the keepers. (Courtesy Sandy Bay Historical Society.)

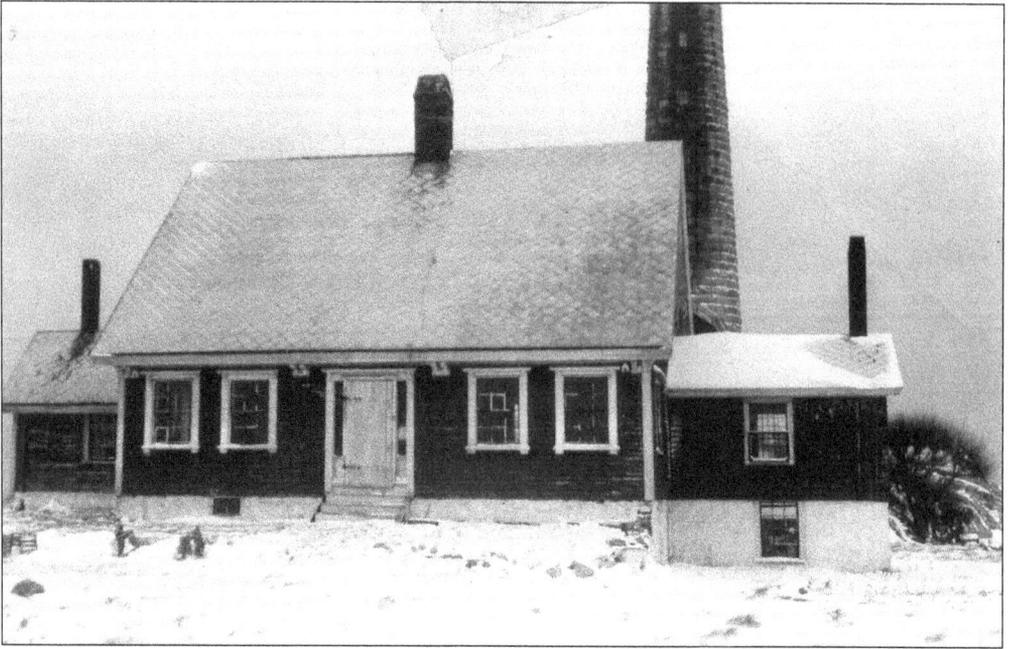

Here is the front of the north house in 1942. It was elegantly constructed with corbels under the roof overhang and decorative window trim. It was heated by steam, using a coal-fired furnace. This house was burned down by the U.S. Coast Guard in 1950. (Courtesy Thacher Island Association.)

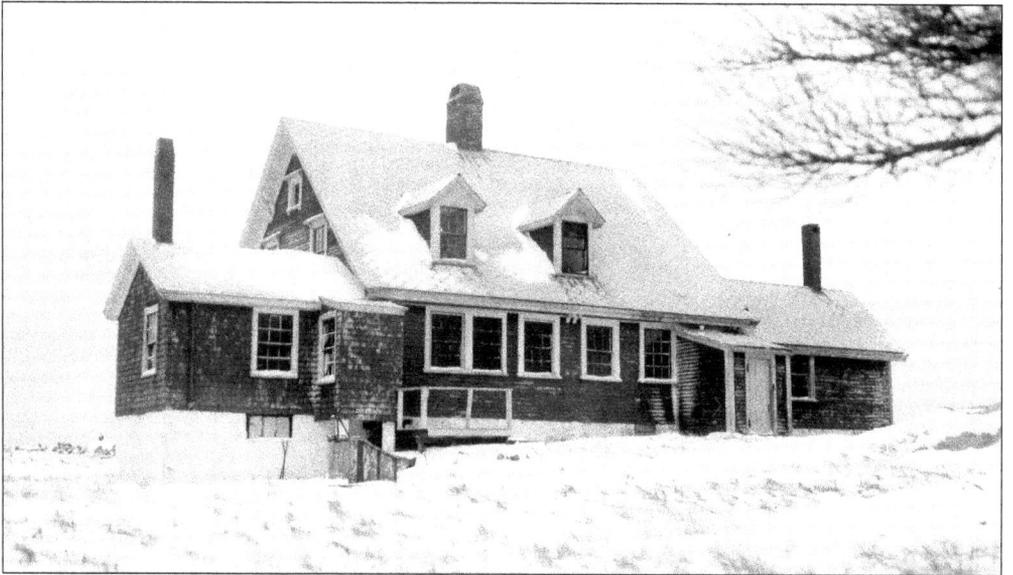

This rear view of the north house shows the two dormers on the second floor facing toward the north tower to enable keepers to view the light from their bedrooms in the evening. (Courtesy Thacher Island Association.)

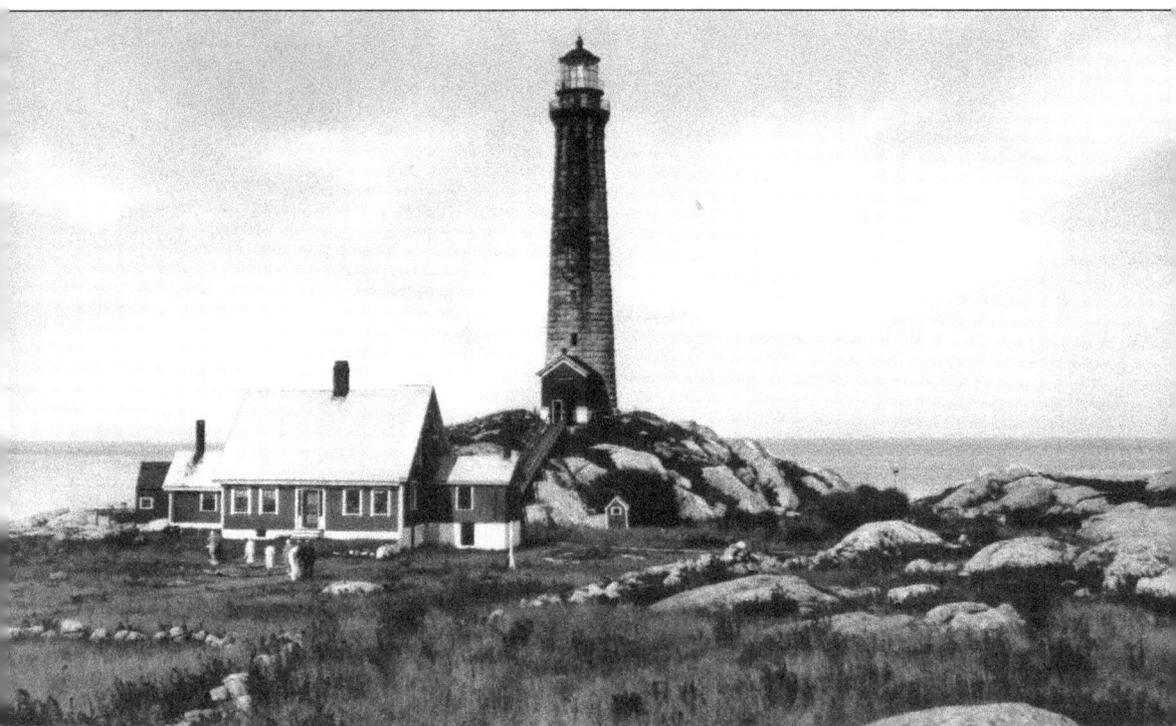

Tourists frequently visited the island. (Note some of them in the foreground around 1920.) With five keeper families living here, friends and relatives visited often. Some keepers welcomed visitors, but others were not so eager to entertain guests. Addison Franklin Tarr was once quoted in an 1890 newspaper article expressing some resentment of tourists: "What would some of these people think if I hailed a carriage, took a ride about their place, criticized everything, and ended by giving them hardly a 'thank you?'" In the 1930s, young visitor Marjorie Arlington, a friend of the keeper's daughter Idella Seavy, recalled the time she was invited to climb the north tower to uncover the light. "After the climb up the 150 stairs, we particularly liked looking down at the sea gulls flying around below us. The light was surrounded by a heavy curtain, and Mr. Seavy told me to step very gently down inside it. Then he pulled the curtain back all the way around and the sun hit the facets of the glass light. I thought I was in fairyland, or in the middle of a rainbow, what a thrill!" (Courtesy Sandy Bay Historical Society.)

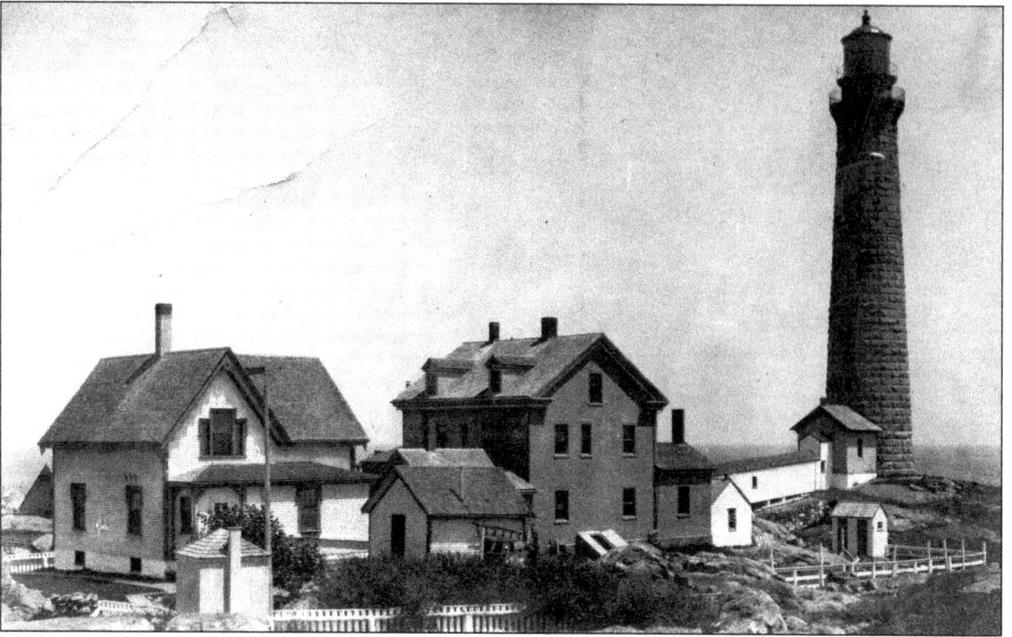

This 1880 photograph shows the neat picket fence and several outbuildings surrounding the principal and assistant keeper's dwelling adjacent to the south tower. (Courtesy Thacher Island Association.)

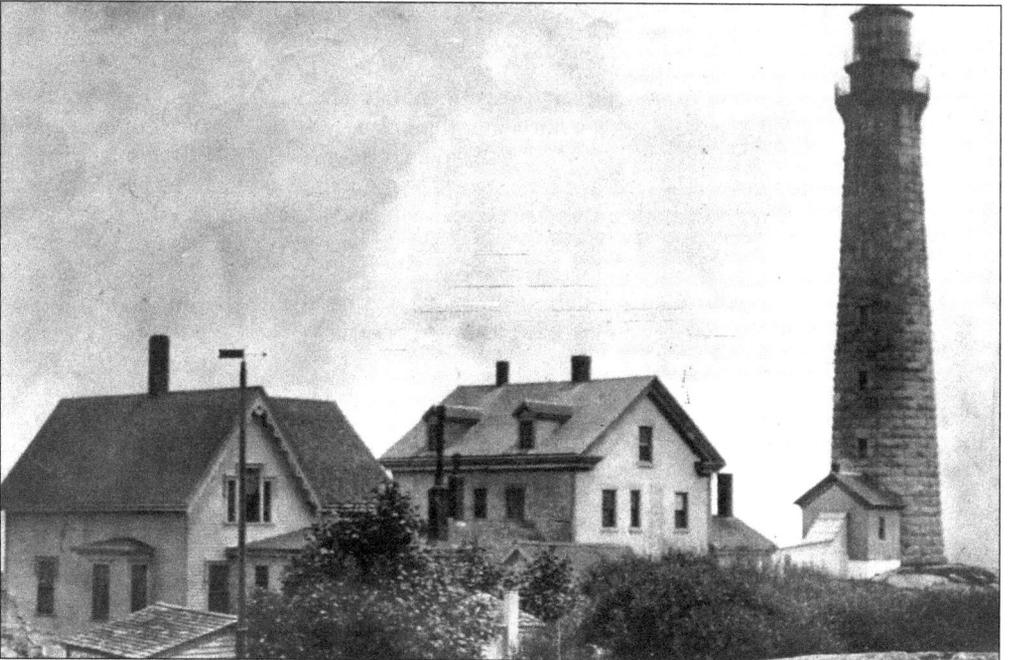

This 1898 photograph shows the fence is gone and the roof profile of the covered walkway has been changed. Also added was the new kitchen on the rear of the principal keeper's house and a small extension with three windows to the west side, allowing for a larger dining room. See how the trees and shrubs have grown since the 1880 photograph above. (Courtesy Thacher Island Association.)

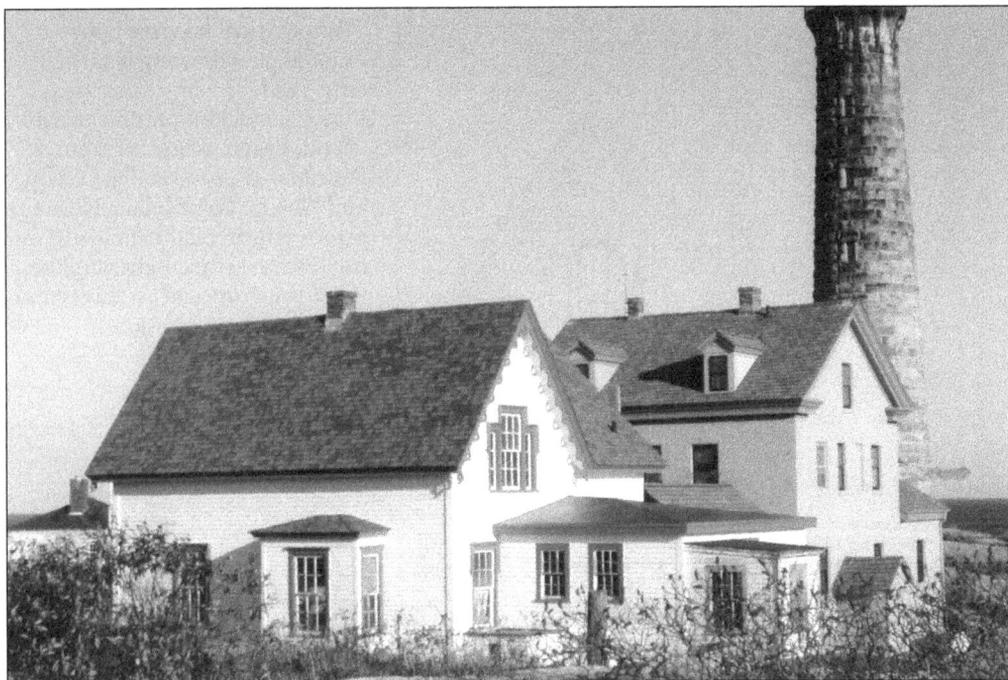

Both dwellings have been restored by Thacher Island volunteers and contractors in 2004 and 2008. Volunteer keepers live in the house on the left during the summer. (Courtesy Thacher Island Association.)

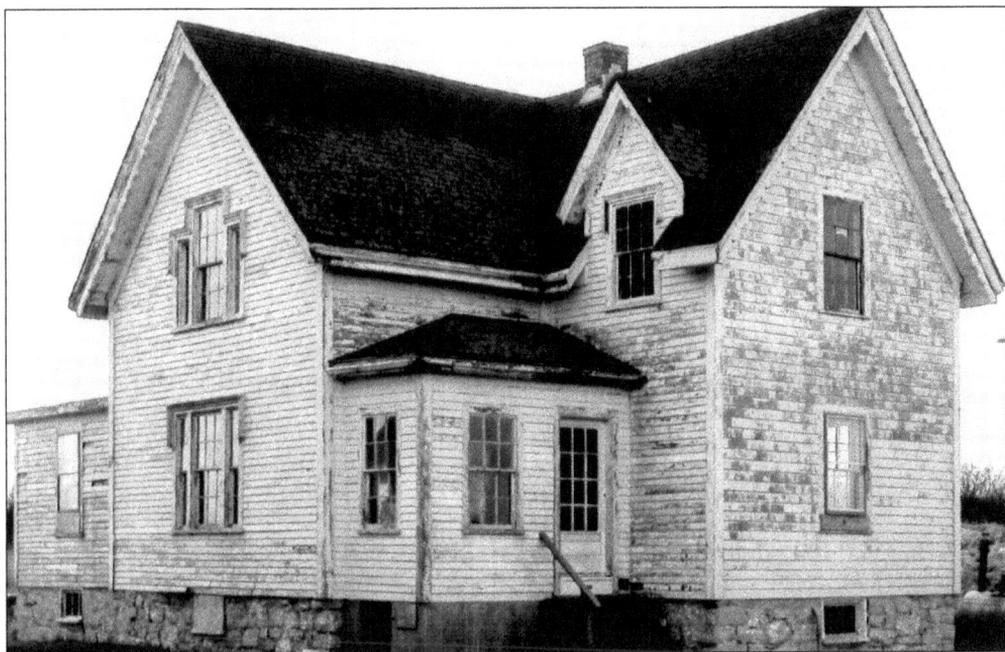

The third and last keeper dwelling was built in 1874 for the principal keeper and his family. The cost to build it was $2,503.47, according to the lighthouse board records of May 26, 1875. This photograph was taken in 1990 prior to restoration. Note the closed-in porch and single windows, all changes made by the Coast Guard in the 1950s. (Courtesy Thacher Island Association.)

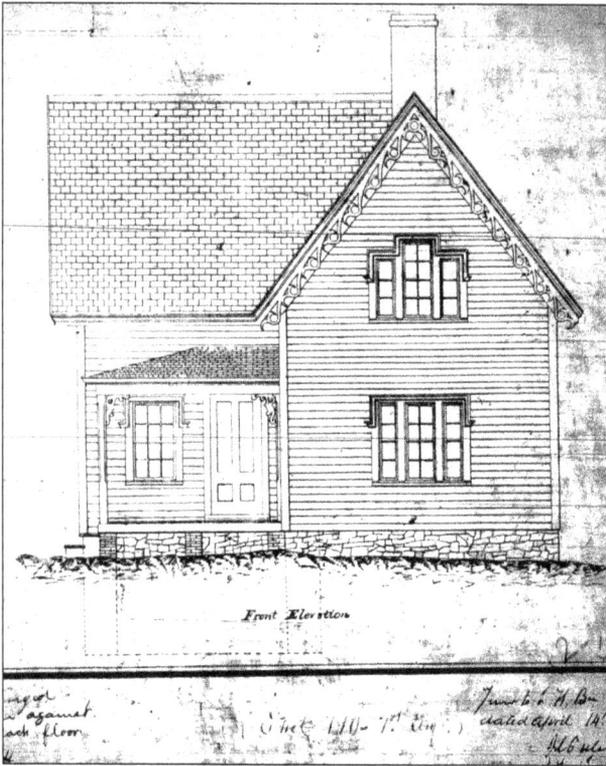

This principal keeper's house original plan drawing was the same used for many other light stations, including Straitsmouth Island, Bakers Island, Seguin, Petit Manan, Nauset, East Chop, and Nobska Point lights. Note the ornate gingerbread trim along the roofline and triple-light windows. (Courtesy National Archives and Records Administration.)

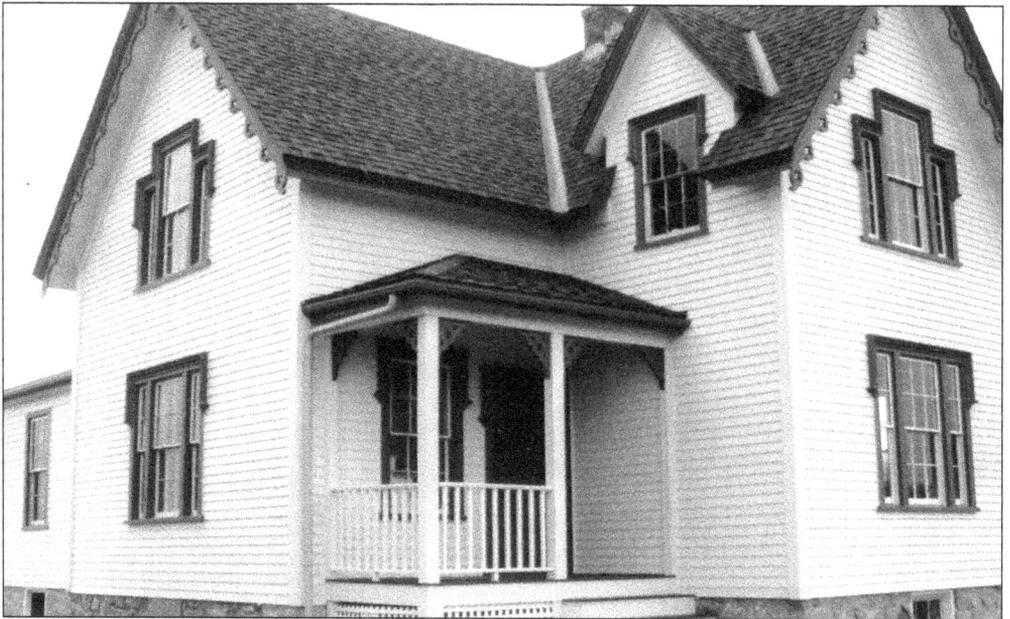

The principal keeper's house was totally restored between 2004 and 2008 to its original 1875 look, which included triple-light windows, a new porch, and gingerbread roof trim. A new visitor center and museum has been installed and is open free to the public. There is a reproduction of a Victorian-era parlor typical of how the keepers lived in the 1890s, with period furniture, including a pump organ. (Courtesy Thacher Island Association.)

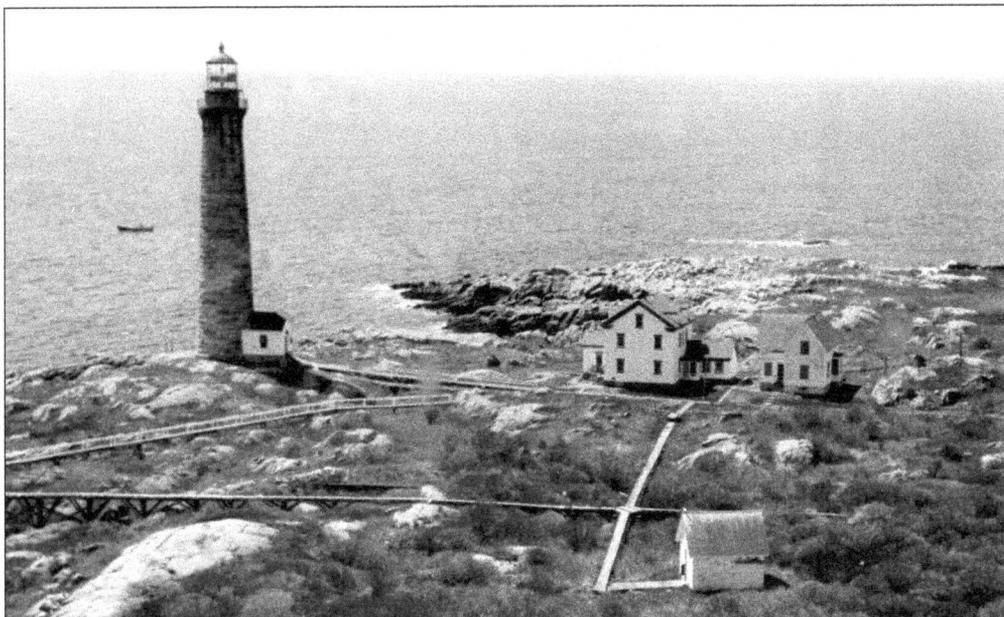

This 1940 aerial view shows the south tower, both keepers' dwellings, and an oil house in the lower right. The railway tram system had a turntable in the center, allowing the tram cart to be sent in different directions. (Courtesy U.S. Coast Guard.)

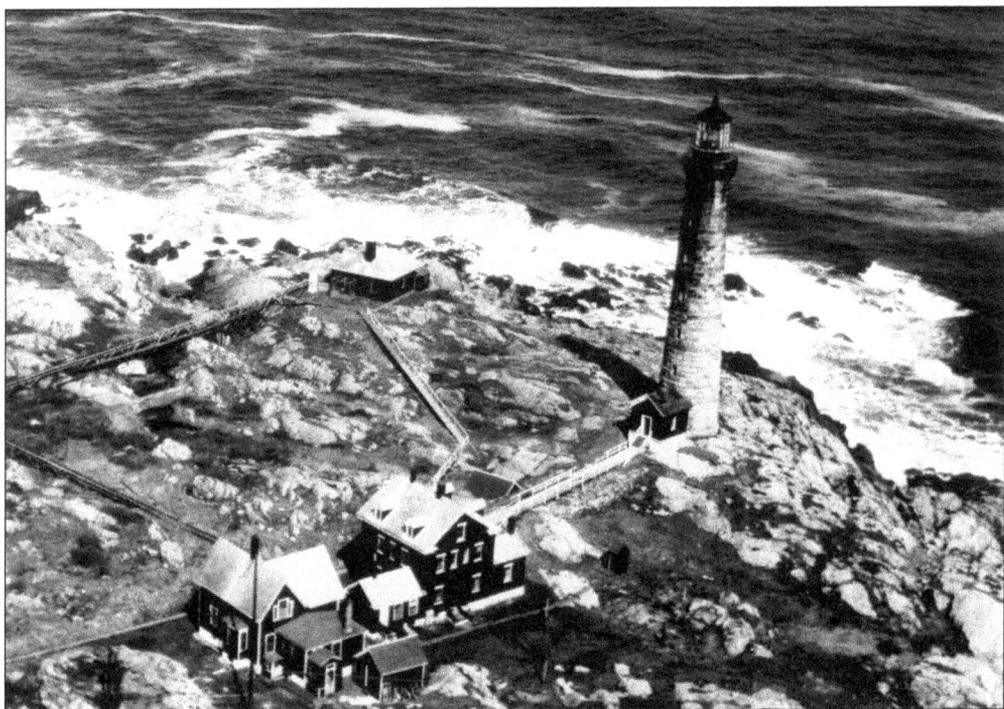

This photograph from about 1935 shows the change in color of the keeper's dwellings as well as the various walkways to the fog signal house and south tower. Five keepers were required to properly maintain and operate the lights, the steam-powered fog signal, and the hoisting engine. (Courtesy U.S. Coast Guard.)

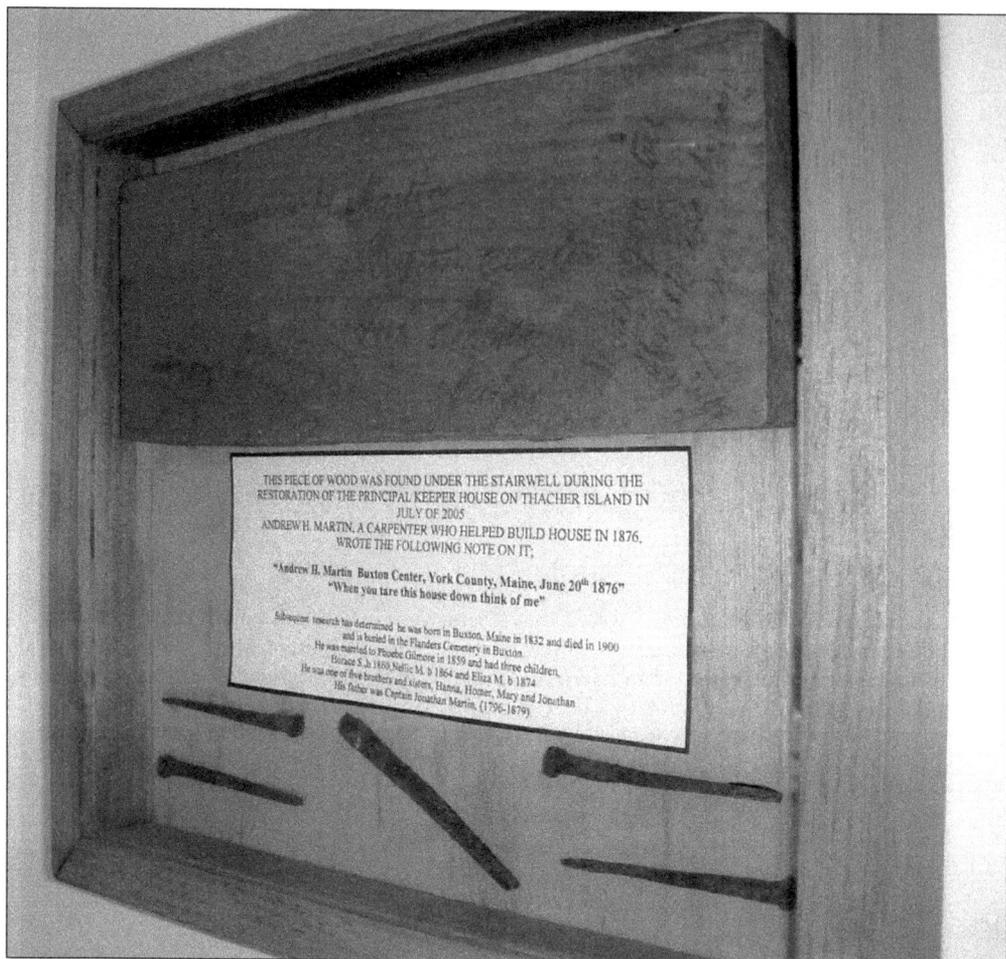

During restoration in 2007, a piece of wood was found under the stairs with a handwritten inscription by one of the carpenters who built the original house in 1876. It said, "When you tare [sic] this down, think of me, Andrew H. Martin, Buxton Center, York County, Maine June 20, 1876." It has been preserved and mounted in the entry hall for all to see. (Courtesy Thacher Island Association.)

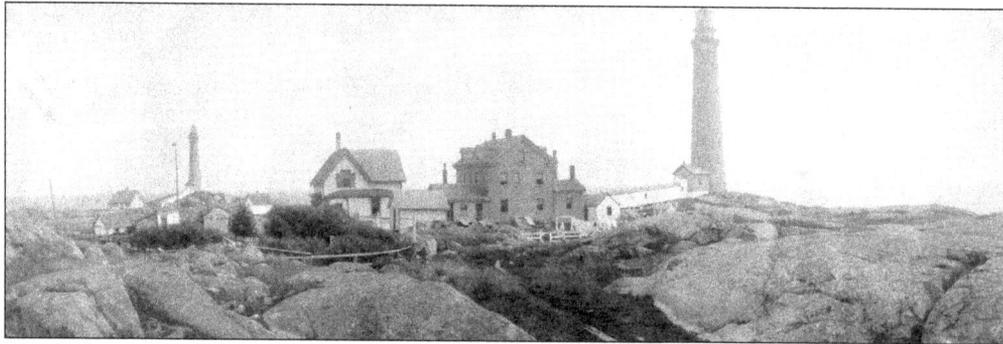

This photograph, taken in 1890, shows a panorama of both towers, the three keeper's houses, several barns, outhouses, storage sheds, and the keeper's laundry hanging in the backyard. (Courtesy Thacher Island Association.)

Four

THE KEEPERS

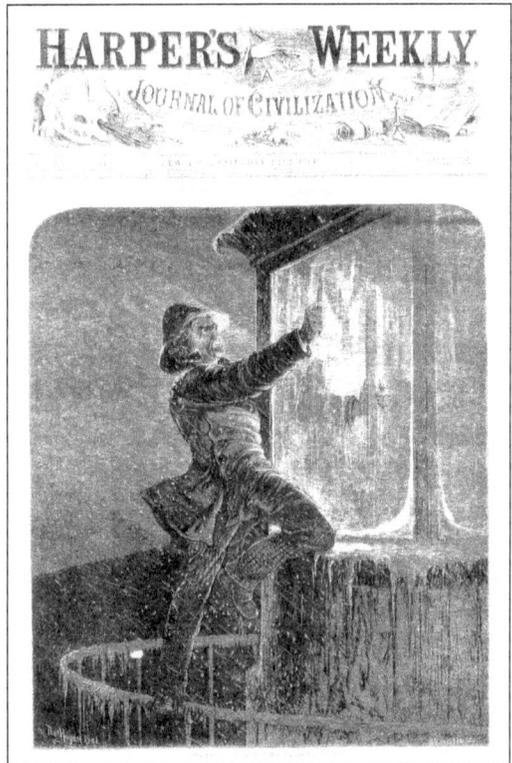

Keepers had to climb the 156 steps in each tower every four hours during the night to trim the wicks, clean the lens and glass, and add more oil to the lamp as well as manage the steam-powered engine (foghorn) in the whistle house. This illustration is from the December 30, 1876, edition of *Harper's Weekly*, showing the keeper chipping the ice off the lantern room glass at Christmastime. (Courtesy Thacher Island Association.)

There were 25 principal lighthouse keepers on Thacher Island from 1771 until the U.S. Coast Guard took over in 1939. There were more than 150 first, second, third and fourth assistants stationed on the island as well. Many keepers were veterans of the Revolutionary War, Civil War, or the Spanish-American War. Many were former seamen or had been in the marine trades. In the early 1800s, most keepers were political patronage choices based on the administration in power at the time. Former principal keepers and the years they served are as follows: James Kirkwood 1771–1775, Stephen Choate 1781–1784, Samuel Huston 1784–1792, Joseph Sayward 1792–1814, Aaron Wheeler 1814–1834, Austin Wheeler 1834–1837, Charles Wheeler 1837–1849, William Hale 1849–1853, Lancelot Kelly Rowe 1853–1855, James Collins Parsons 1855–1861, Albert Giddings Hale 1861–1864, Alexander Bray 1864–1869, Joseph Wingood 1869–1871, Michael Dundon 1871–1872, Albert Hale 1872–1881, Addison Franklin Tarr 1881–1912, Thomas J. Creed 1912–1913, John Cook 1914–1918, George Gustafson 1918–1919, George Howard 1919–1921, Elmo Mott 1921–1927, Simeon Orne 1927–1930, Cecil Kelly 1930–1935, George Seavey 1935–1945, and Austin Beal 1945–1948 (Beal worked as a civilian keeper for the Coast Guard until after the war). (Courtesy Thacher Island Association.)

Boston

The Petition of James Kirkwood

Humbly Sheweth,

That in the Month of December 1771 your petitioner undertook to go to Thatcher's Island to take care of, and look after two Light houses that had been Lately Erected on said Island for the benefit of Navigation, the Island being at some distance from the Main Land and much exposed to hard Gales of Wind & Extream Cold in the Winter which together with the Light houses & dwelling House not being quite finished made it a very uncomfortable habitation, and attended with great difficulty as the Lighthouses stand at a great distance from one another / viz. very properly placed for the Safety and benefit of Trade.

James Kirkwood, the first keeper, was appointed by the colonial court to tend the lights in 1771. He was thought to be a Tory sympathizer and was forcibly taken off the island by Gloucester militiamen in November 1775. He had been hired for two and a half years at "a salary of 100 pounds six shillings and firewood." (Courtesy National Archives and Records Administration.)

very hard one / ever since the Month of December 1771 being Eighteen Months and has never had any Allowance except his Provisions.

He therefore humbly prays your Excellency & Honours would be pleased to take his Case into your Wise & Serious Consideration and be pleased to grant of the aforesaid Sum due to the two assistants and also that you would be pleased to make him such Allowance for his time aforesaid as your Excellency and Honors shall think he reasonably deserves for his hard Services aforesaid.

And as in duty bound shall ever pray &c

James Kirkwood

In 1773, Kirkwood complained in this letter that he was owed 100 pounds salary, past due, for himself and his two assistants for 18 months of work from Massachusetts Bay governor Thomas Hutchinson. This is a copy of Kirkwood's petition to the general court, requesting his past due salary in 1773. (Courtesy National Archives and Records Administration.)

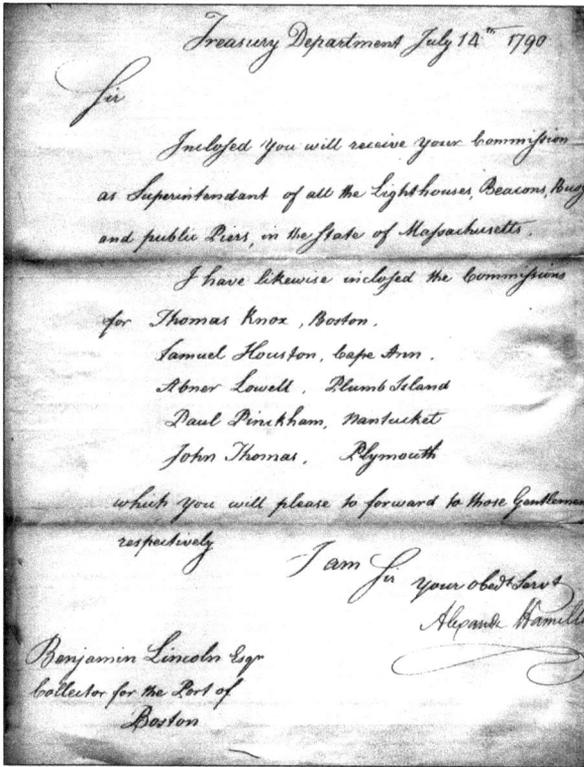

Treasury Department July 14th 1790

Sir

Inclosed you will receive your commission as Superintendant of all the Light houses, Beacons, Buoys and public Piers, in the state of Massachusetts.

I have likewise inclosed the Commissions for Thomas Knox, Boston.
Samuel Houston, Cape Ann.
Abner Lowell, Plumb Island
Paul Pinckham, Nantucket
John Thomas, Plymouth
which you will please to forward to those Gentlemen respectively

I am Sir your obedt Servt
Alexander Hamilton

Benjamin Lincoln Esqr
Collector for the Port of
Boston

The director of the newly created U.S. Lighthouse Establishment was assigned by Pres. George Washington to the secretary of the treasury Alexander Hamilton. This is Hamilton's letter of appointment of Samuel Huston as the first federally employed keeper of Cape Ann lighthouse, on July 14, 1790. (Courtesy National Archives and Records Administration.)

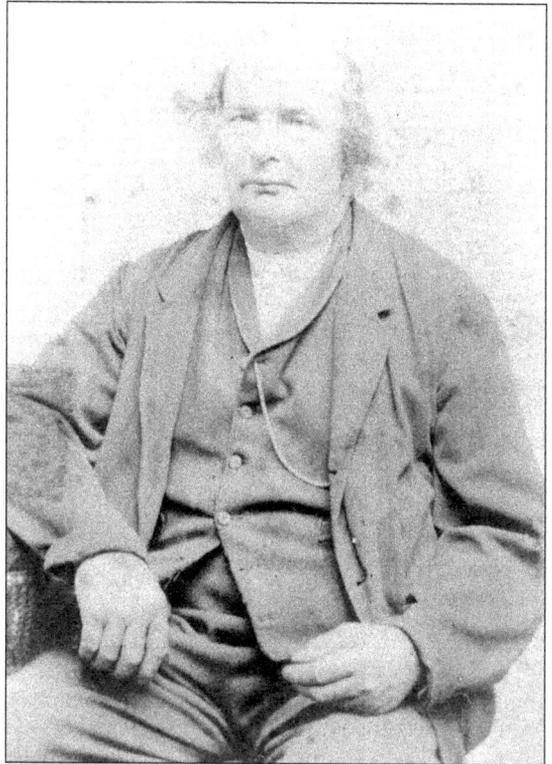

Albert Giddings Hale, aged 48, was the first keeper assigned to the new twin lighthouses in 1861. Hale was a blacksmith in Rockport and proprietor of the Cape Ann Anchor Works in Gloucester. He went to the island for his health after suffering from typhoid fever and served as keeper during the Civil War from 1861 to 1864. He died in Rockport in 1896. (Courtesy Sandy Bay Historical Society.)

Treasury Department,
Fifth Auditor's Office, November 23, 1836.

Sir-

I enclose the appointment of Charles Wheeler as Keeper of the Lighthouse at Thatcher's Island, which you will be pleased to transmit to him. You will inform him of the necessity of his residing and being himself steadily in the house provided for the Keeper.

I am, &c.

439. / 447

(Signed) S. Pleasonton

David Henshaw Esqr. Fifth Auditor and acting Commissioner of the Revenue

Charles Wheeler was appointed keeper in November 1836 and served until 1849. He planted pear, quince, and apple trees, along with currant, gooseberry, raspberries, blackberries, and grape vines, many of which remain today. He cleared two acres of land for a vegetable garden, kept seven cows, and built a milk room. He is credited with saving the crews of the *Ann Maria* on January 21, 1837, and the *Royal Tar*, which struck the Londoner and went down with a cargo of bricks on May 22, 1845. (Courtesy National Archives and Records Administration.)

UNITED STATES PATENT OFFICE.

CHARLES WHEELER, OF ROCKPORT, MASSACHUSETTS.

LIGHT-HOUSE LAMP.

Specification of Letters Patent No. 4,454, dated April 11, 1846.

To all whom it may concern:

Be it known that I, CHARLES WHEELER, of Thatchers Island Light - House, near Rockport, in the State of Massachusetts, 5 have invented certain new and useful Improvements in Lamps or Apparatus for Light-Houses, and that the following description of the same, taken in connection with the accompanying drawings thereof, 10 constitute my specification.

Figure 1, of the drawings above mentioned represents a front elevation of a series of lights as arranged in a light-house. Fig. 2, is a vertical section taken through 15 one of the lamp fountains and reservoir

ing tube of the stop cock. As the oil is consumed more will flow down from the fountain to supply its place. The reservoir K, and fountain L, have a long tube M. 60 See Fig. 2 extending through them. Its lower end opens by a tunnel shaped mouth over a small lamp N, suitably supported underneath one extremity of the oil reservoir. The upper end of the tube passes out 65 of the top of the fountain, and either opens directly into the atmosphere, or it is carried up underneath the bottom of one of the upper reservoirs and terminates at a short distance therefrom. The heat from the aux- 70 iliary lamp passing into the horizontal and

Wheeler patented a device to prevent oil from freezing in the lamp. He conducted experiments on Thacher Island and once wrote, "I have also invented and put to use, a good and useful lighthouse lamp, which saves the government not less than $30 per year. They have now been in use eleven years which has made a saving, in stoves and fuel, of not less than $300." (Courtesy National Archives and Records Administration.)

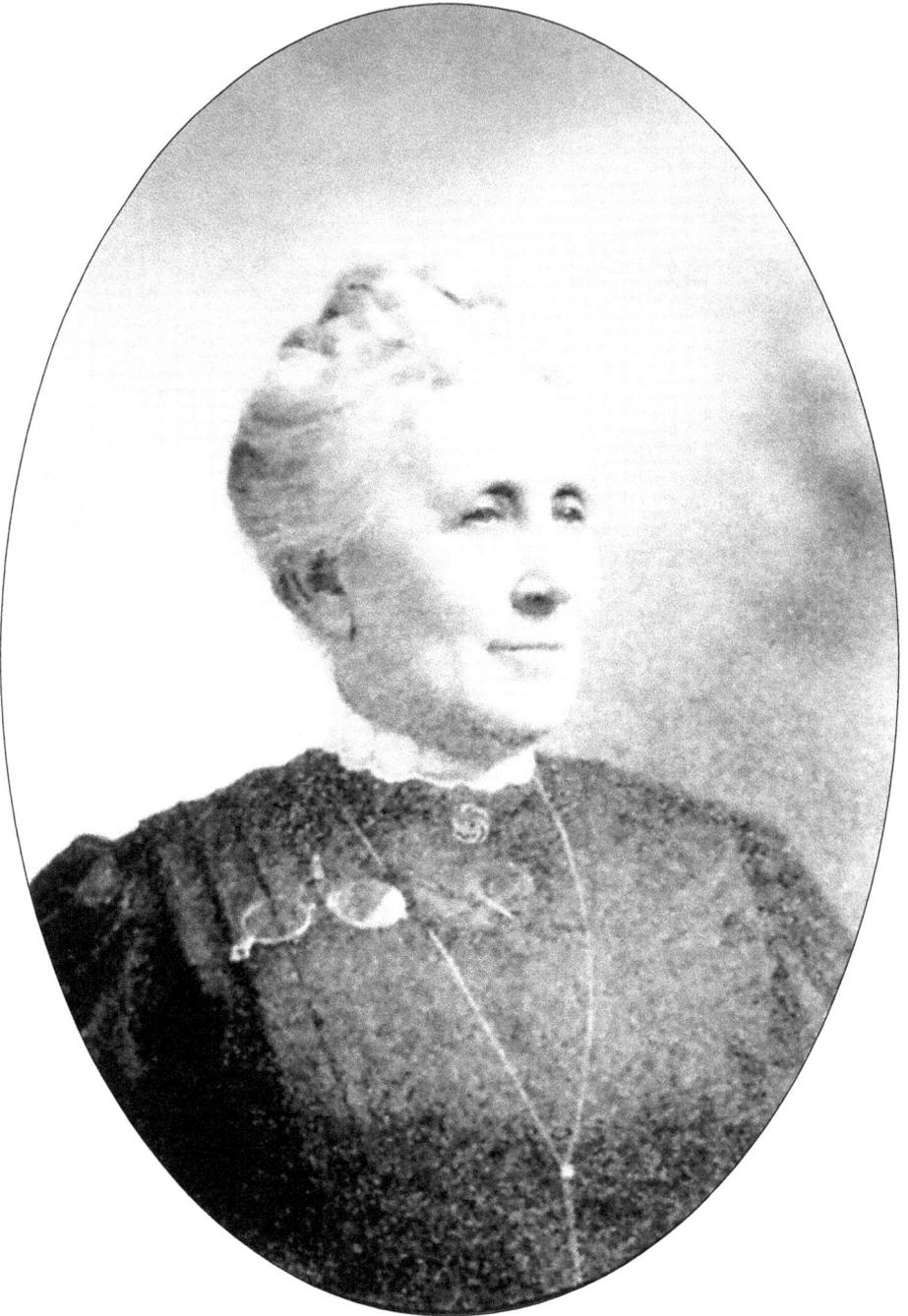

Alexander Bray was principal keeper in 1864. Three days before Christmas, he took his assistant to the doctor in Rockport. A severe snowstorm blew in, preventing his return. His wife, Maria (shown here), and her nephew Sidney Haskell were forced to walk the 300 yards between each light through huge snow drifts and gale-force winds to climb each tower's 156 steps three times each night to trim the wicks, refill the oil lamps, and clean the lenses. Because the lights were kept aflame, Alexander was able to return with his assistant on Christmas Eve. (Courtesy Thacher Island Association.)

This is a later, c. 1900 photograph of Maria Bray. She died in 1921 and lived to be 93. Maria was active in the West Gloucester Universalist Church and superintendent of the Sunday school for many years. She was a frequent contributor to the local newspapers, and edited the *Magnolia Leaves* literary magazine. She was an activist in the anti-slavery movement and the temperance movement. She was the second president of the auxiliary to the Addison Gilbert Hospital and honorary president at her death. When she came to Thacher she became interested in the sea mosses and marine algae and possessed one the finest collections in New England which is held at the Cape Ann Historical Society. (Courtesy Thacher Island Association.)

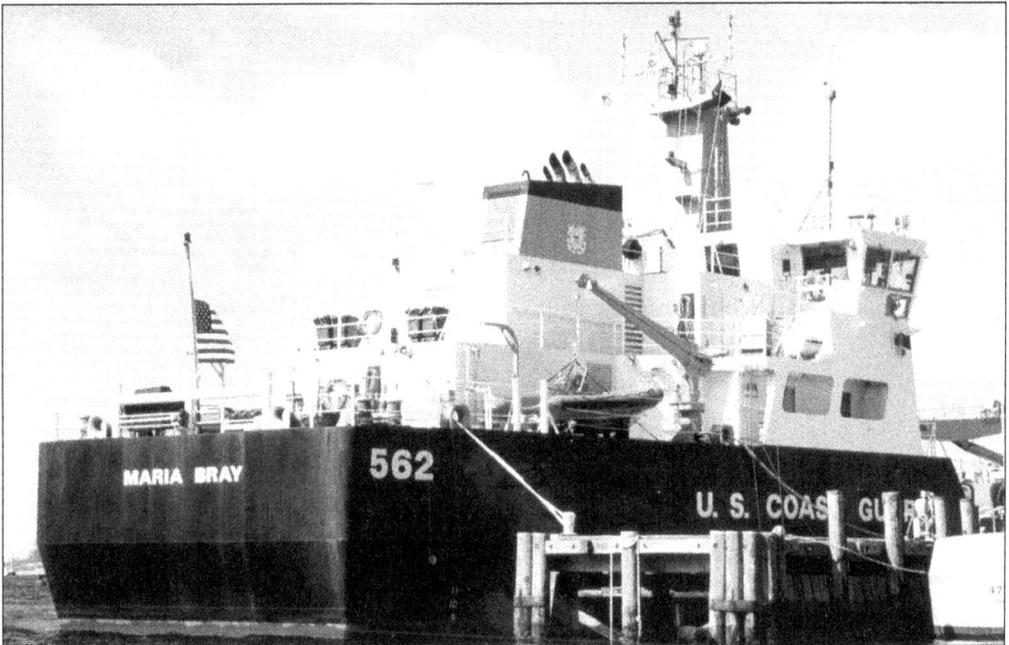

USCGC *Maria Bray* was named in her honor in 2000. This is the 12th cutter of the keeper class of coastal buoy tenders. The cutter is 175 feet long, has a crew of one officer and 17 enlisted men and women, and was commissioned in Mayport, Florida, on July 26, 2000. (Courtesy Thacher Island Association.)

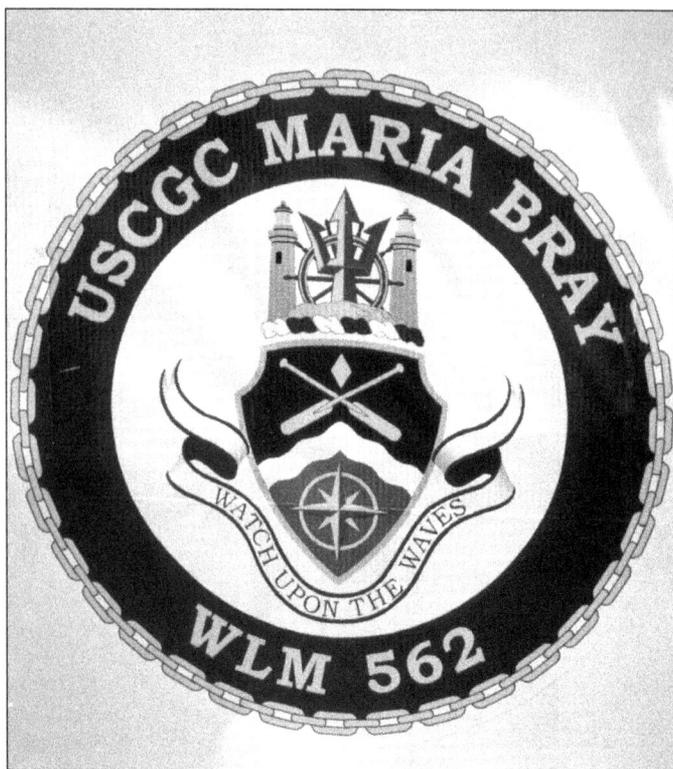

This is the USCGC *Maria Bray* coat of arms. The Thacher Island Lights are represented in the center, and the island represented in an area below the oars surmounted by a compass rose. The oars symbolize the lifesaving mission of lighthouses. The ship's namesake is recalled by the small diamond, the heraldic device of women. The three tines on the trident recall the period of three nights during which Maria Bray tended the lights. (Courtesy Thacher Island Association.)

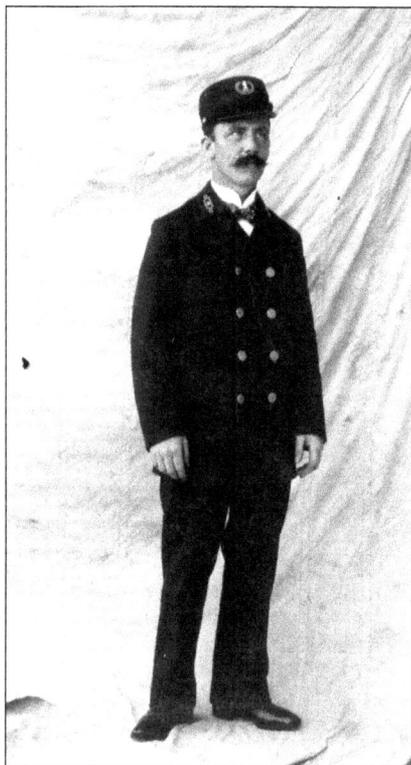

George E. Kezer, keeper in 1898, poses in his uniform. Uniforms were officially required 1884. Typically they had a *k* on each lapel, indicating the principal keeper. Assistants had the numbers one through four, indicating their rank. (Courtesy Barbara Kezer.)

Kezer is with his two children on the stairs of the principal keeper's house. His son Harlan listens intently. The baby Thatcher Warren was born to Kezer's wife, Elizabeth, on the island in 1900. Thatcher later claimed that his father took so long trying to fetch the doctor to the island for his birth that the baby was waving to them from the boat ramp by the time they returned. Between 1902 and 1908, the William Reed family shared the keeper duties with the Kezer family. William Reed or George Kezer rowed the dory across to Loblolly Cove to pick up supplies. They hid a Good Will Soap cart in the bushes (obtained by saving coupons from Good Will Soap), and this cart was used as a conveyance for the children and supplies. They walked the three miles to the Rockport railroad station to pick up supplies ordered each month in advance from a Boston supplier, who would send the goods by train. (Courtesy Barbara Kezer.)

John Farley was the only Thacher keeper ever to die on duty. The log book dated October 20, 1891, noted, "Mr. Farley was fatally injured in landing at the boat-ways. Mr. Farley's body taken on shore put in Odd Fellows Hall 22nd. Farley was buried by Odd lodge." (Courtesy Thacher Island Association.)

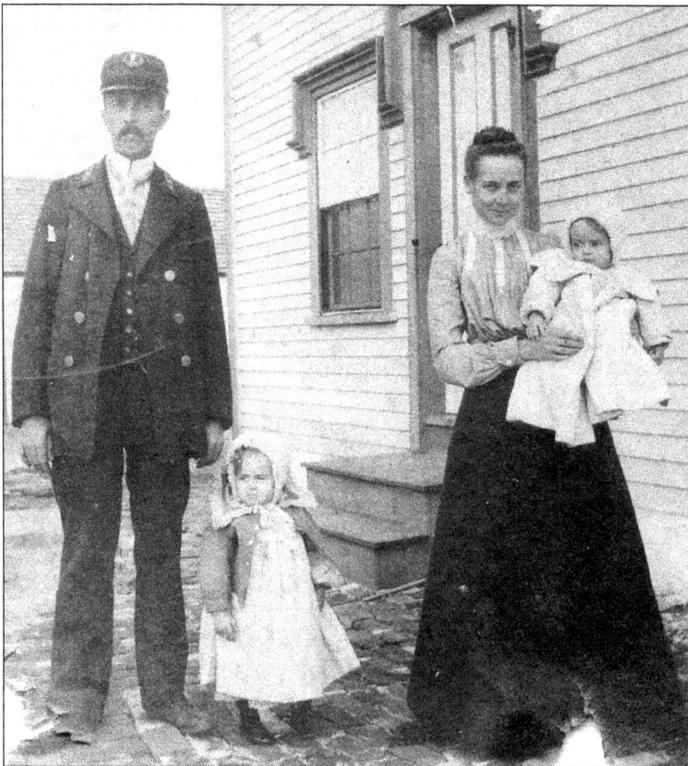

Keeper William Merrill Reed stands with his wife, Dora, daughter Alice (held by Dora), and daughter Louise at his side. He was third assistant keeper from April 20, 1904, until his resignation on December 10, 1905. He was also keeper at Race Point Station in 1902, where this photograph was taken. The family lived in the north tower house. (Courtesy Thacher Island Association.)

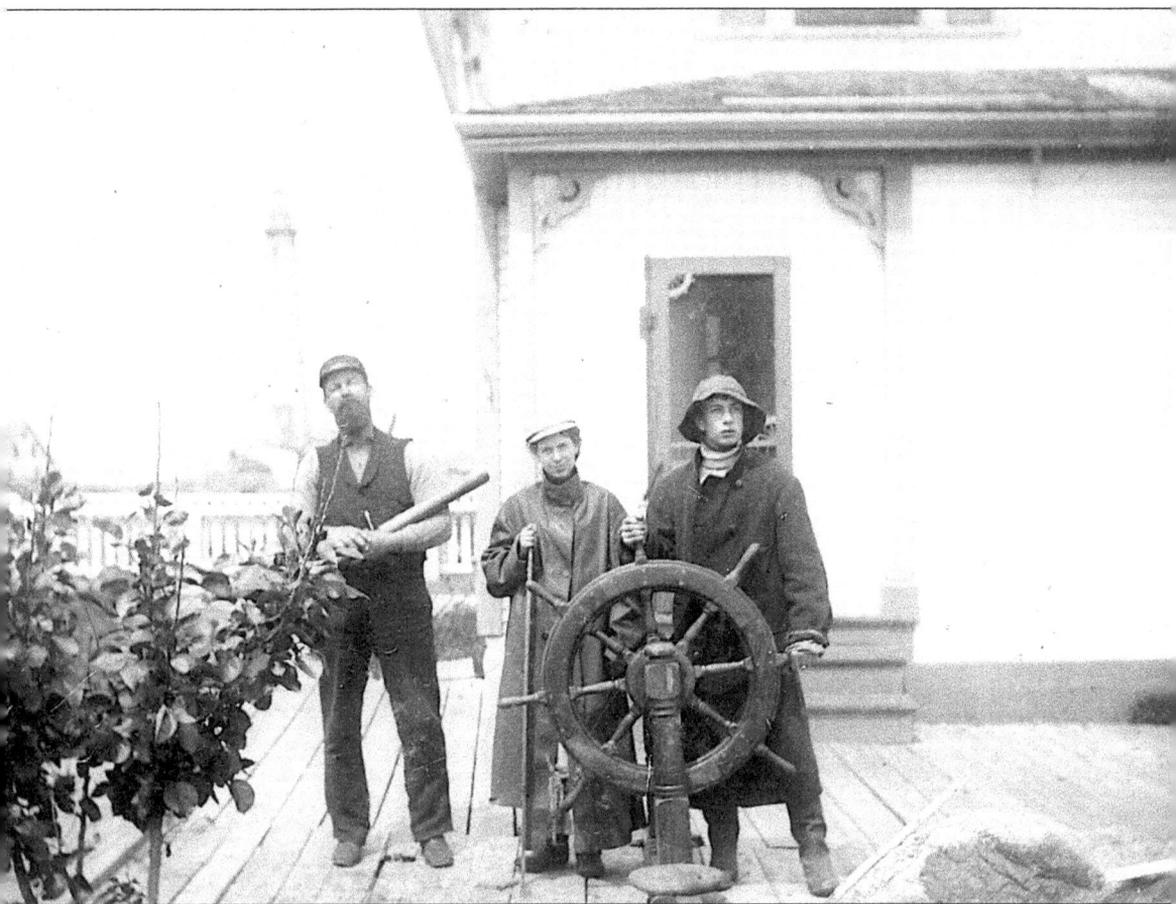

Unidentified keepers pose on the back porch of the principal keeper's house on July 28, 1896. The ship's wheel was salvaged from a shipwreck. The keepers at that time were James Allison, E. C. Hadley, Frank Hall, and Albert Whitten. Whitten was the last person to see the ill-fated SS *Portland* from the north tower about a mile off Thacher before it sunk in 1898. On August 24, 1893, the 25-year-old Whitten and assistant Hadley risked their lives to save the four-man crew of the *Lottie B*, a schooner from St. John, New Brunswick, that struck the Londoner and came ashore on Thacher Island. It struck in the fog at 4:00 a.m., later floated free of the ledge, and anchored to await assistance. Meanwhile the wind increased, endangering the crew, the ship, and the cargo of lumber. At 10:00 a.m., the tug *Cornelia* and the Massachusetts Humane Society's boats arrived on scene but were too late to help. The *Lottie B* dragged its anchor, drifted on the rocks, and crashed to pieces. The cargo of lumber drifted away while Whitten and Hadley made their dramatic rescue. Both received the Massachusetts Humane Society's gold plaque for heroism. (Courtesy Thacher Island Association.)

LOOK FOR BODY IN SEA.

Mrs Asa G. Josslyn, Lightkeeper's Wife, Victim of Melancholia, Disappears from Thatchers Island.

GLOUCESTER, Nov 3—Mrs Asa G. Josslyn, wife of the assistant lighthouse keeper at Thatchers Island, is not on the island, as a thorough search has shown, and she has not left the

Asa Josselyn was a 46-year-old third assistant keeper. On November 3, 1903, he returned from his 12:00 a.m. to 4:00 a.m. watch duty in the south tower. He found a note left by his wife, Linda, indicating she had left the island and was contemplating suicide. Josselyn and the other keepers commenced a frantic search of the island, but no body was found, according to the November 4, 1903, edition of the *Boston Daily Globe*. (Courtesy Thacher Island Association.)

WRITES WIFE'S DEATH NOTICE

Then Josselyn Takes Out New Marriage License.

Rockport People Doubt That Mrs Josselyn Is Dead.

Husband, Who is Assistant at Thatchers Island Light, Says She Left Him Note Intimating Suicide—Story That She is in Wakefield Denied by Her Sister in Boston.

The next day, Josselyn left a death notice at the *Rockport Review*: "To the Editor, Died suddenly on November 2, 1903 Mrs. Asa Josselyn formerly of East Boston, Very Respectfully Asa K. Josselyn." Did Linda commit suicide or not? The next day, Josselyn returned to the island with a woman he identified as his housekeeper, Cora Trommer. They were requested to leave immediately by the head keeper, and he was put on suspension by the lighthouse inspector in Boston. (Courtesy Thacher Island Association.)

Linda was located and interviewed by the *Boston Daily Globe* on November 11, 1903. When asked her reasons for leaving her husband, she stated that he had abused her and not given her money. In addition, she had found a booklet of love letters in the wood shed on the island. Two days later, Josselyn was reported by the Rockport town clerk to have taken out a marriage license with Trommer, aged 29, a widow. (Courtesy Thacher Island Association.)

MRS JOSSELYN TELLS HER STORY

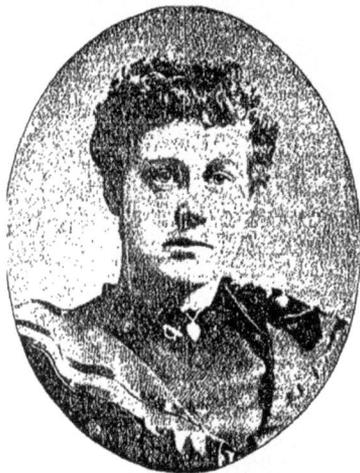

Why She Left Thatchers.

Her Husband Loved Cora.

She Found Book of Love Letters.

Planned Counterplot to Elopement.

Josselyn Refuses to Talk.

MRS LINDA WYLIE JOSSELYN,
Woman Who Feigned Suicide in Order to Foil Plan of Her Husband and Mrs Trommer to Elope.

JOSSLYN'S TRIAL BRIEF AND UNIQUE

Former Lighthouse Keeper

Josselyn had been married years before but had married Linda before the two-year waiting period required by law in those days had passed. Meanwhile, he married Trommer five days later. The courts indicted him for polygamy; he was tried, found guilty, and sentenced to two to four years in prison, according to the *Boston Daily Globe* on February 5, 1904. (Courtesy Thacher Island Association.)

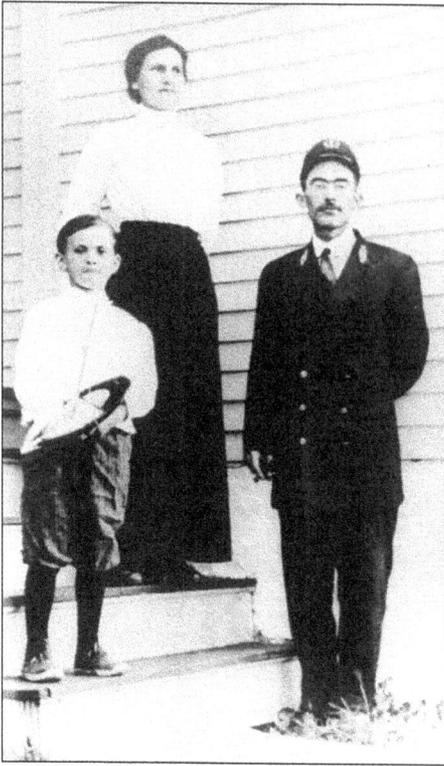

Assistant keeper John E. H. Cook is pictured with his wife, Emma, and their son Donald in 1911. He was a veteran of the Spanish-American War and went to work in 1907, serving under head keeper Addison Franklin Tarr. He was appointed third assistant keeper in 1911. By 1914, he was named principal keeper. Cook spent 13 years in the lighthouse service. (Courtesy David Cook.)

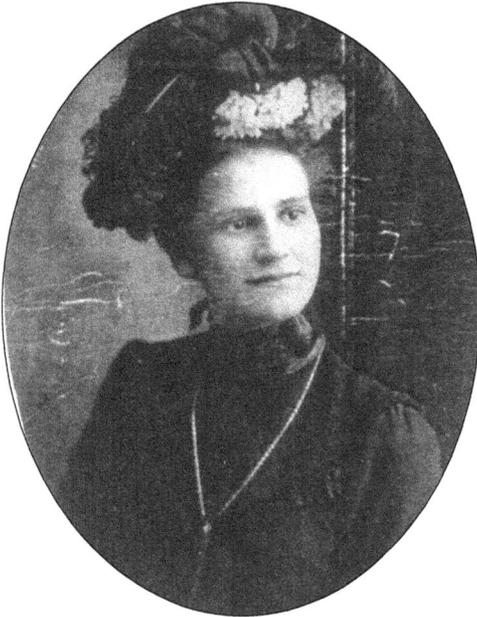

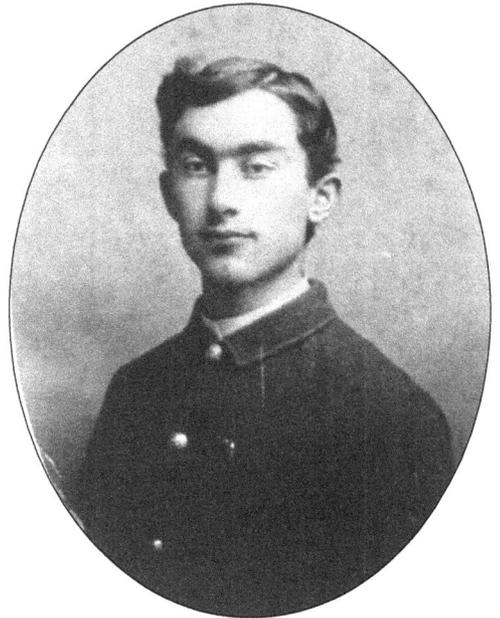

Cook is shown here with his wife in 1900. Cook assisted in saving the crew of the schooner *Commonwealth* on July 22, 1917, as well as the *George W. Anderson* in 1914. He left Thacher Island in 1918 and served as principal keeper at Straitsmouth Island Light. After retiring from the lighthouse service in 1920, he lived in Rockport and worked as a carpenter until his death in 1940. (Courtesy David Cook.)

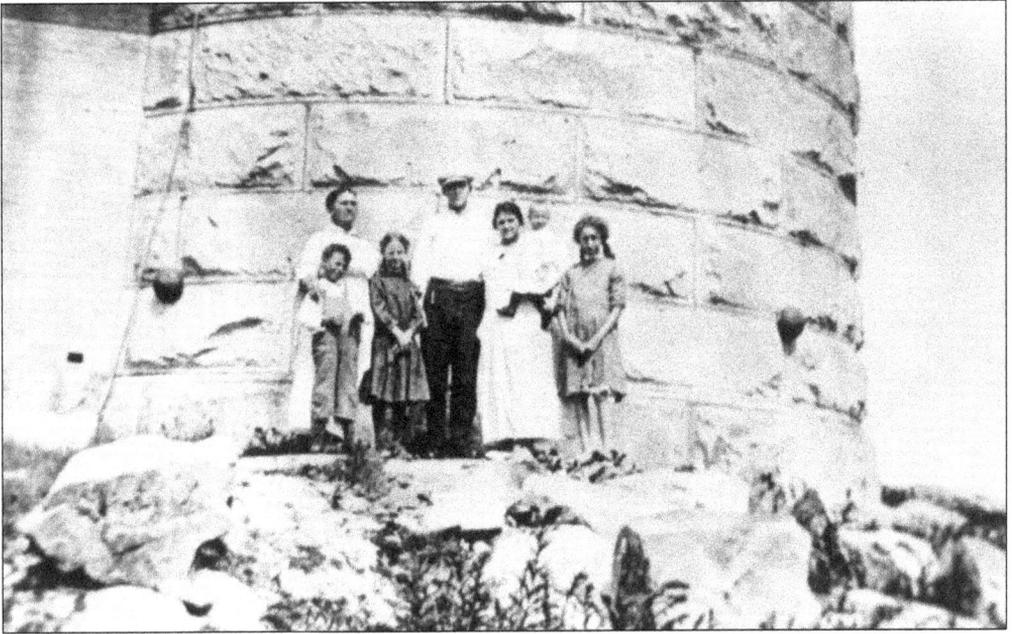

Donald Cook Sr., the smallest child in this photograph, is seen with other island children at the base of the north tower in 1913. Because 12 children lived on the island in 1924, a teacher was hired and held classes in her residence on the third floor of the assistant keeper's house. Two years later, she fell in love with one of the assistant keepers. They married and moved off the island. (Courtesy David Cook.)

Donald Cook Sr. sits with Mildred Carter, daughter of first assistant Howard Carter, in the summer of 1914. Head keeper John E. H. Cook's other help in the spring of 1917 included third assistant George Herbolt and second assistant Frank A. Davis. After the teacher left the island, most of the children boarded on the mainland to attend school. When the children were ready to return, they walked back and forth at a designated spot at Loblolly Cove, and one of the fathers rowed to shore to pick them up. (Courtesy David Cook.)

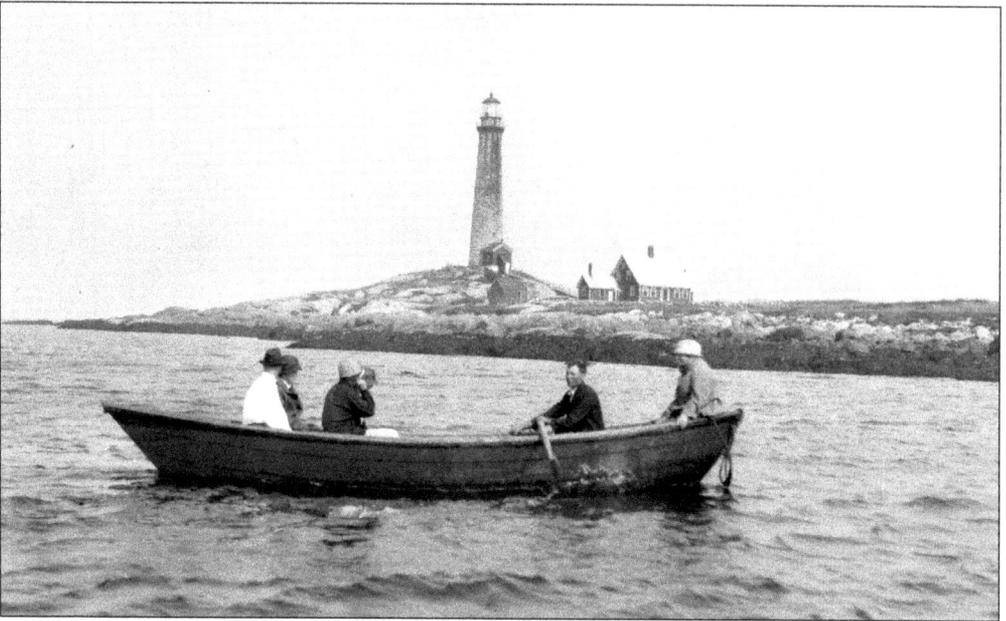

Keepers had to row a mile across Loblolly Cove to bring their children to school in Rockport, and the children had to walk a mile to the school. Often they could not be picked up in the afternoon because of severe weather. Arrangements were made for the children to stay at the home of a Mrs. Dobson on South Street, many times for a week or more if the storms persisted. The government paid her $1 a week for boarding the children. (Courtesy Sandy Bay Historical Society.)

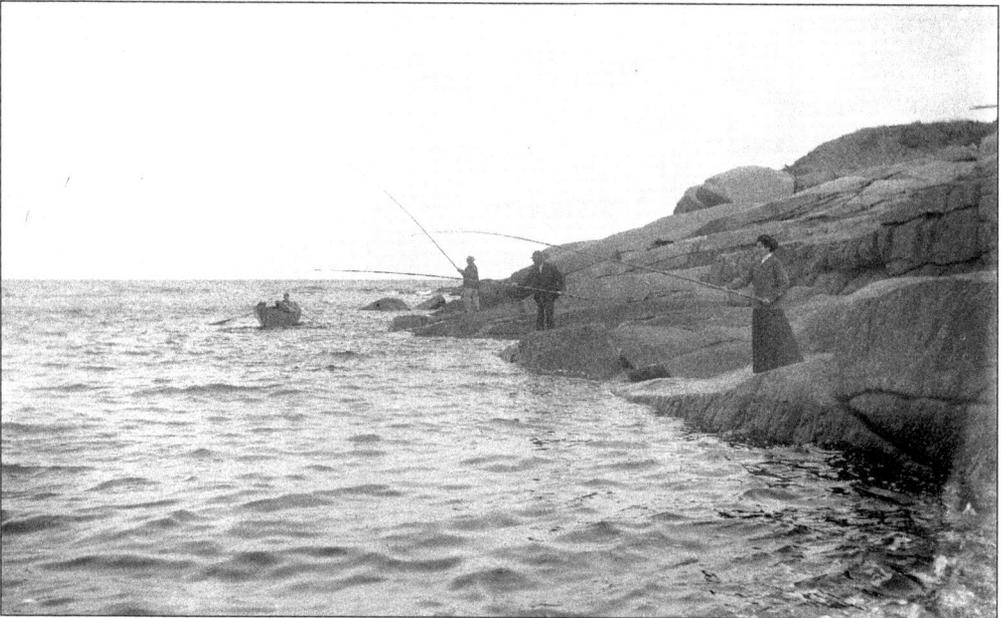

Keeper's wives, besides canning fruits and vegetables grown on the island, often fished to supplement the food supply for the family. They planted vegetable gardens, tended fruit trees, and raised sheep, goats, chickens, and cows. Keeper's wives canned their produce, baked bread, and tended the coal-fired stoves. They also carded, spun, and dyed the wool from the sheep they raised there. (Courtesy Sandy Bay Historical Society.)

Keeper's wives had to always be aware when the lighthouse inspector arrived aboard the tender unannounced. Her job was to keep the paint free of soot for the white glove inspections, no easy task when the stoves used coal. Spotless cleaning was made even more difficult to achieve because paint had a dull finish, and the floor coverings were battleship gray linoleum. (Courtesy Sandy Bay Historical Society.)

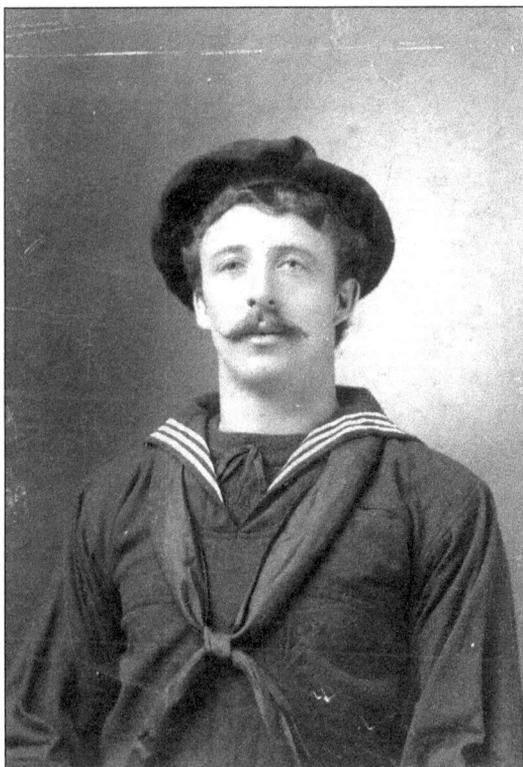

Eugene Norman Larsen was born in Oslo, Norway, in 1879 and served under the British flag in 1897 aboard the SS *Gladestoy*. He came to America and served in the U.S. Revenue Cutter Service as quartermaster until 1910 aboard the USRC *Gresham* and the *Onandaga*. He later served as keeper at Minot's Ledge Light and came to Thacher Island as the first assistant in 1911. (Courtesy Dina Hamilton.)

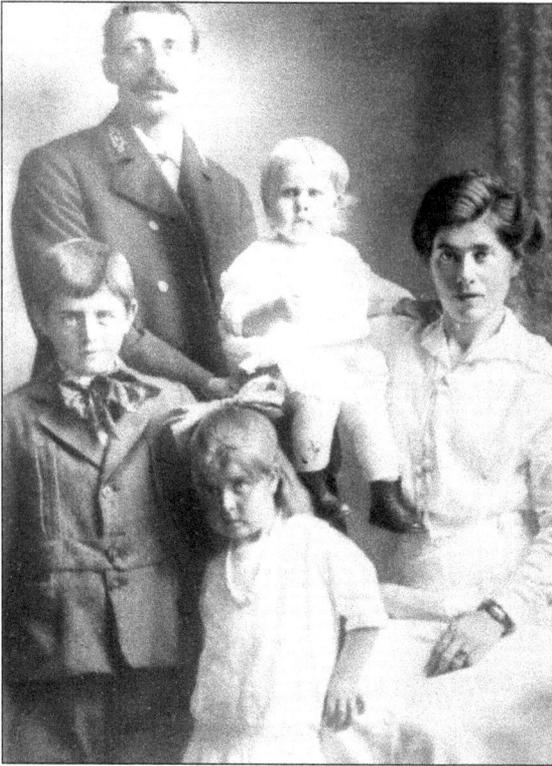

Eugene Norman Larsen is pictured with his wife, Edvardine "Dina," with their first child, Eugen, born in Norway in 1907, their second child, Alice Thatcher, born on the island in 1912, and their third child, Marie Antonette, born in 1915. He was transferred to Graves Light in Boston Harbor and later to Boston Light in 1913. He ended his 44-year career with the U.S. Lighthouse Service as principal keeper at Sankaty Head Light on Nantucket in 1944. (Courtesy Dina Hamilton.)

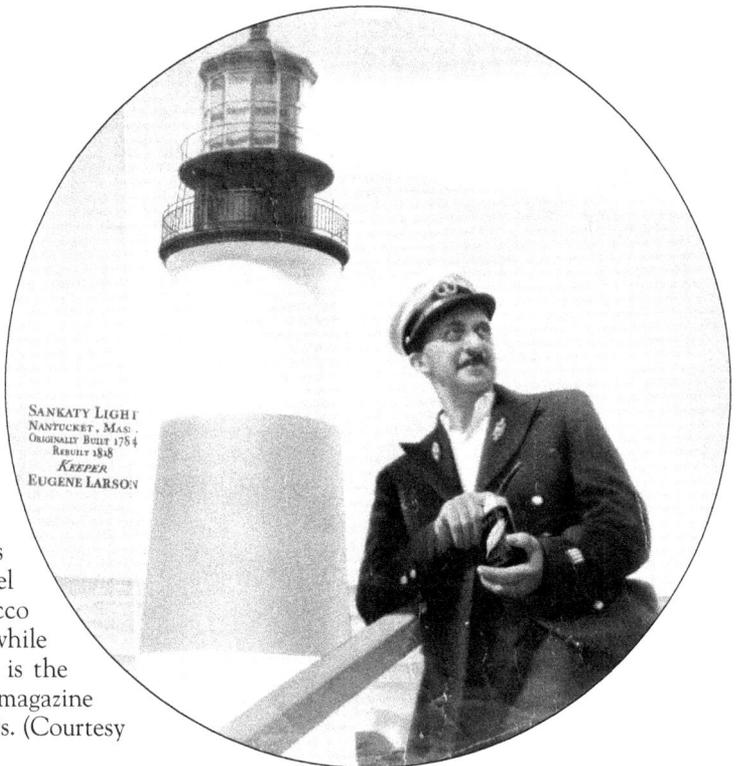

Larsen and his wife had five more daughters during the 30 years they spent at Sankaty Head Light. He was awarded many commendations by the lighthouse service for his meticulous care of the light station. He was chosen once as a model for a Granger Tobacco Company advertisement while serving at Sankaty. This is the photograph used in the magazine advertisement in the 1930s. (Courtesy Dina Hamilton.)

SANKATY LIGHT
NANTUCKET, MASS.
ORIGINALLY BUILT 1784
REBUILT 1848
KEEPER
EUGENE LARSON

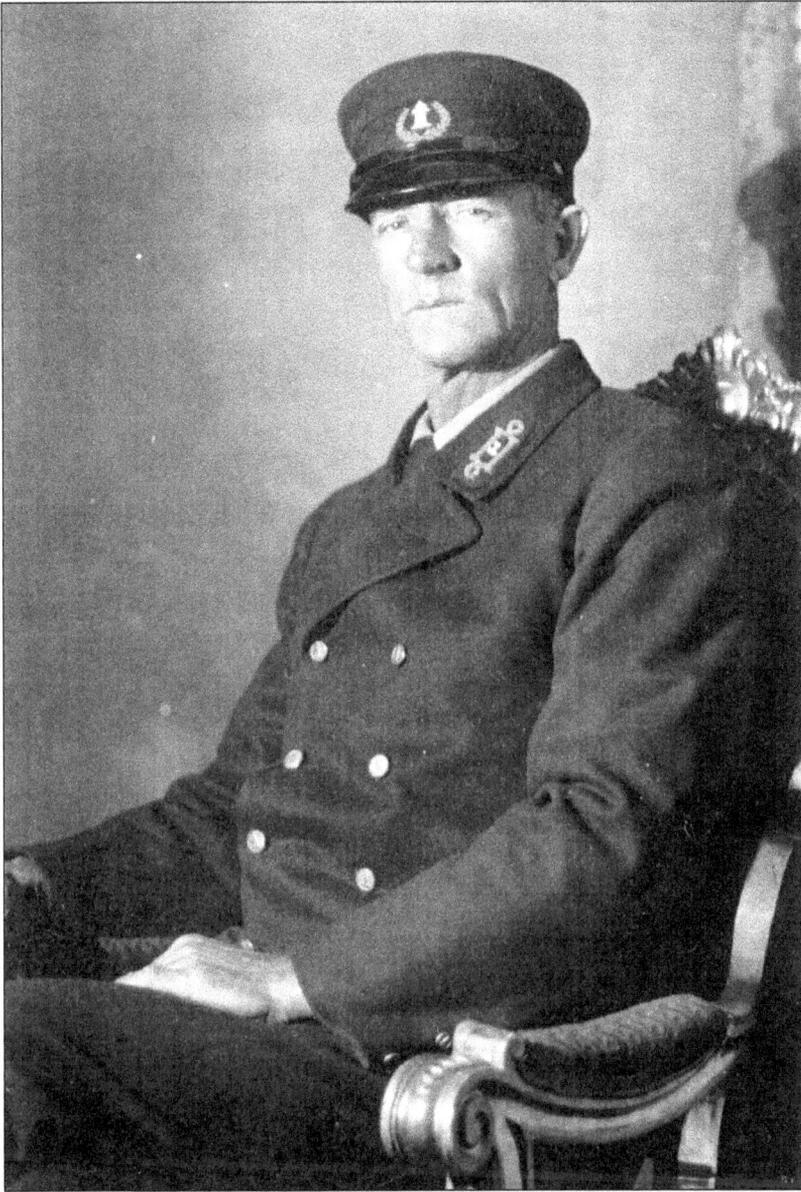

William (Bill) Daggett (1870–1945) was first assistant keeper from 1918 to 1926. He married Ida Josephine Phillips in 1889, when he was 19 and she was 17 years old. They had six children, five sons and one daughter. Prior to joining the lighthouse service, he was a cook aboard the rock sloop *America* at age 14, delivering granite up and down the eastern seaboard. He was transferred to Deer Island Light in Boston Harbor for two years after a seven-year stint at Thacher Island. He later became a mate and pilot on the tug HS *Nichols*, working for the Rockport Granite Company for 28 years. He also raised cows and sheep on the island. In the summer, he swam them over from the mainland and brought them back in the winter months. Daggett had a weather-beaten face carved by years of exposure to the sun and sea. At age 84, with more than 60 years at sea, he posed for artists at the North Shore Art Association. They attempted to capture his rugged personality and weather-beaten features in oil, watercolor, and charcoal. (Courtesy Leola Morse.)

In 1939, the Coast Guard assumed responsibility for the nation's lighthouses. Crews on the island varied from three to six men until 1980. The Coast Guard left the island after automating the lights and foghorn with solar power. A Coast Guard Aids to Navigation Team now visits the island occasionally to check on the condition of the lights and the fog signal equipment. (Courtesy Thacher Island Association.)

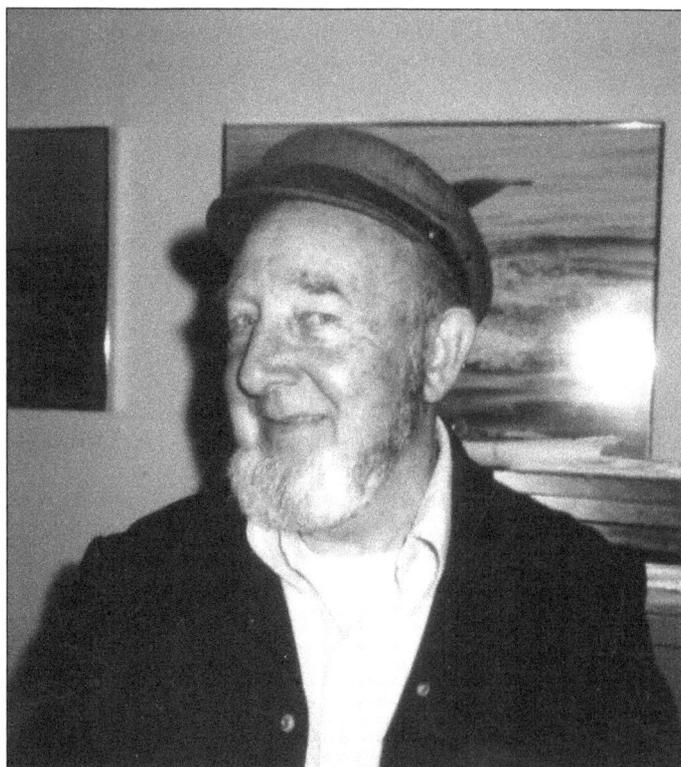

At age 63, Russell Grubb was the first civilian keeper assigned to the island under the Thacher Island Association. Grubb lived there for two years (1980 to 1981), along with his cat, a dog, two sheep, a baby lamb, three goats, and five hens. Before taking this job, Grubb was with the First National Bank of Boston for 18 years. (Courtesy Thacher Island Association.)

Grubb retired to Maine in 1985, and this cartoon of him with his menagerie was done by *Boston Globe* artist Phil Bissell in thanks for his volunteer work for the Thacher Island Association. Bissell was one of the original board members of the association. (Courtesy Phil Bissell.)

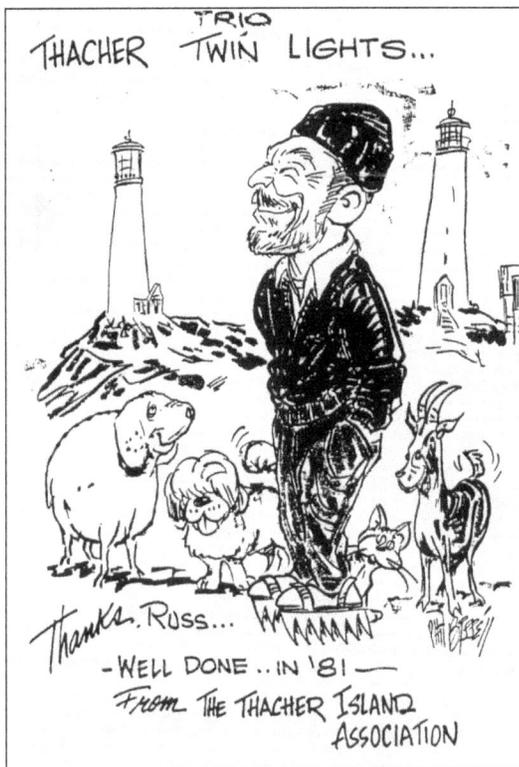

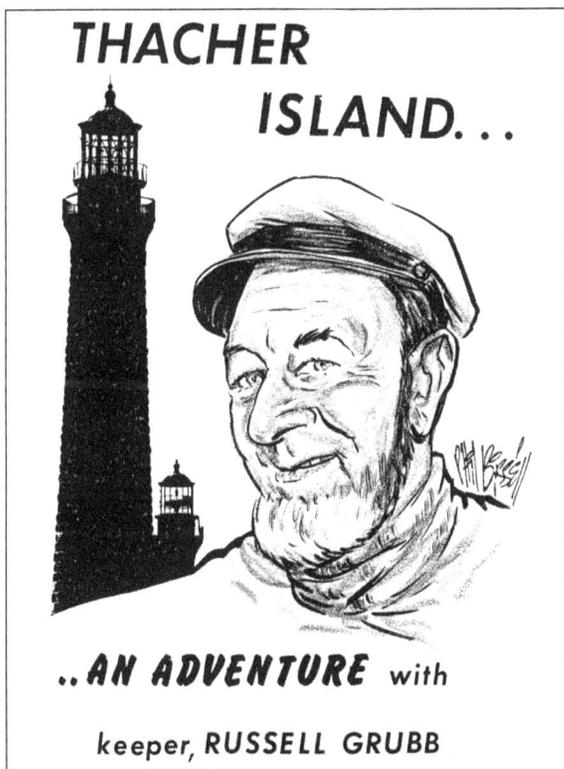

Grubb wrote a memoir of his experiences, which he published in 1983. This is the illustration used on the cover done by Bissell, taken from the adjacent photograph. (Courtesy Phil Bissell.)

Armand and Betty Desharnais were the first married couple to work as civilian keepers under the association, serving from 1986 to 1992. They spent 42 months, including winters, on the island. Armand was a former civilian worker for the Coast Guard, and Betty was a housewife who raised nine children. Armand worked on the automation of several lighthouses from Maine to Florida in the 1970s. He rebuilt the whistle house wall after the "perfect storm" of 1991. (Courtesy Thacher Island Association.)

George and Dottie Carroll lived on Thacher for 36 months from 1987 to 1992. They substituted for Armand and Betty Desharnais during the summer months. Dottie had worked in a regional high school as secretary to the principal, while George served aboard a Liberty ship and an LST in both Europe and the Pacific during World War II and was a printer for 31 years. (Courtesy Thacher Island Association.)

Five

THE WHISTLE HOUSE

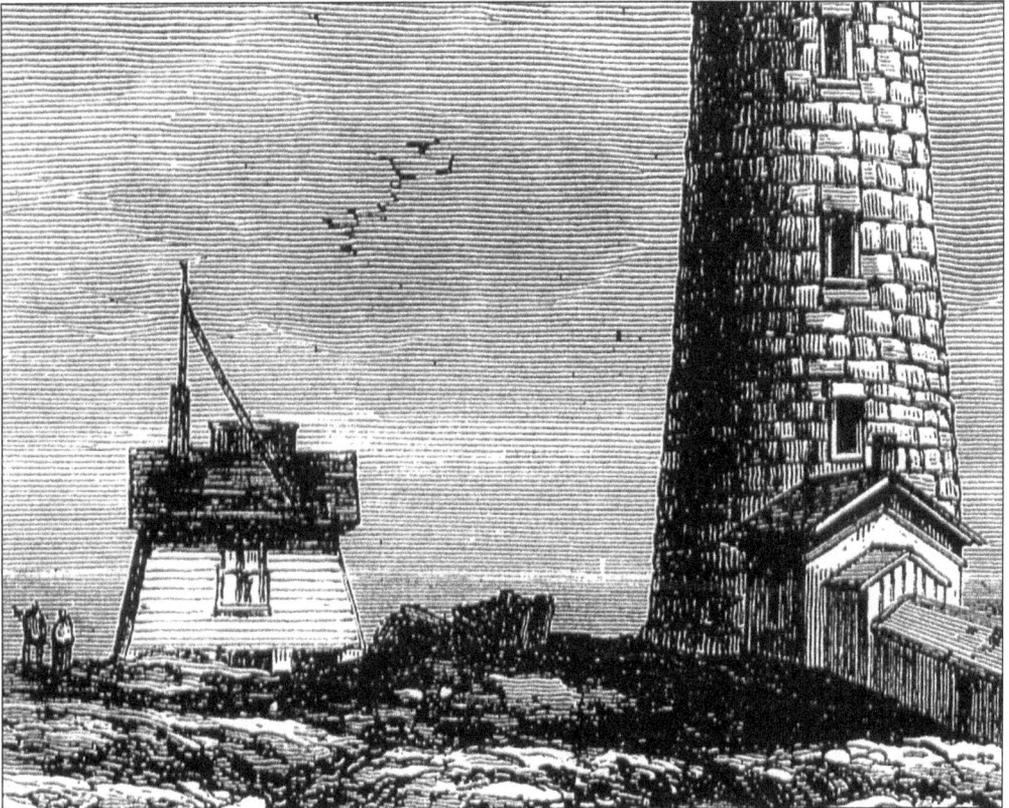

The first fog signal house was built along with the new towers in 1861, as seen in an illustration from *Harper's New Monthly Magazine*, March 1874. It was originally a foghorn powered by a steam engine with a horn on the ocean-side wall of the building. In 1887, the horn was replaced with two steam whistles, and since then, the fog signal building has been called the whistle house. (Courtesy Thacher Island Association.)

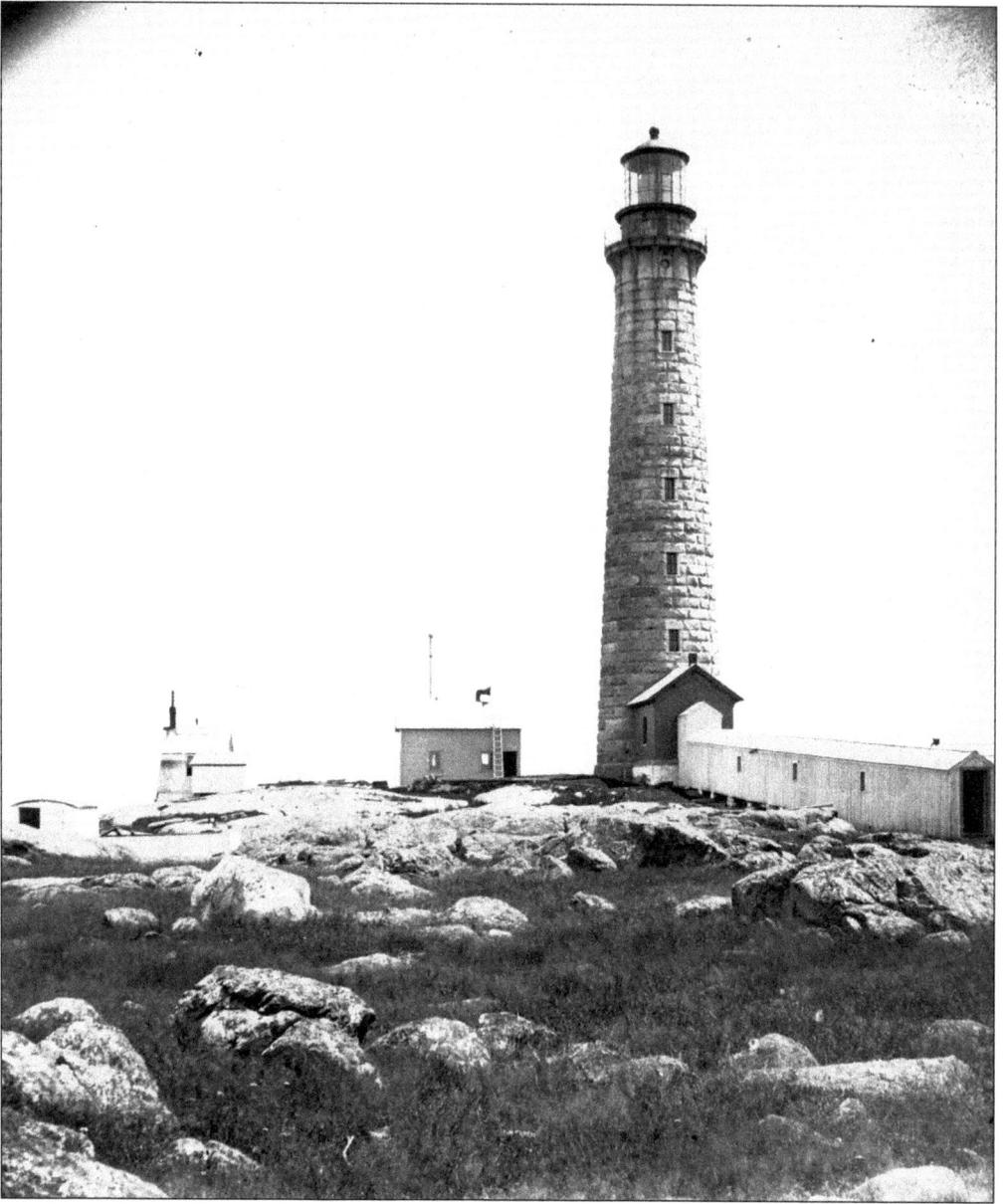

This c. 1873 photograph shows two fog signal buildings next to the south tower. Mariners complained that the horn could not be heard, and it was declared inefficient by the lighthouse service in 1866. The second house was built closer to the south tower, with a 32-inch Ericsson steam engine and a 15-foot horn erected on the roof. (Courtesy National Archives and Records Administration.)

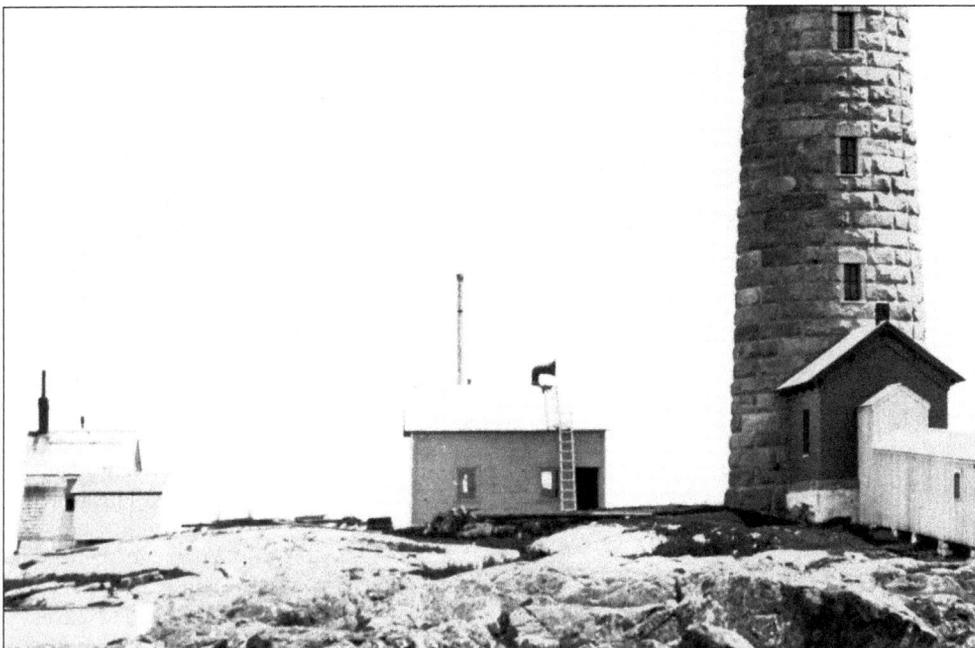

This close-up shot shows the two fog signal houses, the first being built in 1863 and the second close to the tower in 1867. Both eventually proved ineffective, and the earlier fog signal buildings were replaced by the current brick structure in 1887. (Courtesy National Archives and Records Administration.)

This is a letter of approval of the contract from the lighthouse board to Maj. W. S. Stanton, engineer of the second lighthouse district, for a new fog signal to be built by the Arthur J. Brennan Company of Boston, dated October 16, 1886. (Courtesy National Archives and Records Administration.)

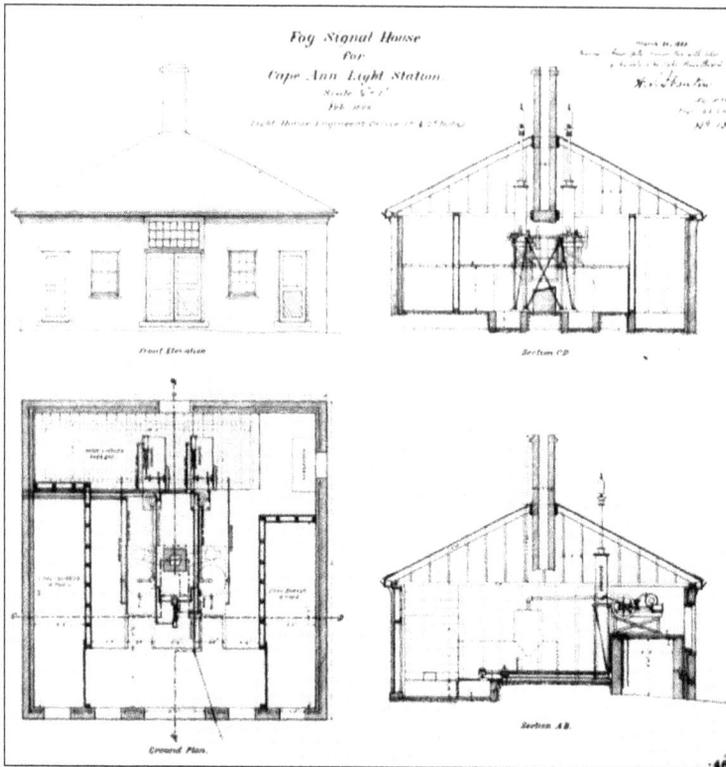

This fog signal house drawing dated February 1888 shows the 32-foot-by-32-foot brick building currently in place. The building was approved by the lighthouse board on October 7, 1886, and erected for $2,200. This new building included two 15 inch steam whistles. They were powered by two coal driven steam boilers. This is when the building became known as the whistle house. (Courtesy National Archives and Records Administration.)

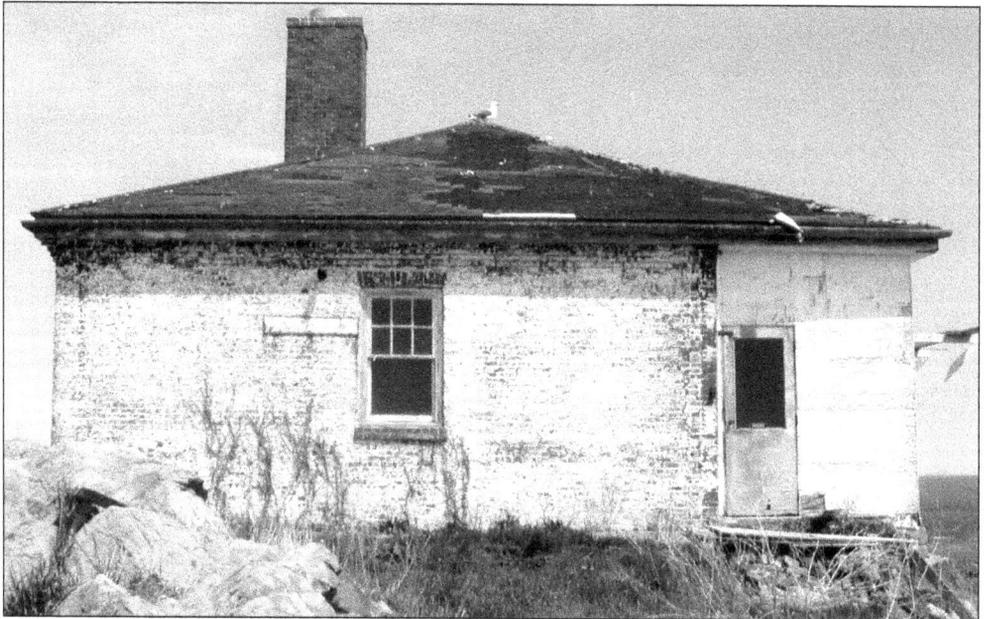

Today's whistle house is being restored. The 1893 keeper's log stated, "The whistle was in continuous operation for 590 hours and used 36 tons of coal." By 1945, steam was eliminated and replaced with a diesel-driven compressed air system with two horns mounted vertically in the ocean-side brick wall. In 1968, a Leslie Supertyphon double sound emitter was installed. (Courtesy Thacher Island Association.)

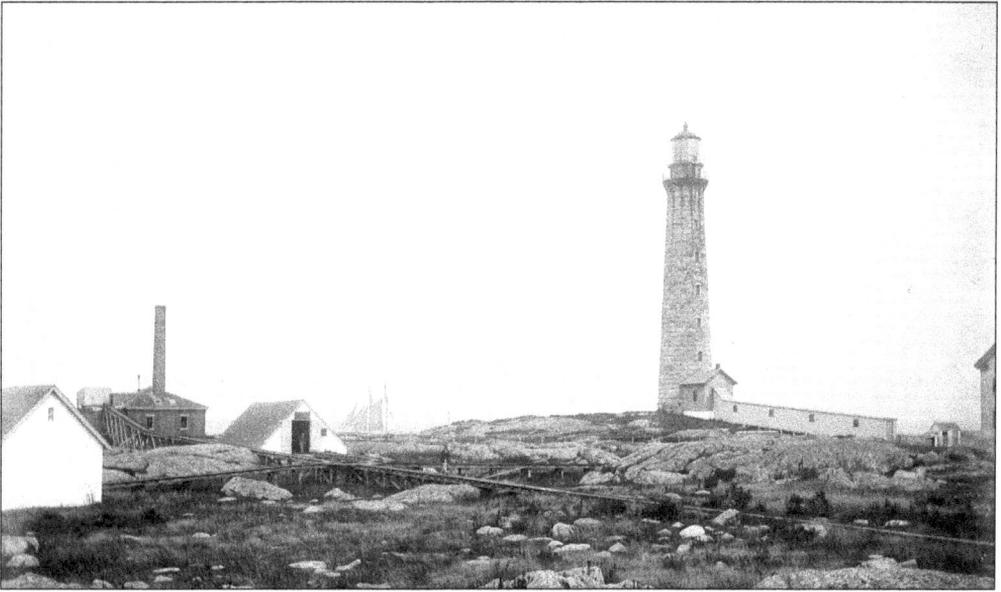

This photograph shows the whistle house with a tall brick chimney and the 6,000 gallon, triangular roofed, covered cistern used to provide water for the steam engine. It was built in 1900 to supply water for the Crosby steam engine. Note the trestle that climbs to the roof of the whistle house so the coal carts could dump their load into the coal bin dormer. The signal characteristic was an eight-second blast, silent for four seconds, a blast for four seconds, then silent for 44 seconds. (Courtesy Thacher Island Association.)

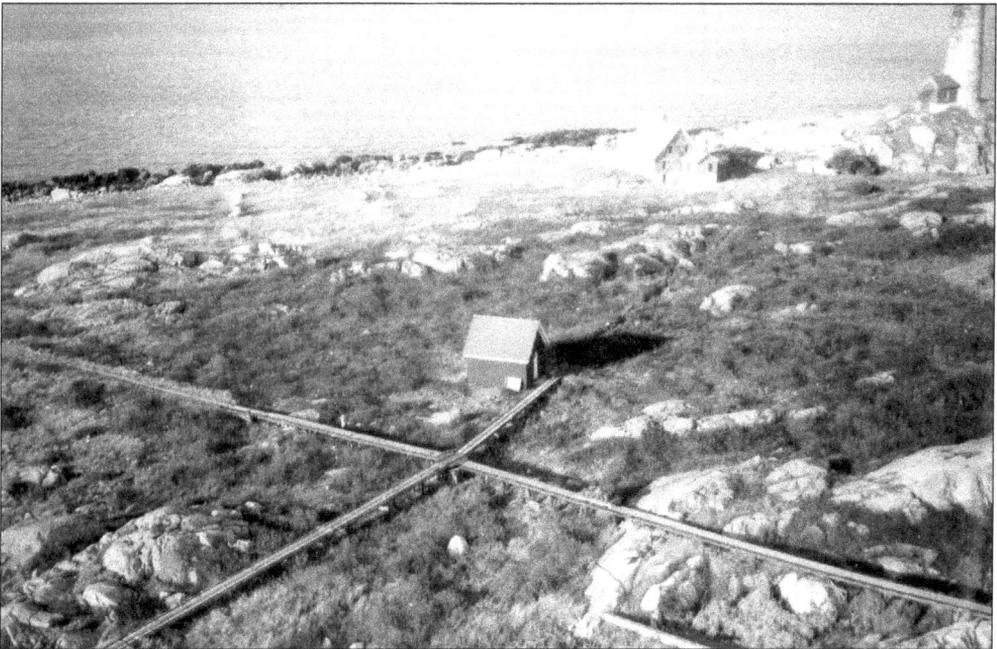

Here is an aerial view of the new tramway track system around 1948. In 1899, a railway system with carts to haul coal from the lighthouse tender at the boathouse up to the whistle house was installed. A turntable was used to switch the carts from an east–west to a north–south track, allowing the carts to service the keeper's dwellings as well. (Courtesy U.S. Coast Guard.)

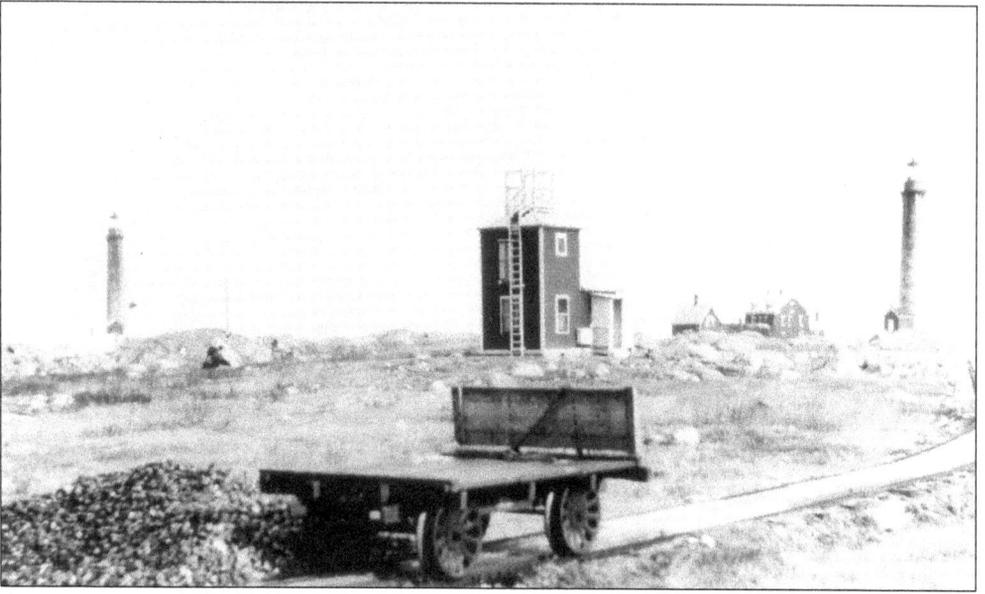

A cart is seen on the tramway in 1926 near the radio compass station. In 1930, one of the keeper's children wrote, "I woke one morning and what looked to me to be a big ship apparently anchored near the boat slip. Big excitement! The 'government tender' had come. They off-loaded the 'tender' using carts and dollies, loads of coal, barrels of potatoes, apples, and supplies for the winter. Next morning the tender was gone and life was back to normal." (Courtesy Thacher Island Association.)

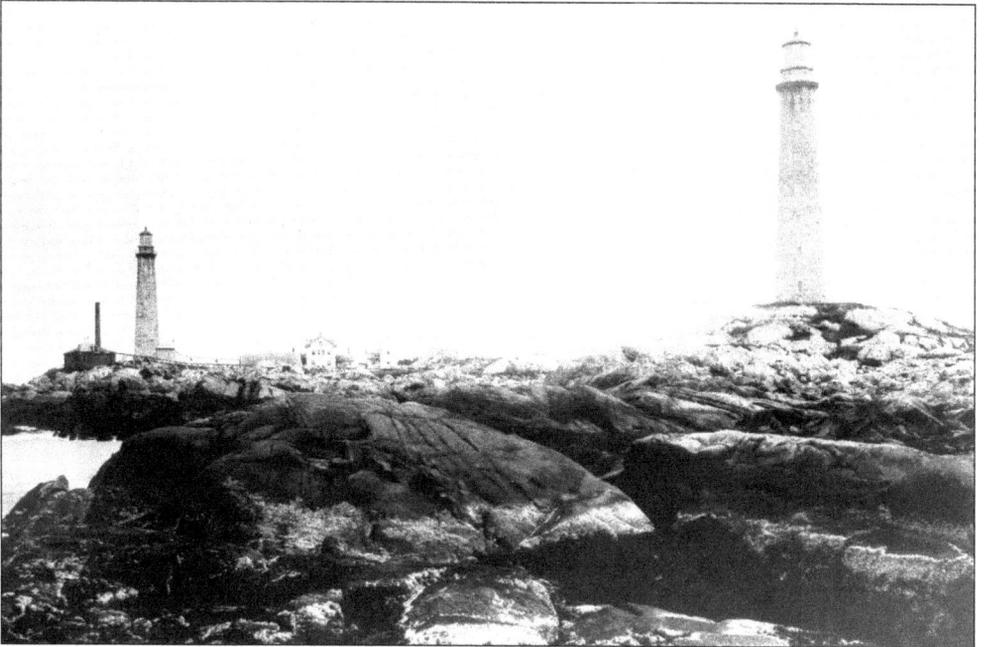

The railway trestle went to the roof of the whistle house, enabling keepers to drop 50-pound bags of coal through the roof dormer directly into a coal bin. Two hoisting engines towed the carts up to the whistle house and on to the trestle to the roof. The carts were operated by gravity on their return to the boathouse. (Courtesy Thacher Island Association.)

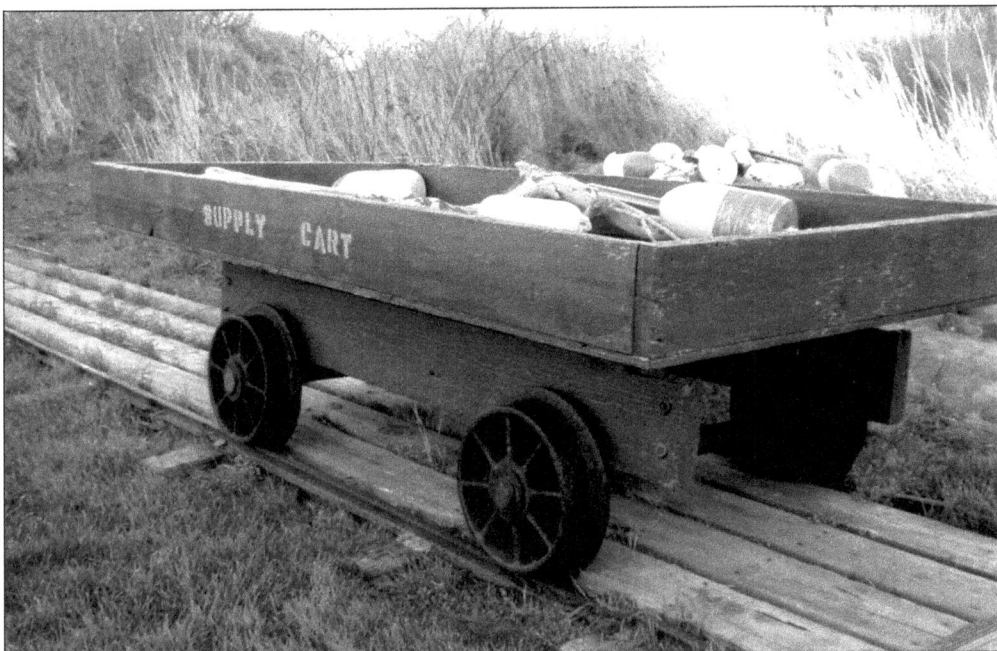

The cart has been restored in this photograph. The association plans to restore much of the 500 feet of railway to get the cart rolling again. Alice Orne, daughter of keeper Simeon Orne, in 1929 recalled, "We used to get my brothers and sister to push the cart up to the top of the trestle and then we would ride it all the way to the boat house." (Courtesy Thacher Island Association.)

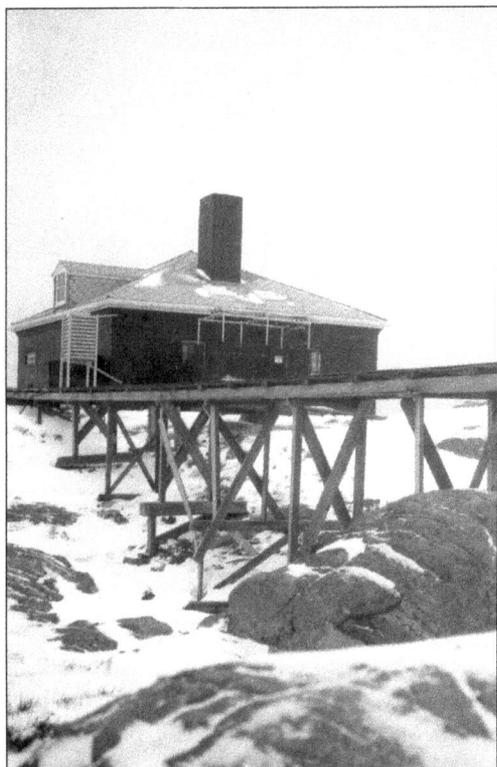

Note the roof dormer where coal was delivered into a bin inside. Here in 1945, the trestle has been lowered, and the smoke stacks have been replaced with a small brick chimney because the horn was no longer powered by steam but by a diesel generator instead. (Courtesy National Archives and Records Administration.)

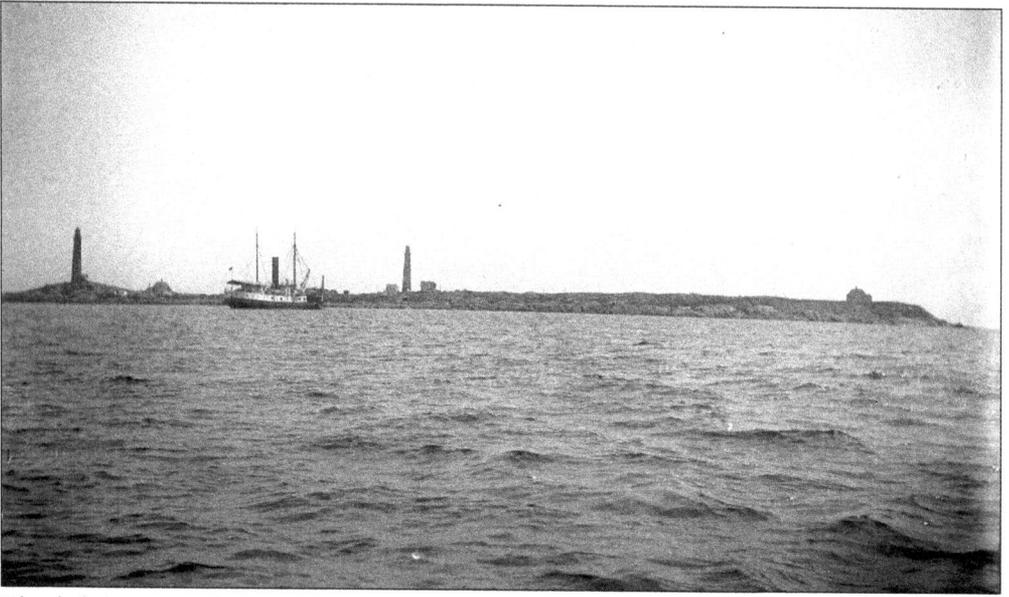

The lighthouse tender USLHT *Mayflower* is seen delivering supplies to Thacher Island on August 12, 1913. Keepers had to unload as much as 30 tons of coal at a time, which had to be hauled across the island to the whistle house. Tenders also carried library books in neat wooden cases that were exchanged by keepers at different light stations along the coast. (Courtesy Sandy Bay Historical Society.)

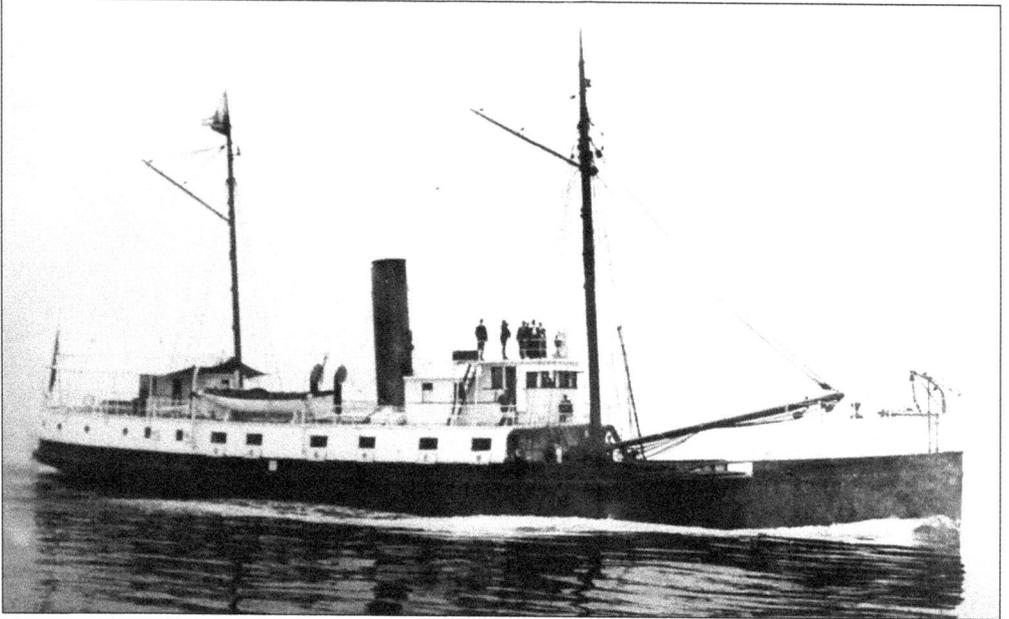

The *Mayflower* lighthouse tender was used by the second Coast Guard district from 1898 to 1924. In 1943, its name was changed to USCGC *Hydrangea* and decommissioned in 1945. Lighthouse tenders were named after trees and flowers during this period. Other tenders that have serviced Cape Ann Light Station were *Daisy* (1877–1879), *Fern* (1884), *Verbena* (1875–1889), *Geranium* (1889), *Myrtle* (1902), *Ameria* (1903), *Azalea* (1919–1926), and *Lotus* (1926). (Courtesy U.S. Coast Guard historian.)

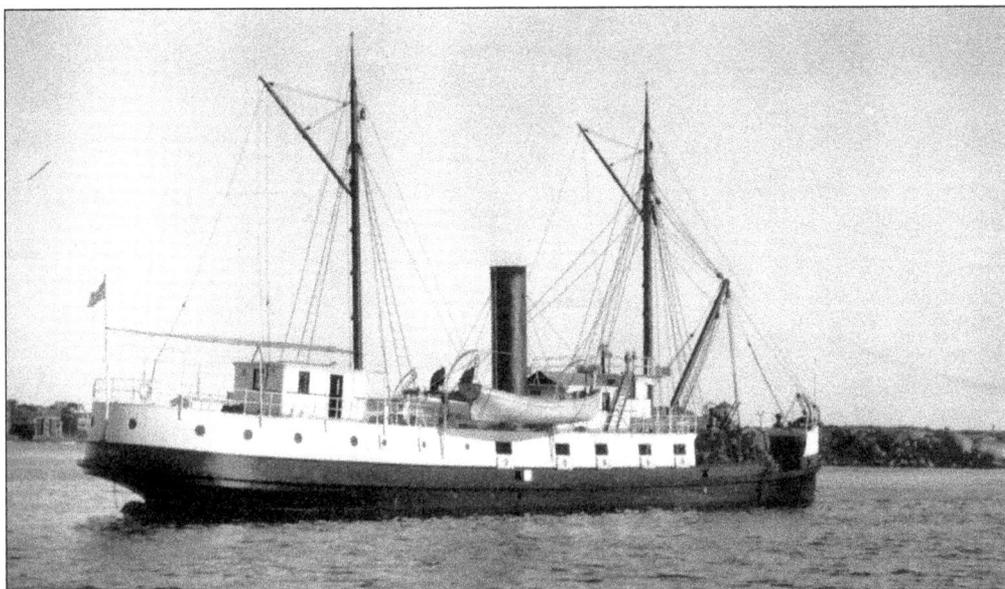

This is an aft view of the *Mayflower* with a lifeboat in its davit. The cabin shown to the left was the district inspector's quarters. Lighthouse inspectors arrived unannounced periodically to look at the facilities and give instructions for work that needed to be done. All tenders were painted with black hulls and white superstructures. They also flew the triangular lighthouse service flag and carried polished brass miniature lighthouses affixed to their bows for identification. (Courtesy U.S. Coast Guard historian.)

These foghorns, shown in disrepair, have been restored for demonstration use. On January 10, 1924, a new diaphone type *f* horn was installed after being delivered by the lighthouse tender *Mayflower*. This horn had such a unique sound, *bbbbeeeeoooo*, that local resident Homer Clark, who was an advertising executive for Lever Brothers Company, developed a popular radio commercial using this sound for advertisements for Lifebuoy soap in the 1940s. Clark's home on Eden Road overlooked Thacher Island. (Courtesy Thacher Island Association.)

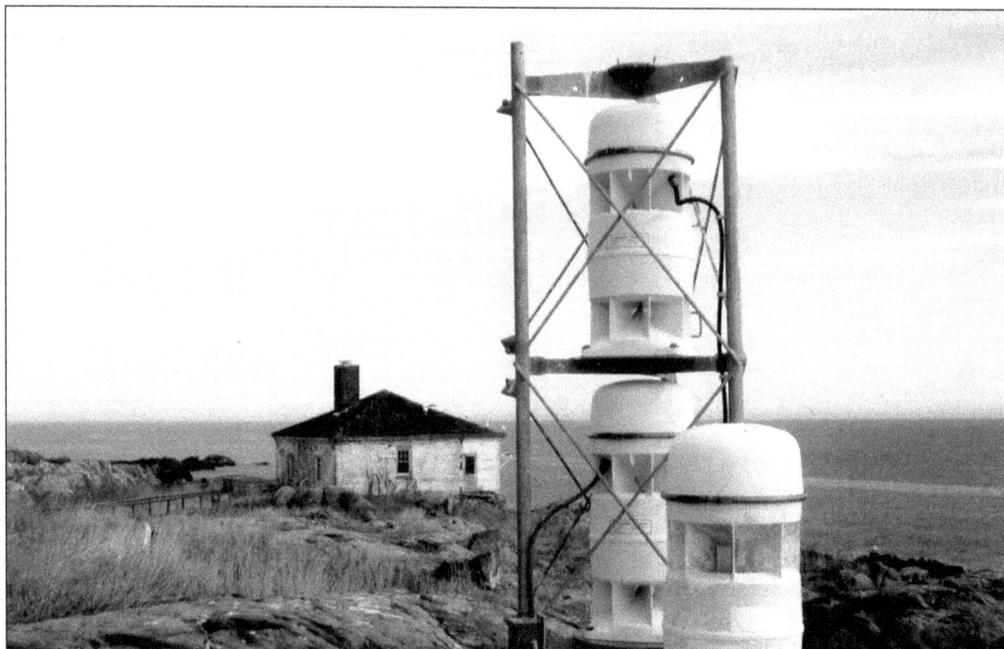

When the Coast Guard moved off the island in 1980, it automated the foghorns and the south tower light beacon and placed these new, modern solar-powered electric air horns outside at the base of the tower and closed the whistle house operation for good. (Courtesy Thacher Island Association.)

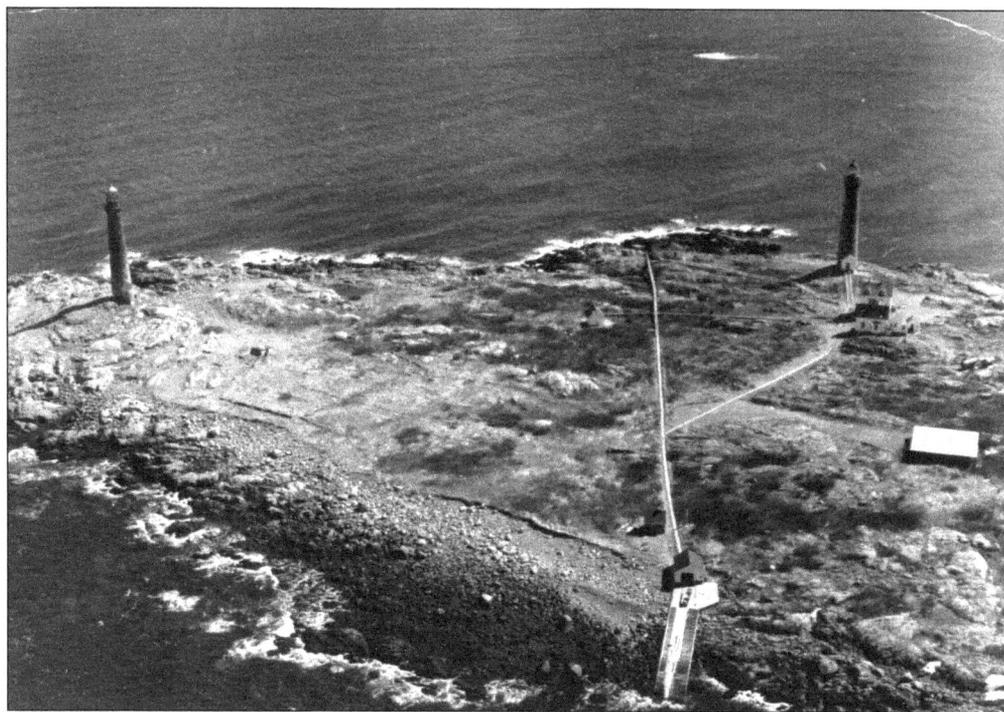

This aerial view shows the tramway running from the boathouse in the foreground to the whistle house at the top of the photograph around 1960. (Courtesy U.S. Coast Guard.)

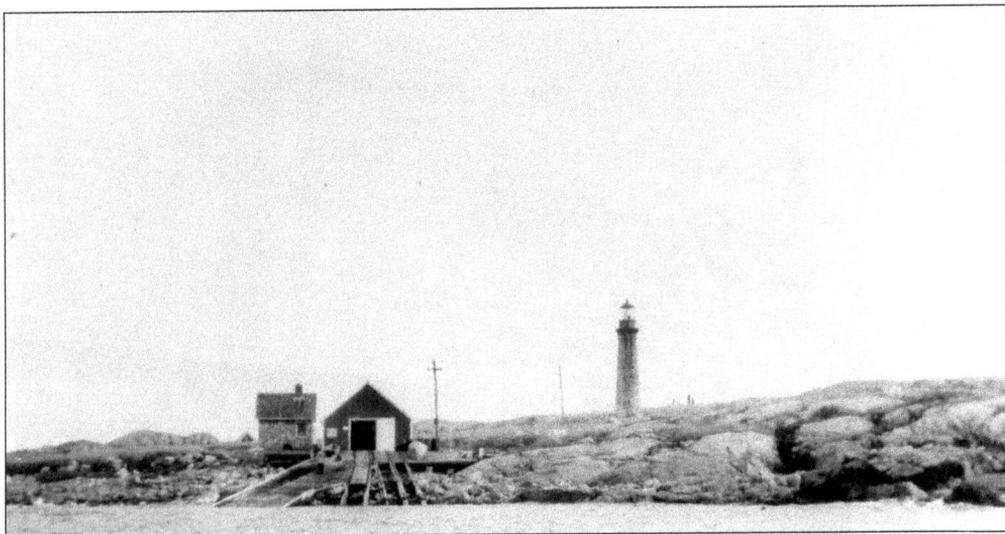

Boathouse and ramp are photographed around 1926. The first boathouse and ramp were built in 1842 under the direction of keeper Charles Wheeler. They have been replaced more than six times due to severe storms since then. Note the railway tracks in the center of the ramp, which allowed the cart to go to the water's edge to receive materials from the lighthouse tender. (Courtesy Thacher Island Association.)

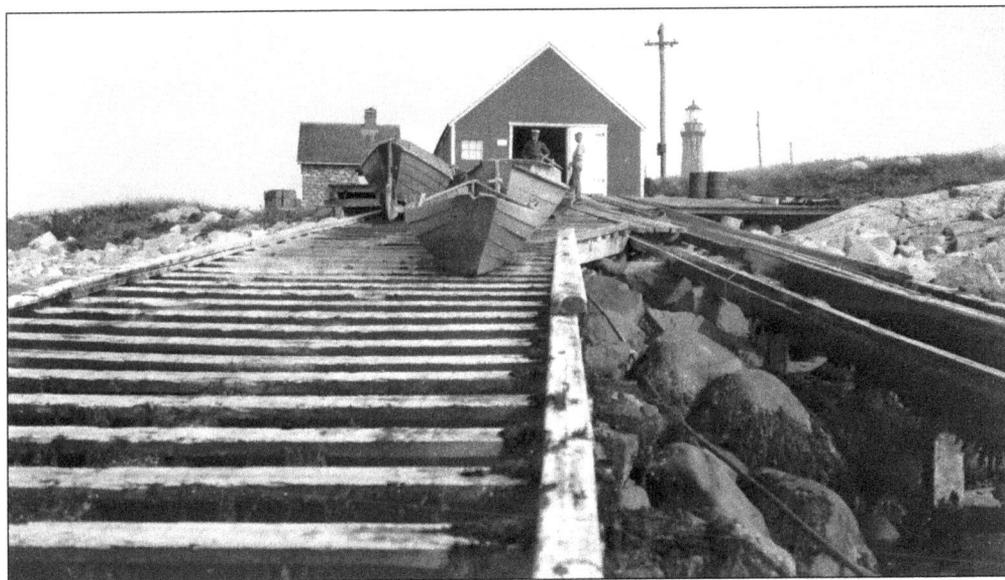

The boathouse and ramp are pictured in March 1940 with the boat launches ready to go. This boathouse and ramp have been in the same location since Wheeler first built them in 1842. (Courtesy Thacher Island Association.)

This lighthouse service motorboat was used at Straitsmouth Island Light and Thacher Island around 1920. Dories and rowboats have been used since the earliest years by the keepers. This lifeboat was self-bailing, self-righting, 34 feet long, weighed 4,000 pounds, and had an oak frame and mahogany planking. It was motorized and had a canvas cover to ward off the waves. (Courtesy Thacher Island Association.)

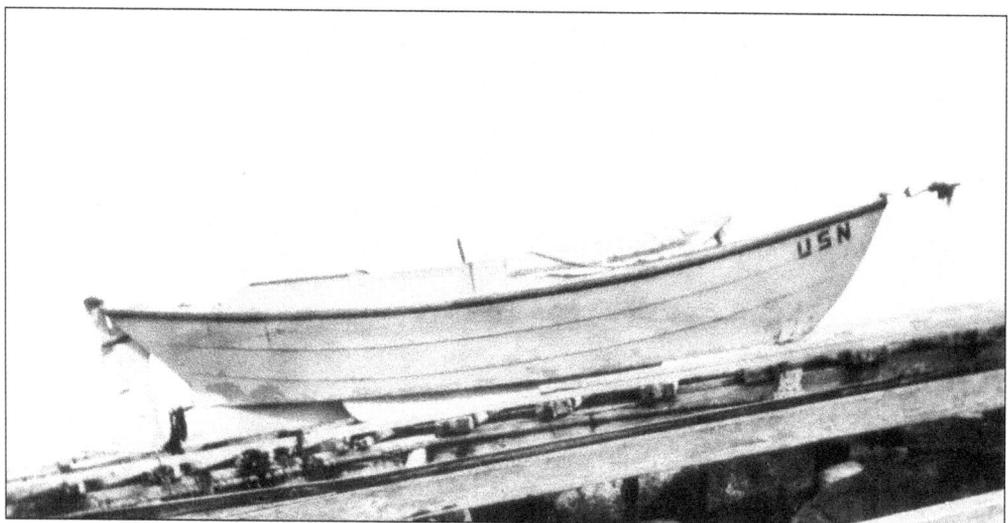

The navy dory is pictured on the boat ramp used by the navy radio compass station team around 1922. Emma Cook, wife of the keeper John Cook, earned recognition as a skillful handler of boats while wearing a rowing costume of the day—a daring divided skirt. She usually rowed standing up as the fishermen did. Today the keepers use a 14 foot, five-person inflatable powered by an outboard motor for trips to the mainland. (Courtesy Thacher Island Association.)

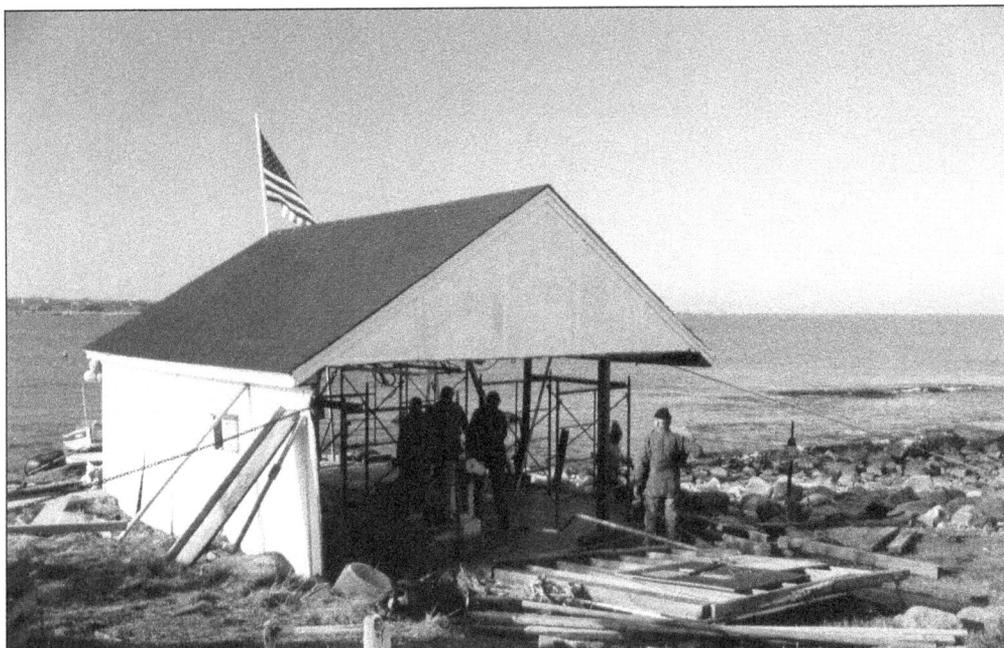

Both the boathouse and ramp were severely damaged after the perfect storm of 1991. Here only one wall remains, as volunteers work to replace the three missing walls in 1992. (Courtesy Thacher Island Association.)

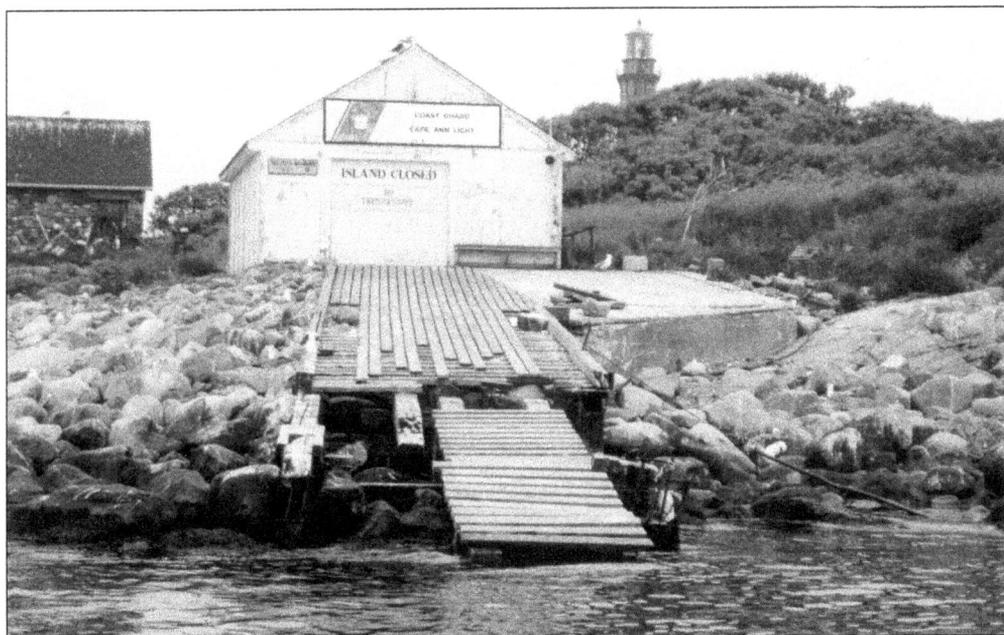

Although the boathouse was fixed by Thacher Island Association volunteers, the ramp required major repairs that were beyond the scope of the volunteers' skills. The Coast Guard eventually repaired the ramp in 2000 prior to turning the island over to the Town of Rockport. (Courtesy Thacher Island Association.)

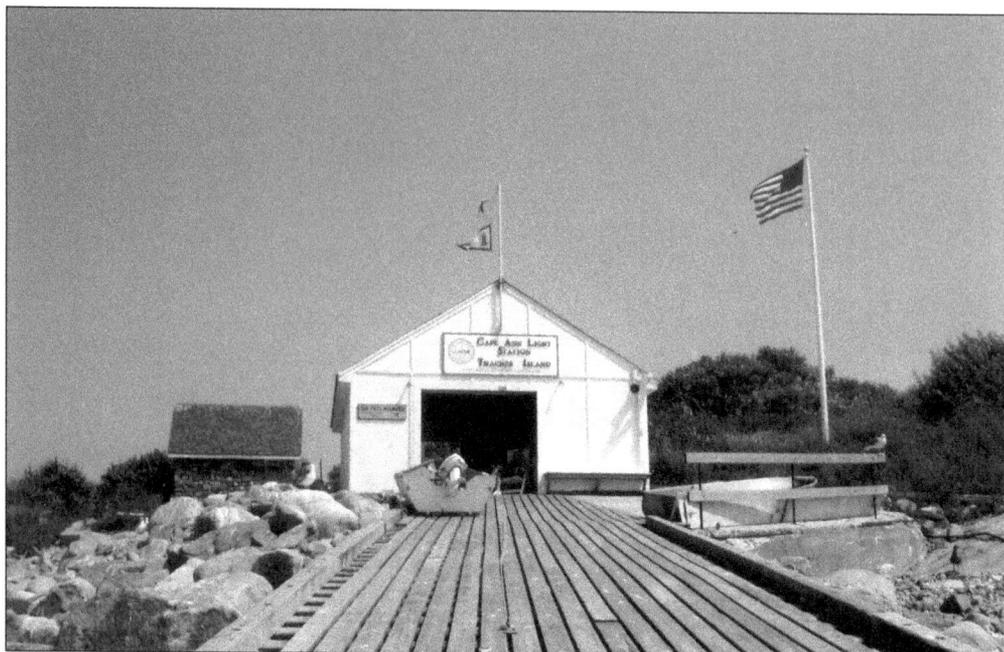

Here is today's boathouse with the restored ramp and new signage erected by the Thacher Island Association. Today's ramp measures 12 feet wide and 120 feet long. Deck boards are separated by a few inches, allowing surf surge to go through rather than have water pressure force the ramp up from below. (Courtesy Thacher Island Association.)

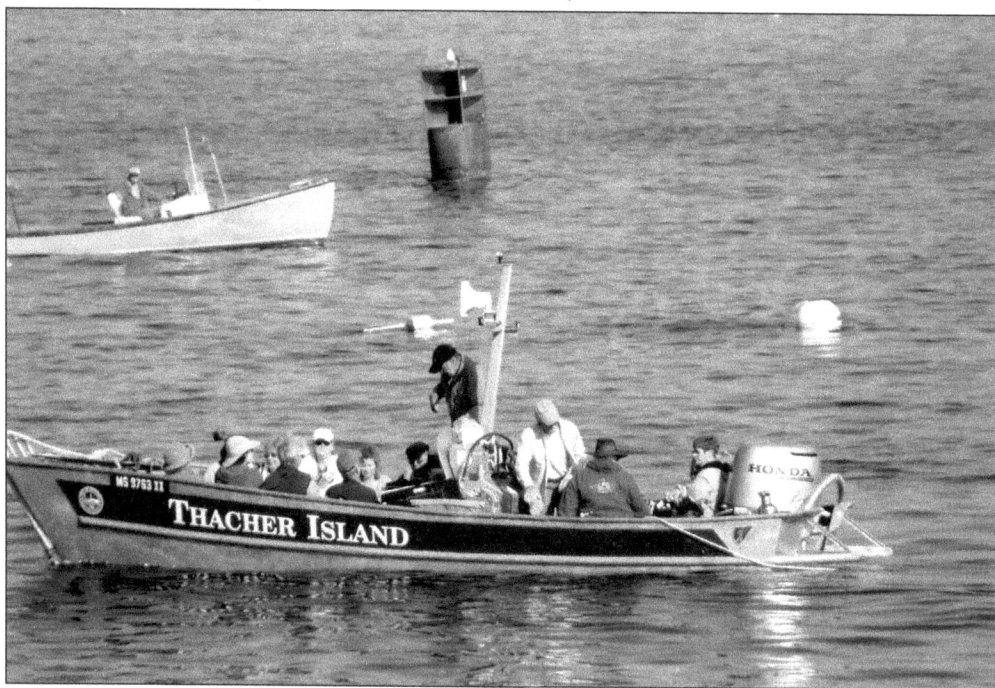

The current Thacher Island launch is used to ferry people and materials out to the island. Weekly trips are made during the summer months, with volunteer workers and tourist visitors. (Courtesy Thacher Island Association.)

This oil house construction drawing, dated February 7, 1889, indicates it was built for $750. Because it had to service two lighthouses, it was built double sized to hold 325 five-gallon cases or butts of oil/kerosene. The lighthouse service ordered oil houses to be built of brick with a slate roof for fire protection for the safety of the keepers. (Courtesy National Archives and Records Administration.)

The oil house was positioned near the trestle and railway to enable the keepers to use the cart to bring the oil butts to the towers, as shown in this 1940 photograph. Kerosene (also known as mineral oil) had replaced lard oil in first-order lights around 1885. (Courtesy Thacher Island Association.)

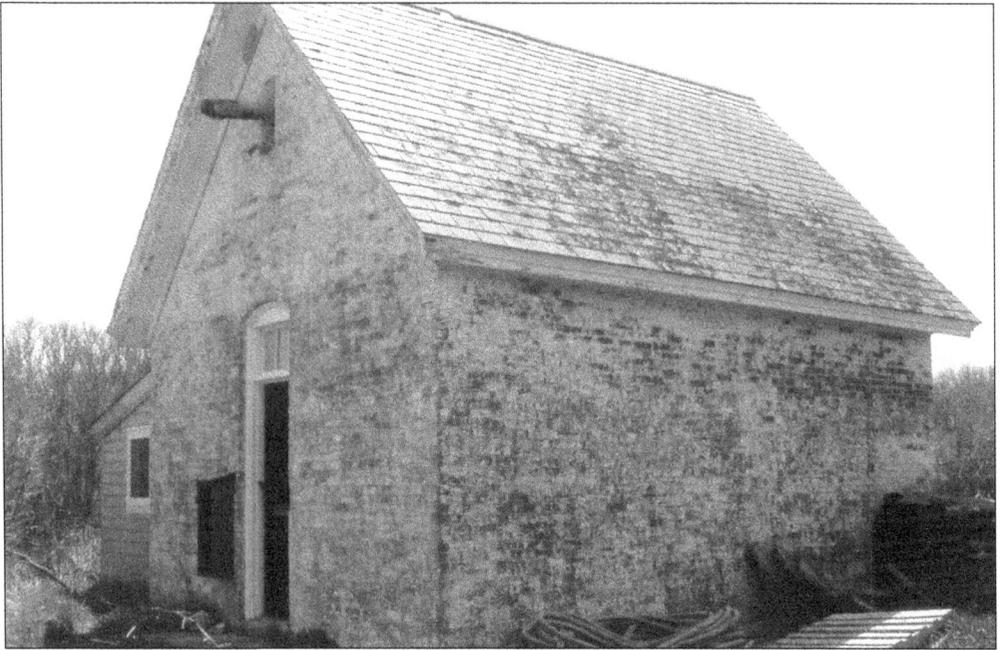

The oil house today is the only building on the island with a slate roof. It is currently in use as a storage garage for the island tractors and other heavy equipment as well as a machine shop. (Courtesy Thacher Island Association.)

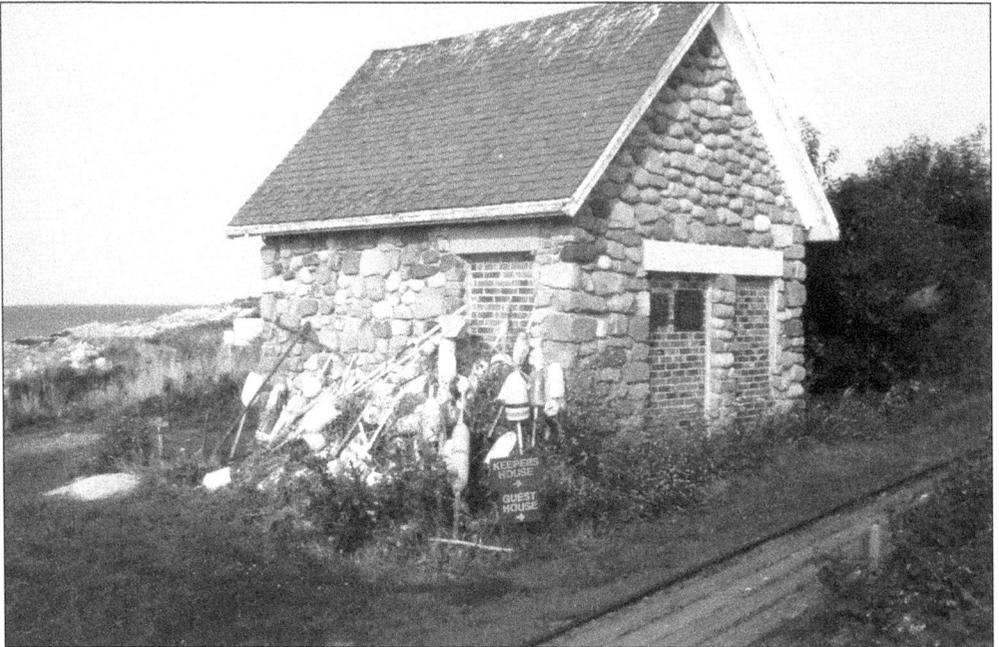

The stone utility house was initially used to store a hoisting engine that had cables running through the now-bricked-up window down to the boathouse ramp to tow the carts up. It was later used as a transformer house connecting the land-side submarine electric cables to the island. Today it houses the emergency generator that supplies backup power for the island. (Courtesy Thacher Island Association.)

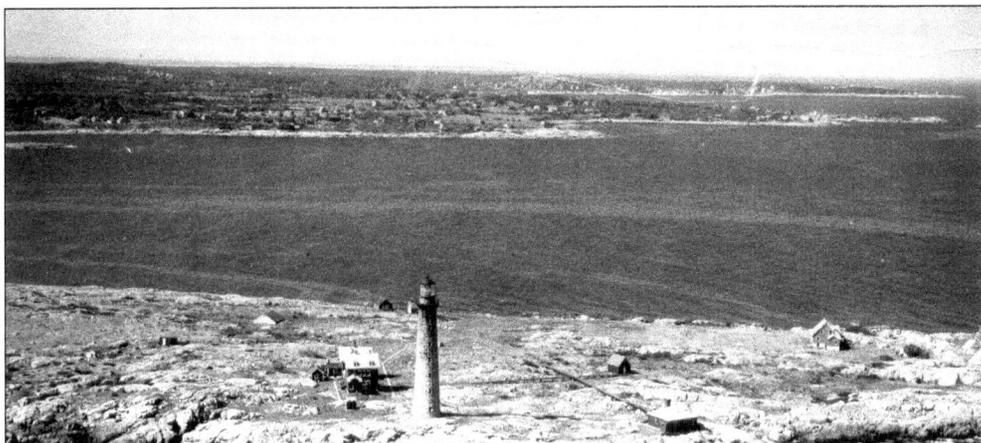

This 1939 aerial photograph looks west toward the Rockport shoreline and Loblolly Cove on the far left; the U.S. Life-Saving Service station at Gap Head is in the upper far right. Rockport Harbor is located on the upper-right side beyond the first spit of land. The boathouse is located just to the left of the tower and shows how far the keepers had to row to shore either to Loblolly, the lifesaving station, or to Rockport Harbor. (Courtesy U.S. Coast Guard.)

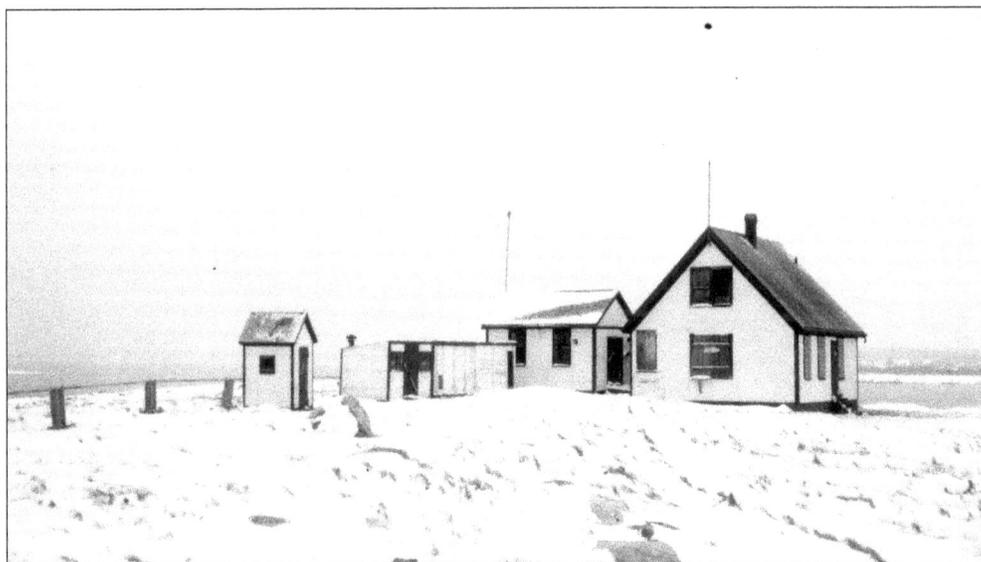

A radio compass station was built on the southern end of the island in 1919 by the navy. It was used to help ships find their position in the fog through the use of radio signal triangulation. Twenty-nine radio signal stations were built by the navy along the East Coast during World War I. The station and barracks are shown here in the winter. (Courtesy Thacher Island Association.)

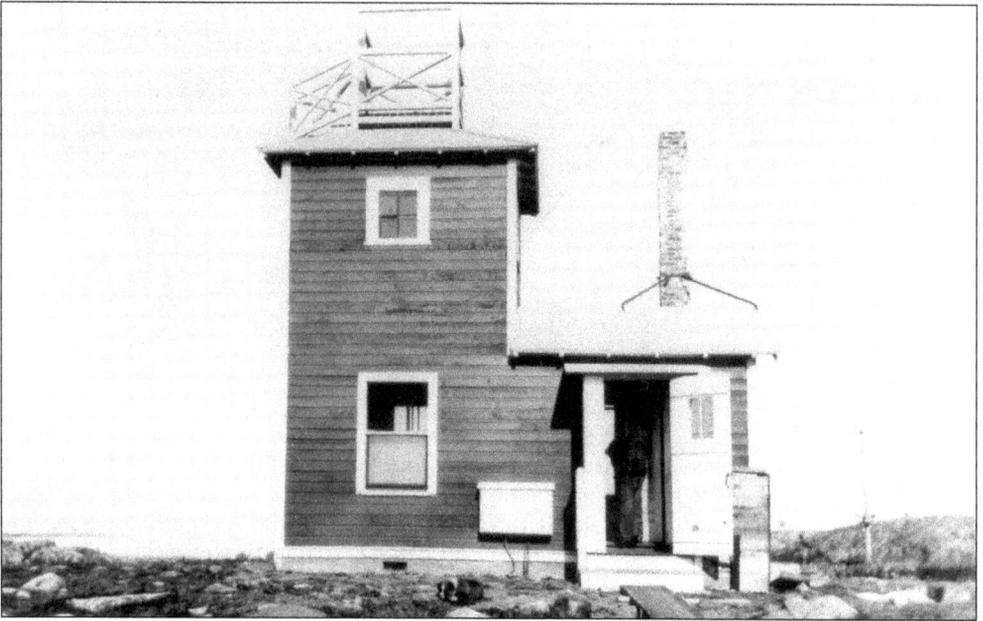

This is a close-up view of the radio compass station lookout tower and antenna, which was also used to track German submarines that prowled the waters off Thacher Island during World War I. The lookout tower with directional antenna housed the radio compass equipment and operations room. Six naval officers were housed there year-round until 1930. (Courtesy Thacher Island Association.)

This covered cistern collected rainwater into a 25,000 gallon brick-lined tank in 1948. Today the cistern is covered by a W-shaped corrugated sheet metal roof and enclosed with wire mesh walls to keep birds out. Rainwater is collected from the roof, directed into the cistern, and pumped directly to the houses. (Courtesy Thacher Island Association.)

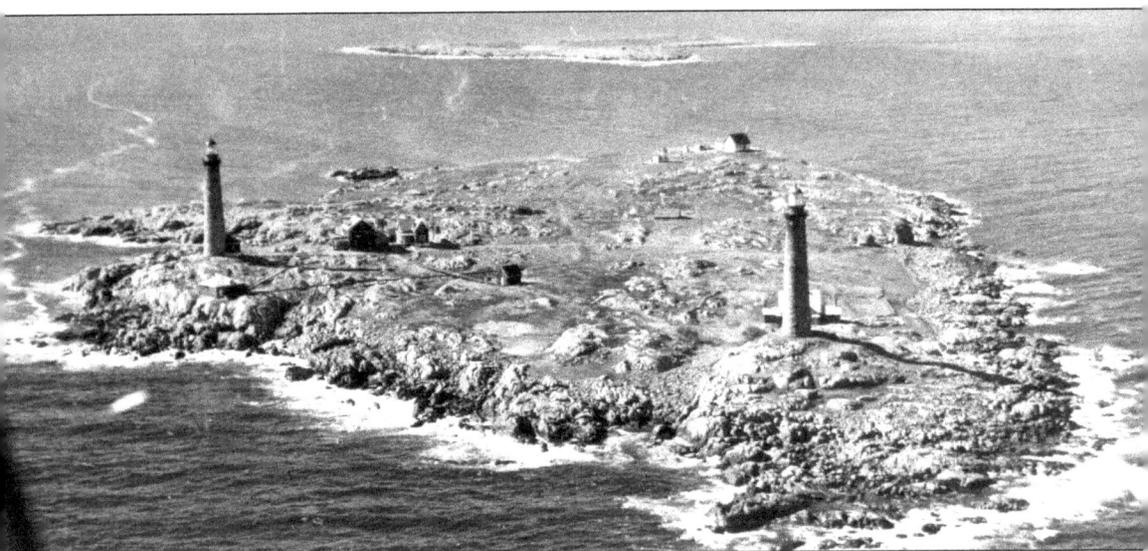

Note the radio compass houses and tower at top right and the cistern directly in the center to the left of the tower. This aerial photograph was taken in 1947, a year before the radio compass buildings were abandoned and burned down. The Coast Guard sent a crew to demolish the station in 1948. They left after burning the structure down, but the wind changed direction and began to blow at 50 miles per hour, sending smoldering embers that started another fire and quickly spread. Families feared that the fire would reach the houses, but their greatest fear—potentially the most dangerous—was that the fire would set off an explosion in the whistle house's compressed air tanks. Luckily a squad of firemen, coastguardsmen, and town's people from Rockport came out again to fight the fire. They brought pumps and laid 800 feet of hose. The fire burned two small buildings near the boathouse and actually blistered the paint on both keeper houses. They were successful in dousing the fire just in time. (Courtesy U.S. Coast Guard.)

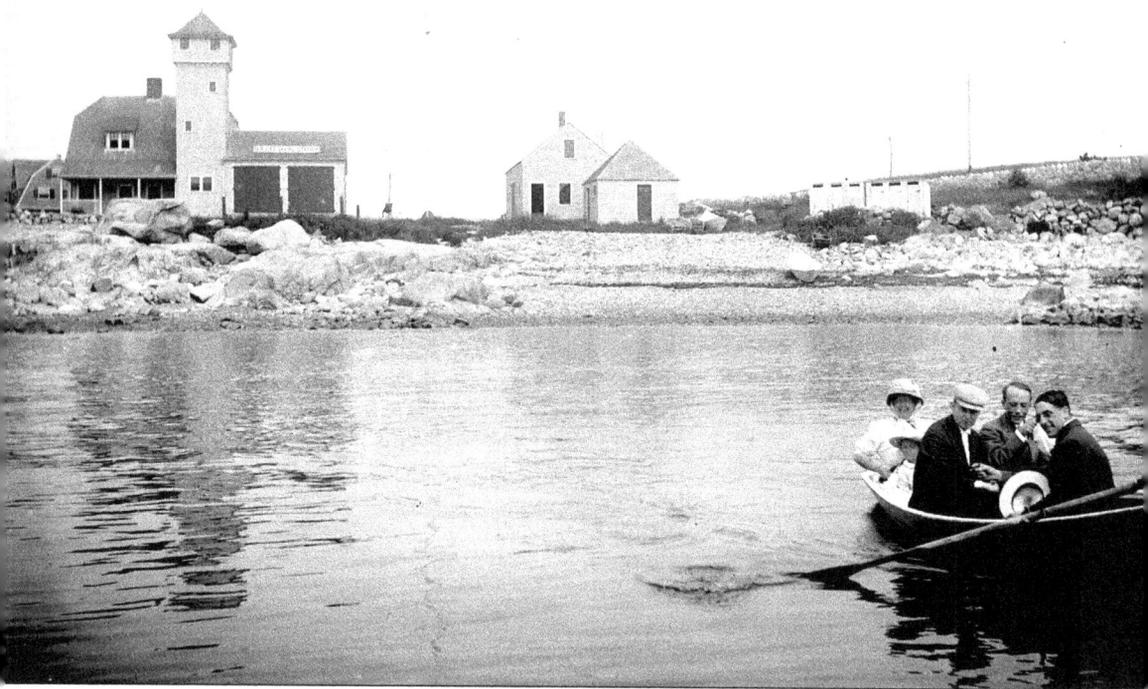

The Straitsmouth Life Saving Station (later the Coast Guard station called Gap Cove-Straitsmouth) lies across the inlet about 3,000 yards away from Thacher at Gap Cove near Marmion Way. An act of May 4, 1882, authorized the establishment of a complete lifesaving station on Cape Ann, and in 1889, the station appeared at a new site at Gap Cove. The name Straitsmouth came into use on July 1, 1902. The station was still listed as active until July 1964, and it guarded the dangerous stretch of ocean between Plum Island, Thatcher Island, and Gloucester Harbor. The design of this station was of the Duluth type by architect George Tolman, which was characterized by its large, square lookout tower on the front. The stable or boat shop at the right were built about 1889. There were 28 similar stations built in the country, and six were in Massachusetts. Today it serves as a private home. Photographer Charles Cleaves can be seen in the rowboat holding his straw hat in 1920. (Courtesy Sandy Bay Historical Society.)

Six

AN ISLAND SURROUNDED BY HISTORY

On November 29, 1775, U.S. schooner *Lee* out of Gloucester captured the British brigantine transport HM *Nancy* near Thacher Island. Thousands of muskets, bayonets, flints, and shot were seized. A giant brass mortar with a 13-inch bore was captured and christened "Congress" by Gen. Israel Putnam. It was quickly shipped to Gen. George Washington's camp at Cambridge. This painting, by Irwin John Bevins, shows the *Lee* escorting the *Nancy* into Gloucester, incorrectly showing the stars and stripes flags which had not yet been created. (Courtesy Mariners Museum.)

This painting by an unknown artist shows a U.S. Revenue Cutter Service ship capturing a British brig off Thacher Island during the War of 1812. A reproduction of this painting is exhibited with the first-order Fresnel lens at the U.S. Coast Guard Museum in New London, Connecticut. (Courtesy Peabody Essex Museum.)

OLD STONE
★ FORT ★

Site of fort erected by public subscription as a protection against British warships during the war of 1812, captured in a sneak attack and dismantled by frigate NYMPH. Ammunition gone, all nine seafencibles taken prisoner, the townsmen hurled rocks, using their stockings as slings.

In August 1814, the British frigate *Nymph* sent men to Thacher Island to steal potatoes from the fields planted by the keepers. On September 8, 1814, while the *Nymph* was hiding behind Thacher Island, they sent two barges at night with muffled oars loaded with British Royal Marines to attack the Sea Fencibles fort erected by the town militia of Rockport at the end of Bearskin Neck. (Courtesy Thacher Island Association.)

The British Royal Marines captured the nine sleeping sentries called Sea Fencibles in their barracks and set fire to the fort. The barracks building still stands today. (Courtesy Thacher Island Association.)

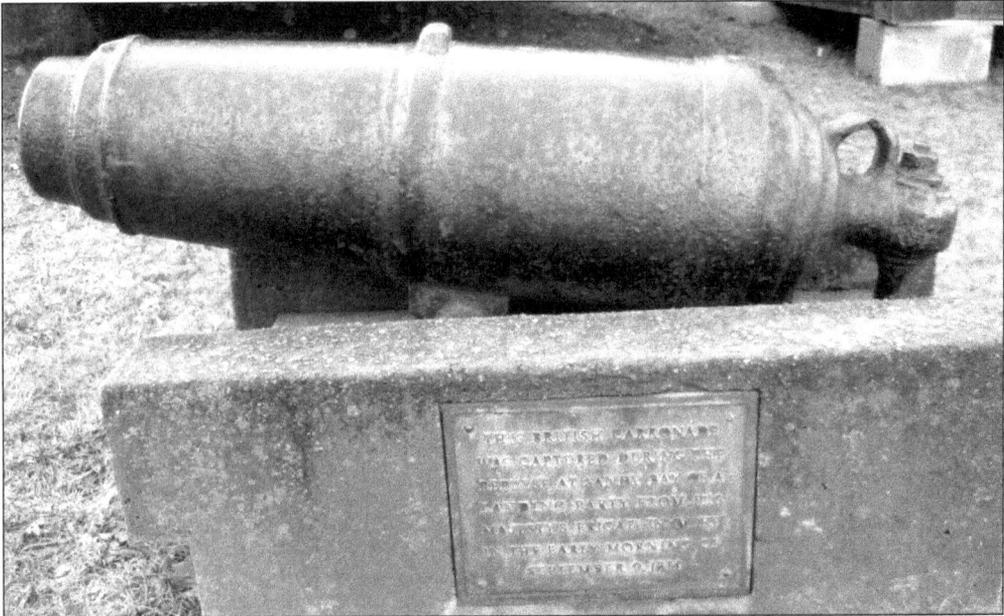

A second barge went to the old harbor and tried to silence the meetinghouse alarm bell by firing several cannonballs at the belfry (now the First Congregational Church). The cannon's recoil loosened a plank on the bottom of the barge, causing it to sink. Twelve Royal Marines were captured and imprisoned. The salvaged cannon now is mounted on the front lawn of the church. (Courtesy Thacher Island Association.)

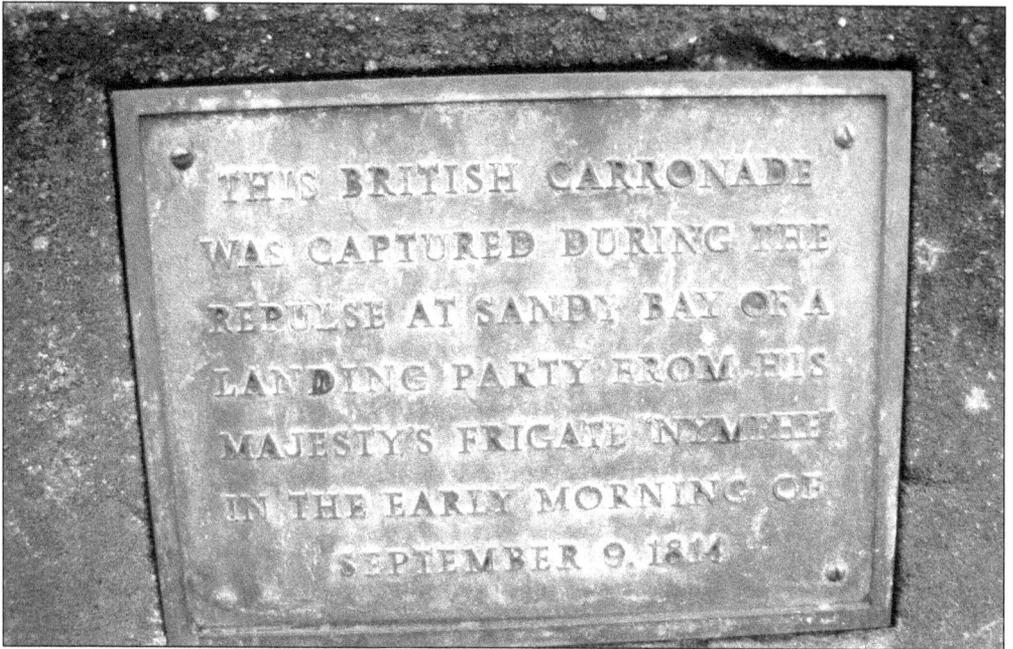

The plaque on the cannon reads, "This British Carronade was captured during the repulse at Sandy Bay of a landing party from his majesty's frigate Nymph in the early morning of September 9, 1814." (Courtesy Thacher Island Association.)

The Congregational church belfry has a reproduction of the cannonball imbedded in its steeple. (See the second column from the left.) The actual cannonball is on display inside the church. Eventually a prisoner exchange was made for the captured sentries, and the fishermen of Rockport were given "free liberty to fish unmolested" by the British. (Courtesy Thacher Island Association.)

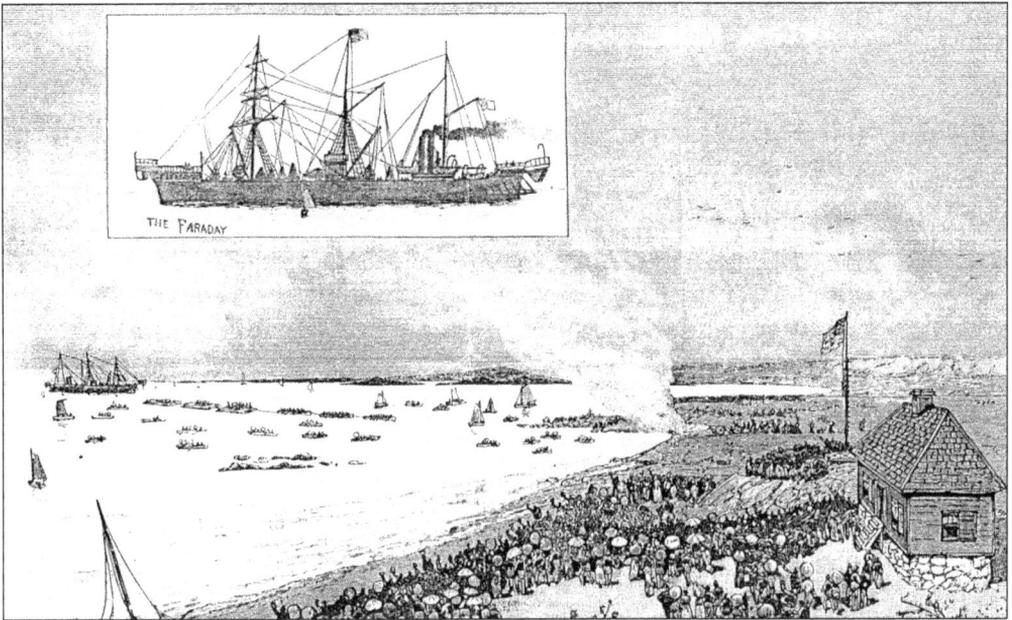

The cable ship SS *Faraday* arrived on May 22, 1884, to lay the shore end of the transatlantic cable to Pebble Beach, Rockport, about a quarter-mile from Thacher Island. The cable was run out past Thacher and swung north to Canso, Nova Scotia, across the North Atlantic to Waterville, Ireland, a distance of over 1,600 miles. This illustration was originally printed in *Frank Leslie's Illustrated Newspaper* on May 31, 1884. (Courtesy Sandy Bay Historical Society.)

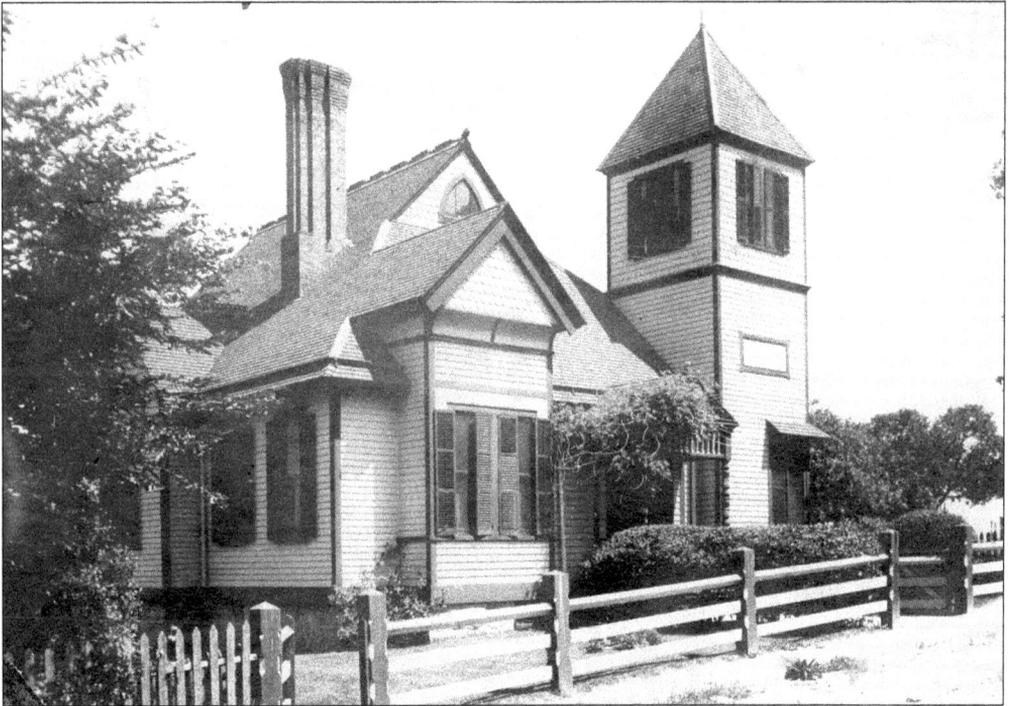

The original Commercial Cable Company office still stands on Norwood Avenue in Rockport and serves as a private home today. (Courtesy Sandy Bay Historical Society.)

This is the interior of the operations room of the Commercial Cable Company house in Rockport in 1885. These men are operating several telegraph keys. The first transatlantic cable message via the new cable was received here on May 26, 1884, from Dover, England. (Courtesy Sandy Bay Historical Society.)

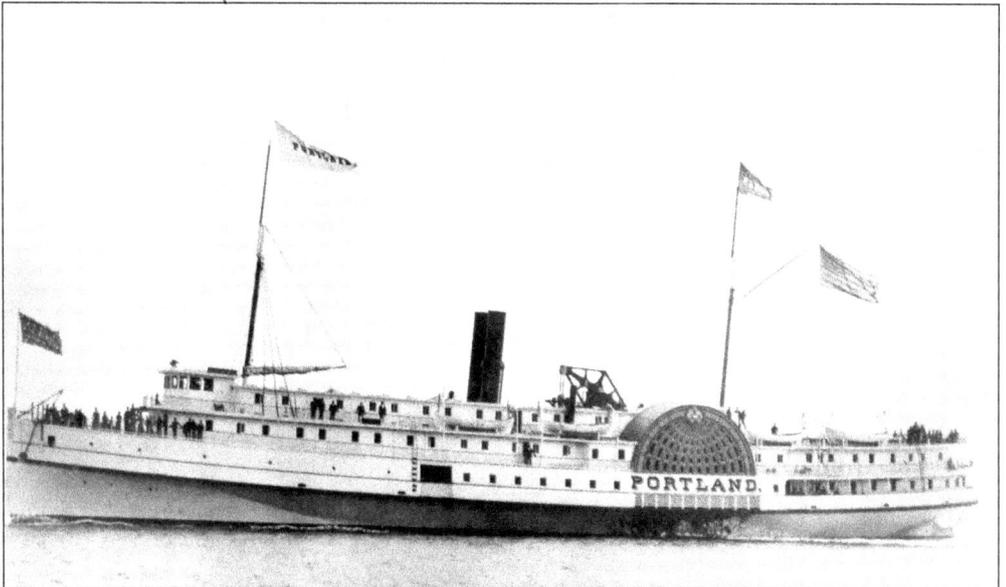

One of the greatest storms in 100 years, dubbed the Portland gale, hit Massachusetts Bay in 1898. The wooden-hulled side-wheeler steamship SS *Portland* was last seen by keeper Albert Whitten at 9:30 p.m. on November 11 off Thacher Island, heading south. It sunk, with all 192 passengers and crew lost. The tragedy was called the "Titanic of New England." The wreck was discovered in 2002 on Stellwagan Bank in 460 feet of water, not seven miles from Thacher Island. (Courtesy Sandy Bay Historical Society.)

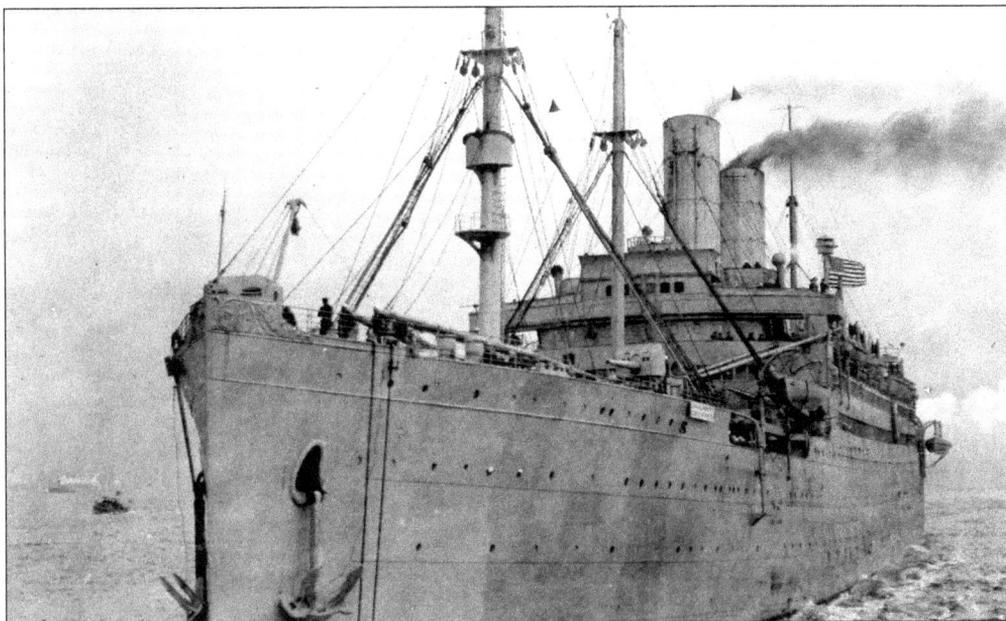

In February 1919, Pres. Woodrow Wilson was almost shipwrecked on Thacher Island aboard the USS *George Washington*, shown here returning from the Versailles peace treaty talks of World War I. He was saved by the quick action of the Thacher Island third assistant keeper Maurice Babcock, who blew the foghorn repeatedly to warn them away. (Courtesy U.S. Naval Historical Records.)

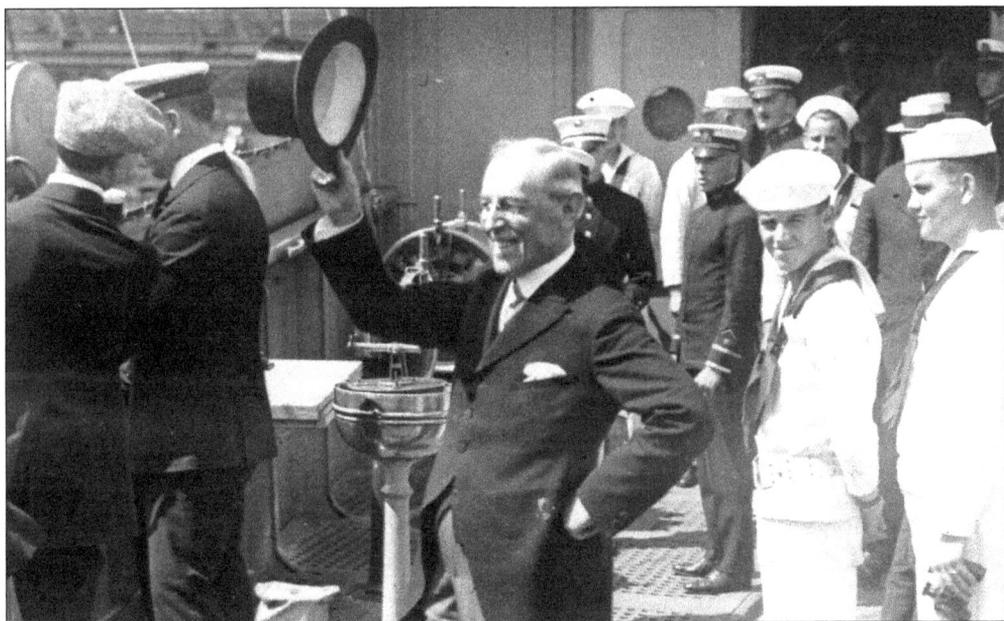

This is Wilson aboard the USS *George Washington* in February 1919 as it docked in New York City the day after it almost went aground on Thacher. Ironically another future president was also on board. Franklin Delano Roosevelt, who was then assistant secretary of the navy, was on the bridge with the captain when the incident occurred at Thacher. (Courtesy U.S. Naval Historical Records.)

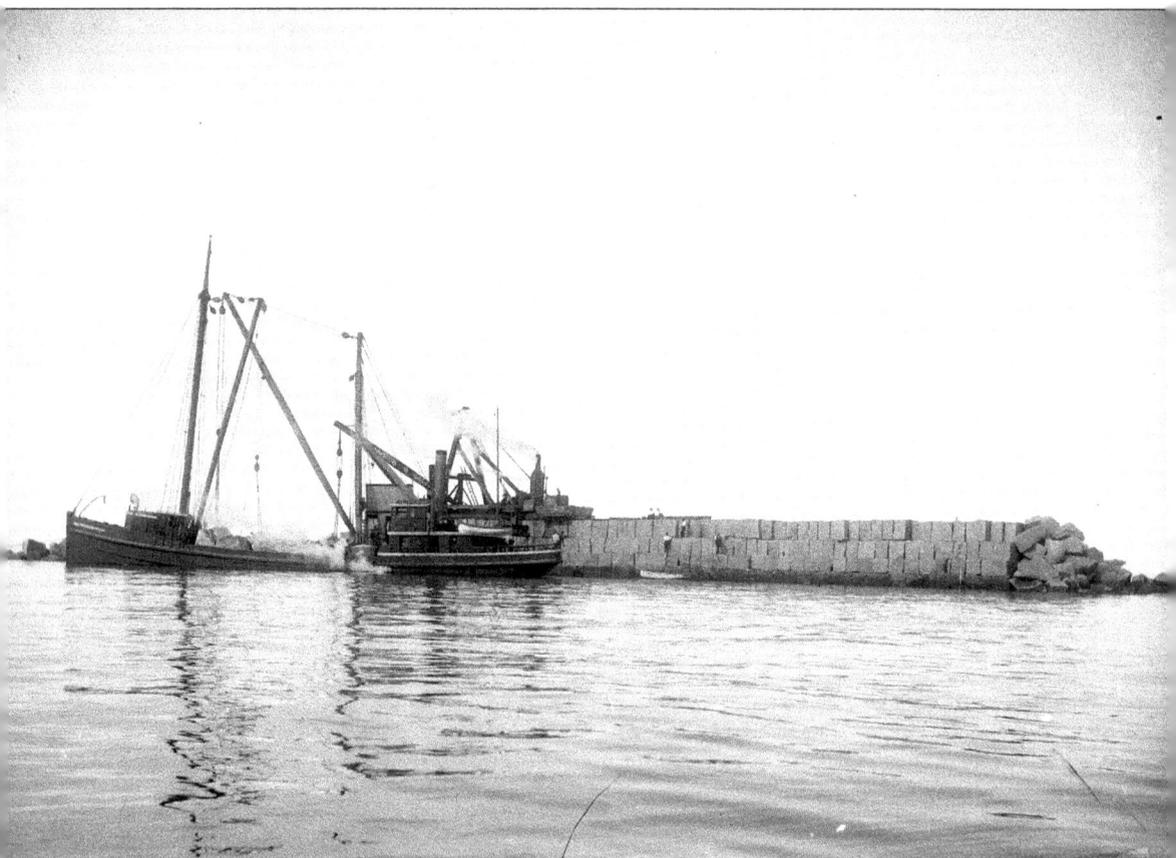

In 1884, discussions were held among top-ranking army engineers and members of the congressional House Committee on Rivers and Harbors, asking for $100,000 for the establishment of a national harbor of refuge. In 1896, the House Committee on Rivers and Harbors, headed by Rep. William H. Moody of Massachusetts, asked for an additional $150,000 for the project. The first contract was signed on November 12, 1885, and the project was started. In 1898, a giant federal project called the Sandy Bay National Harbor of Refuge was started in Rockport. It was to provide a safe harbor in storms and was used as a base for naval exercises held by the North Atlantic Fleet. Here a lifting scow and granite sloop are constructing the breakwater in 1900. (Courtesy Sandy Bay Historical Society.)

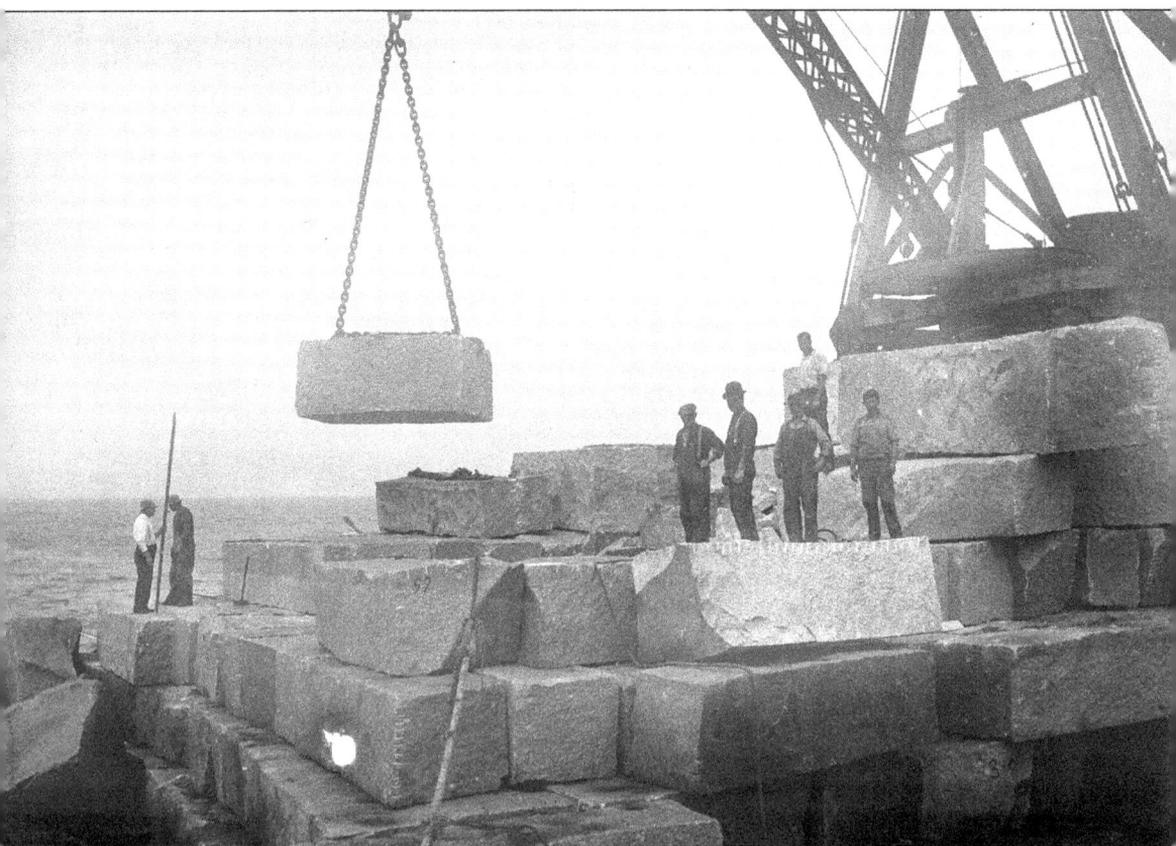

Here a barge lifts the granite blocks, weighing more than 20 tons each, onto the breakwater. Each block measured 20 feet by five feet square. It required five million tons of granite to complete and estimated to cost over $10 million. Granite was supplied by the major granite companies in Rockport. From 1885 until 1894, over 650,000 tons of granite was sunk into the bay. By 1919, the breakwater project was abandoned for good due to World War I, which started in April 1917. This was the end of the age of sail and was probably one of the nation's largest "pork barrel" legislations of the time. With that, it also ended the visits of large numbers of naval vessels. Only 625 feet of the planned 9,000 feet were completed, and much of that has been since destroyed by storms. (Courtesy Sandy Bay Historical Society.)

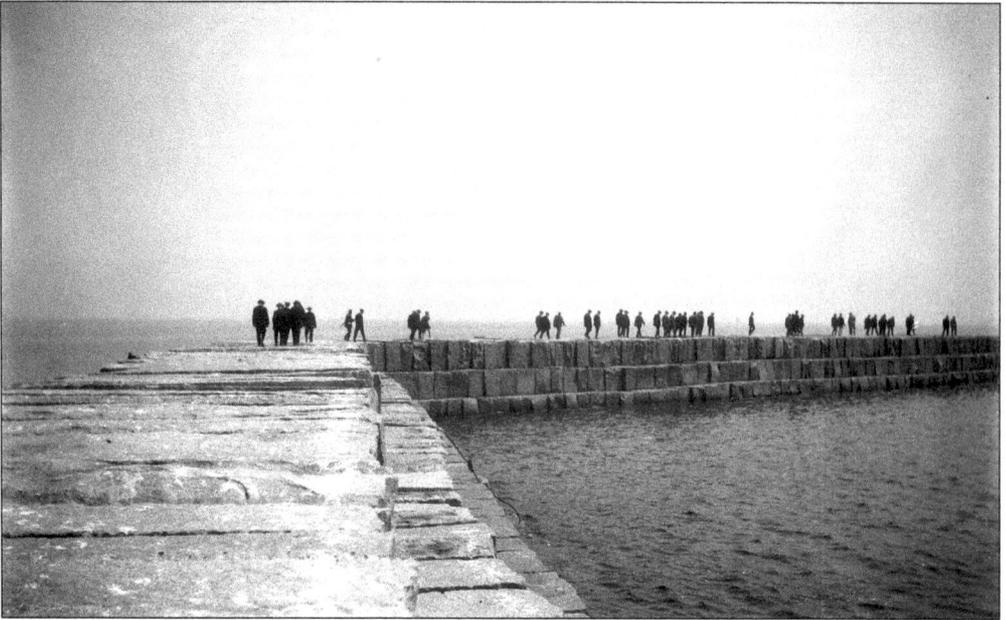

The harbor of refuge was to consist of a V-shaped granite block wall extending one mile northwest toward Andrews Point and southerly about three quarters of a mile towards Thacher Island and Avery's Ledge. The harbor would have enclosed 1,664 acres and was designed to hold 5,500 ships. It was to be situated in an area where over 147 total wrecks and 560 partial disasters occurred between 1874 and 1894. (Courtesy Sandy Bay Historical Society.)

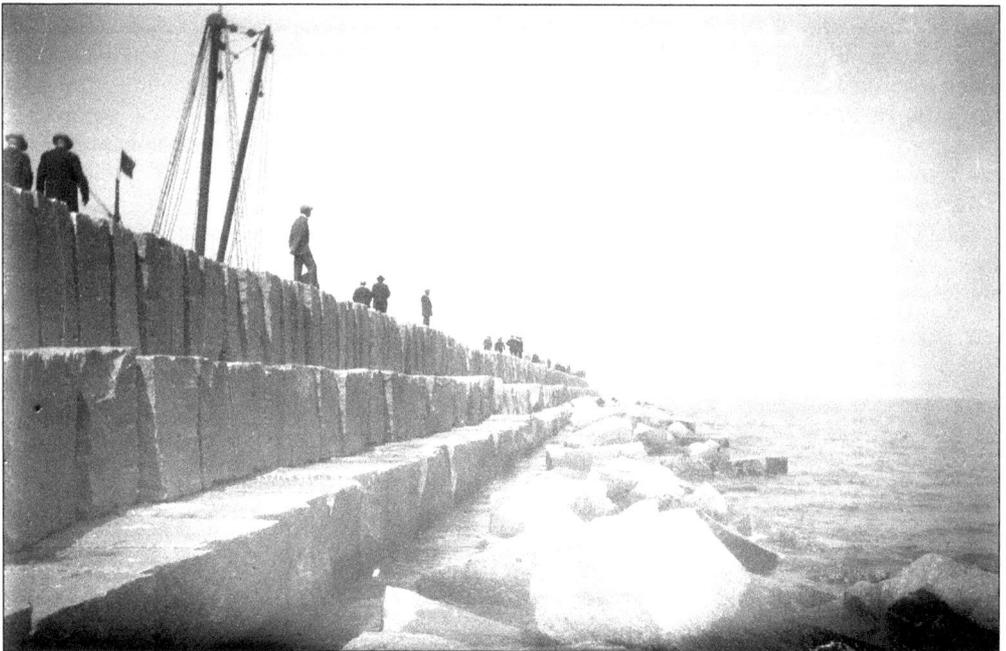

Many people visited the breakwater. This photograph gives a sense of its scale and size. It was abandoned in 1919 and never completed for lack of federal funding. (Courtesy Sandy Bay Historical Society.)

U.S. Naval visits to Rockport's Sandy Bay Harbor were encouraged to demonstrate that this breakwater was good for the country and its defense capabilities. Hundreds of naval vessels began making annual visits. Beginning in 1896, the newly built *Massachusetts*, shown here, held its initial speed trials, starting at Thacher Island and running 31 miles north to Cape Porpoise, Maine, and back to Thacher. It broke all records, running at 16.4 knots per hour. On July 6, 1899, the *Gloucester Daily Times* announced the planned arrival of the squadron under Adm. William Thomas Sampson. The North Atlantic squadron was made up of the battleships *New York*, at 384 feet, with 6 eight-inch guns and 12 four-inch; the *Indiana*, at 10,000 tons, with 685 enlisted men and 42 officers; the *Massachusetts*, at 11,000 tons; and the armored cruisers *Brooklyn*, at 402 feet, 8 8-inch, 12 5-inch, and 5 18-inch torpedo tubes; and the *New Orleans*. The *Texas* came as well, which was the first steel battleship in the U.S. Navy, commissioned in 1895. It was 325 feet long, had 18 guns, and included a compliment of 400 officers and enlisted men. (Courtesy Sandy Bay Historical Society.)

Here are a few of the North Atlantic squadron, mentioned previously, having arrived in Sandy Bay Harbor on July 8, 1899. From left to right are the *Kearsarge*, *Missouri*, and the *Maine*. These ships had recently fought in the Spanish-American War in Cuba and were well known by most people. Bonfires and fireworks lighted up the shore in the evenings. (Courtesy Sandy Bay Historical Society.)

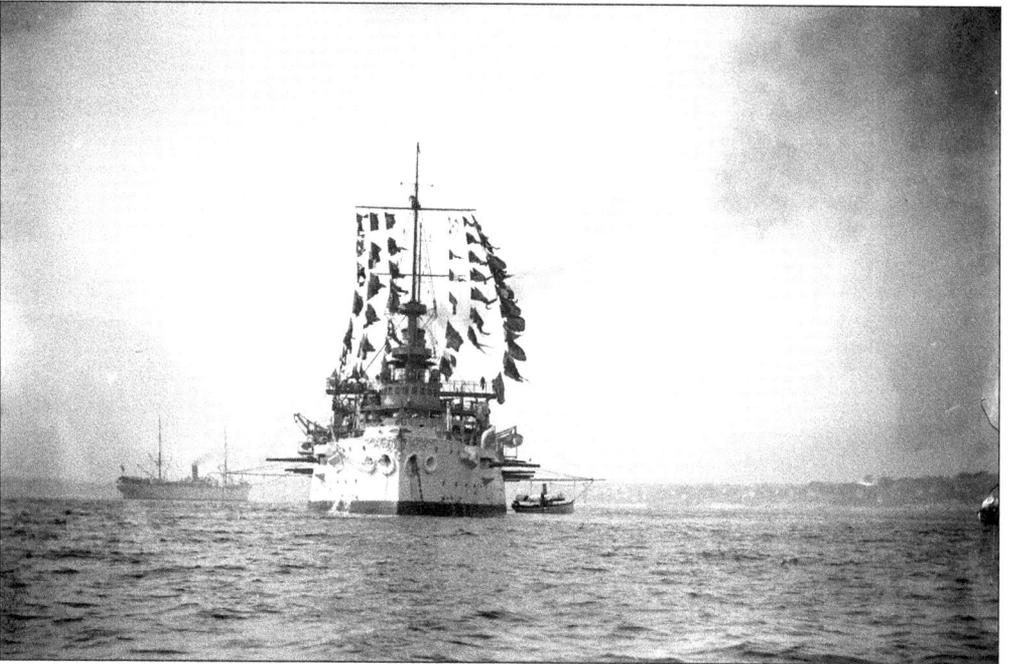

In August 1902, the *Olympia* (flagship of Adm. George Dewey), along with battleships *Massachusetts*, *Alabama*, and *Kearsarge*; cruisers *Brooklyn* and *Montgomery*; the former presidential yacht *Mayflower*; dispatch boats *Gloucester* and *Scorpion*; cruisers *Panther* and *Prairie*; and six torpedo boats visited. The ships displayed their pennants and signal flags and at night performed a spectacular searchlight show for the townspeople. (Courtesy Sandy Bay Historical Society.)

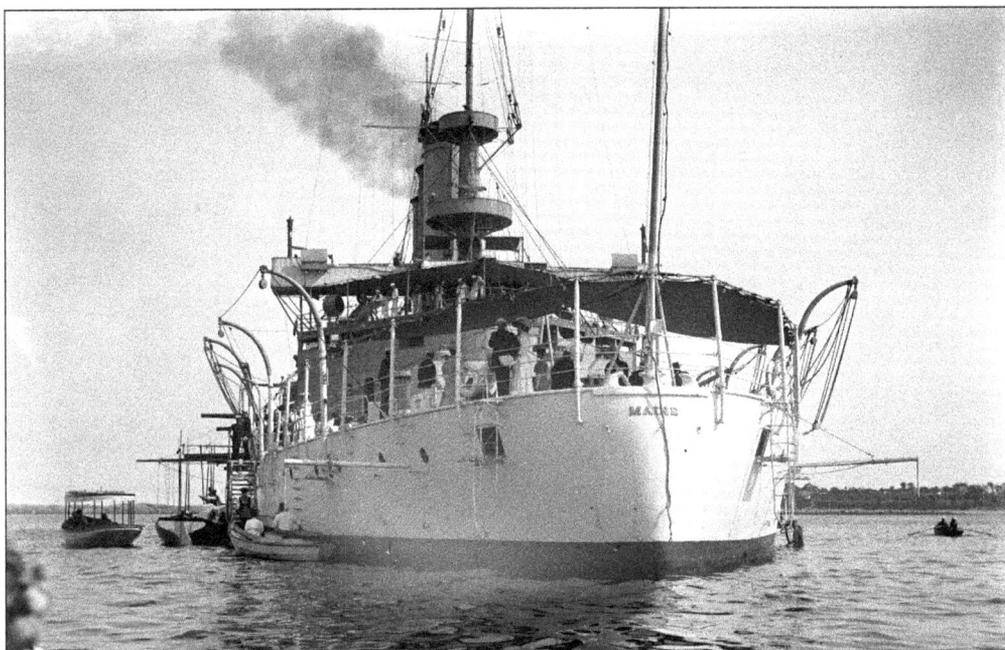

Rear Adm. Robley "Fighting Bob" Evans, commander-in-chief of the U.S. Atlantic Fleet, arrived in his flagship *Maine*. Having just steamed past Thacher Island, he is shown here anchoring in Rockport Harbor in 1906. Accompanying him were the battleships *Missouri*, *Illinois*, *Kearsarge*, *Indiana*, *Kentucky*, *Alabama*, and the cruiser *Yankton*. Some 5,000 men were aboard these vessels, duplicating the population of the town. (Courtesy Sandy Bay Historical Society.)

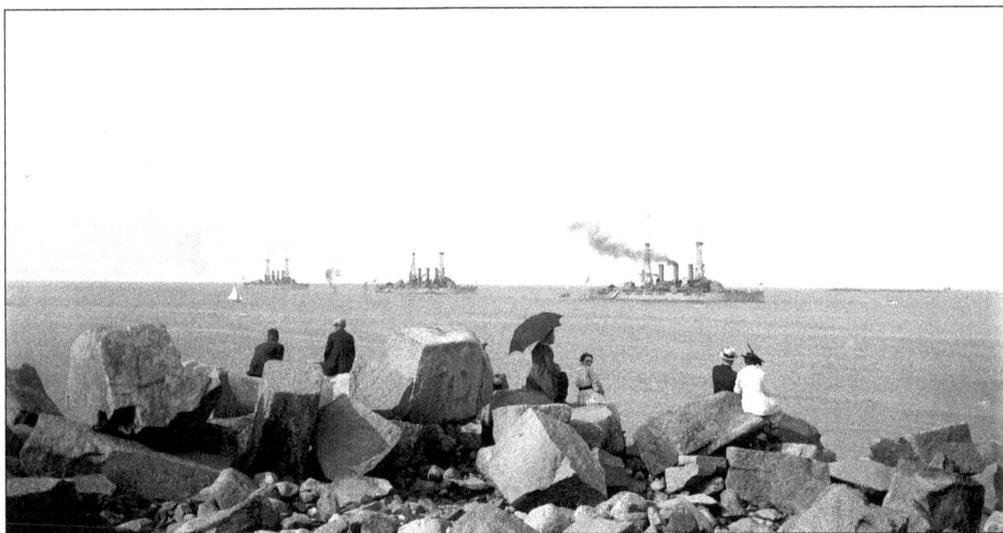

Crowds gather on Granite Pier to view 32 vessels in the harbor in 1915. Upon arrival, the *Maine* gave the town a 13-gun salute from its six-inch guns. Lights strung up on the masts outlined the ship. On July 18, 1915, 10,000 people witnessed a searchlight demonstration. Notice the breakwater being constructed at the horizon on the right. (Courtesy Sandy Bay Historical Society.)

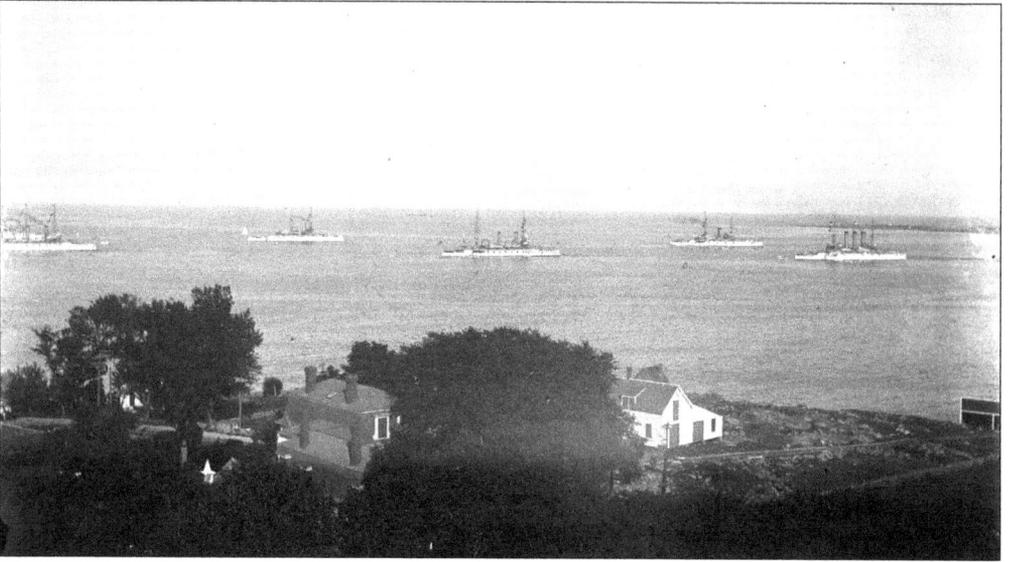

Theodore Roosevelt's "Great White Fleet" came to Rockport often after its around-the-world tour. This fleet toured the world from December 16, 1907, to February 22, 1909. Eighteen battleships, six torpedo boats/destroyers, and seven auxiliary ships used 2.9 million tons of coal and traveled 43,000 miles to six continents and 20 ports. This is a view of the fleet from Pigeon Cove Hill in Rockport in 1911. Thacher Island can be seen in the far upper right. (Courtesy Sandy Bay Historical Society.)

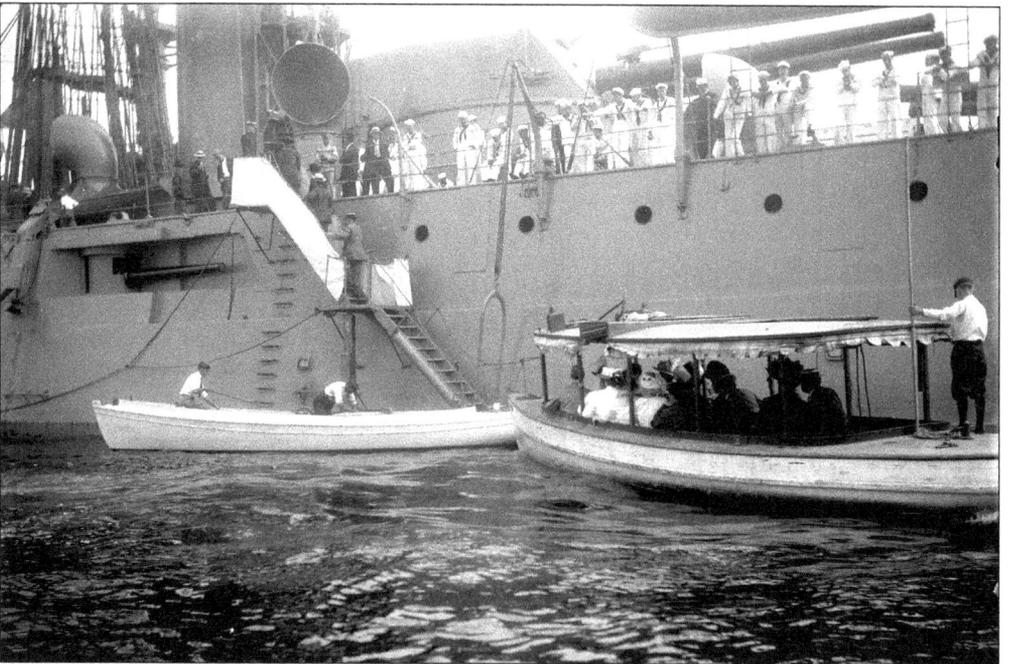

The public was invited to board the naval vessels daily. The navy provided the captain's gig to ferry passengers. Here the gig arrives with visitors to the *Alabama*. (Courtesy Sandy Bay Historical Society.)

120

On board the battleship *Indiana*, a young man has his picture taken in front of the giant 13-inch guns. Numerous newspaper stories were written during the *Indiana's* stay. It was a perfectly positioned public relations event that highlighted the reasons why the navy was here. One story stated, "To the townspeople the great significance of the visit of the warships lies in their proximity to the shore, which demonstrates the possibilities of the harbor. The government is constructing one of the greatest artificial harbors in the world by means of the Sandy Bay breakwater . . . when completed the citizens expect to see this port a shipping metropolis of New England second only to Boston." A sham battle was conducted around Rockport and Thacher Island. Adm. Francis J. Higginson was commander of the defending "blue fleet," and his job was to destroy and or capture the attacking "white fleet" of Capt. John E. Pillsbury. On the morning of August 24, 1902, after four grueling days at sea, the white fleet struck their colors and surrendered to Higginson's torpedo destroyer boats about eight miles south of Thacher Island. Seven torpedo boats sunk the Great White Fleet right here in Rockport Harbor. (Courtesy Sandy Bay Historical Society.)

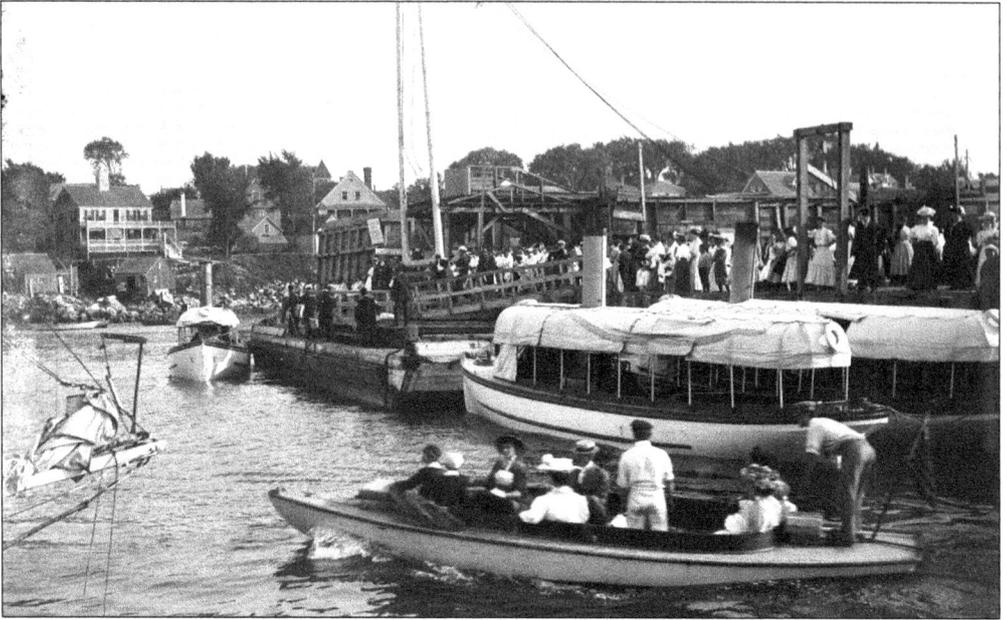

Visitors wait their turn on T-Wharf in Rockport Harbor to be ferried out to the fleet battleships aboard steam launches. One story said, "Viewed from the shore the marine picture is inspiring. The white hulls, immaculate in their brilliant hue, with their top hamper and funnels of government yellow, looked like huge birds of prey sitting upon the water, willing yet loath to show their terrible talons." (Courtesy Sandy Bay Historical Society.)

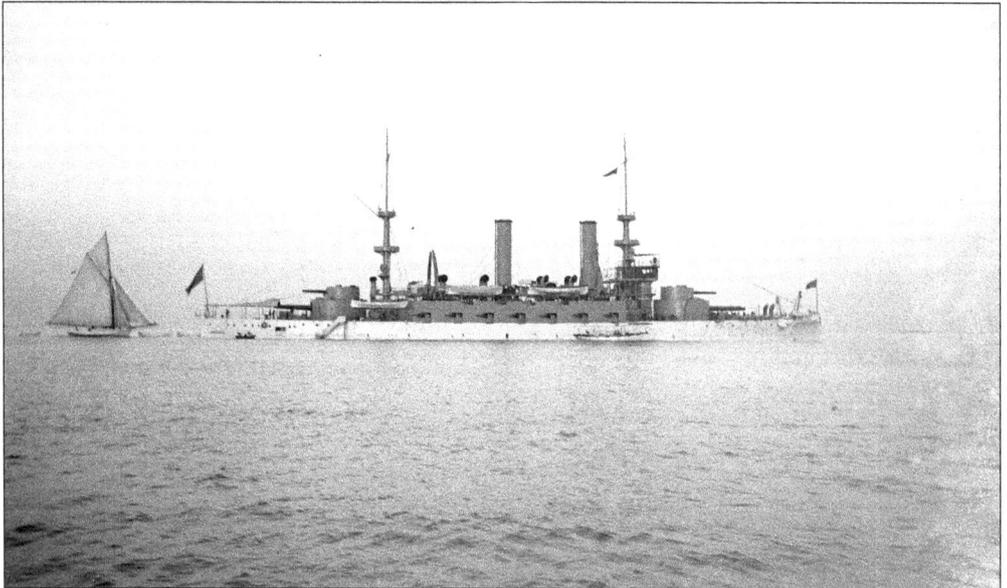

A fishing schooner passes the *Kearsarge* in 1902, giving a dramatic view of the passing of the age of sail to the age of steam. A newspaper story stated, "The electric cars conveyed thousands of people from the city and other places to see the vessels, their minds naturally turned with anticipatory pleasure to the scene which promised them next Friday, when the new battleship *Maine* will make her trial trip over the Cape Ann course from Thacher Island to Cape Porpoise and back." (Courtesy Sandy Bay Historical Society.)

Joe "the Animal" Barboza Baron, a Cosa Nostra informer, was hidden in the assistant keeper's house at Thacher Island in October 1967 while under federal witness protection. Sixteen FBI agents and federal marshals guarded him along with several dogs. They escorted him to court on multiple occasions, traveling by lobster boat, helicopter, and other times by a Coast Guard cutter. He even once hid in a laundry truck. Many times, boaters were warned away from the island by rifle-toting guards. Baron was paroled in 1969 after serving a year and told to leave Massachusetts forever. In 1971, he pled guilty to second-degree murder charges in California and was sentenced to five years at Folsom Prison. Less than three months after his release, he was murdered in San Francisco by a mafia capo from Boston, on February 11, 1976. He once bragged, during his stay on Thacher Island, that he had killed at least 26 people in his career. He was 36 years old when he was killed, having spent 17 of those years in prison. (Courtesy Boston Globe.)

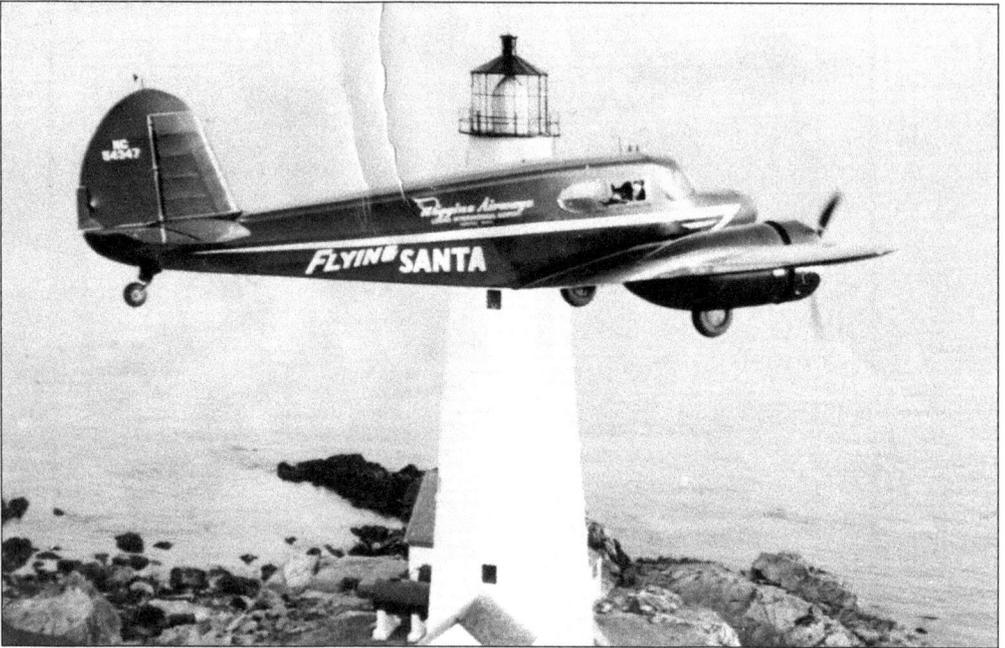

Nicknamed Flying Santa, Edward Rowe Snow often dropped gifts to the keepers on Thacher Island and many other light stations from 1936 until his death in 1982. Here he is seen flying over Boston Light dropping a package to keeper Leo F. Gracie. This photograph appeared in the December 11, 1947, issue of the *Boston Herald*. (Courtesy Dolly Bicknell.)

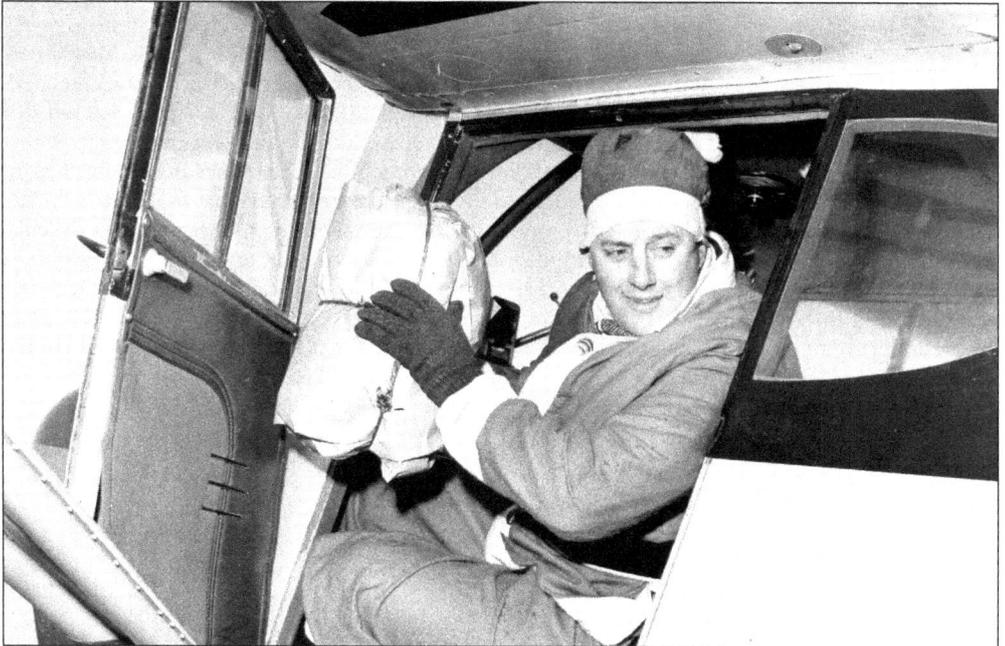

Flying Santa is shown here ready to drop Christmas gifts in 1939. In 1947, Snow dropped packages to over 176 lighthouses and Coast Guard stations up and down the East Coast. These packages contained candy, coffee, newspapers, magazines, dolls, toys, pen and pencil sets, and razor blades, as well as copies of his latest books. (Courtesy Dolly Bicknell.)

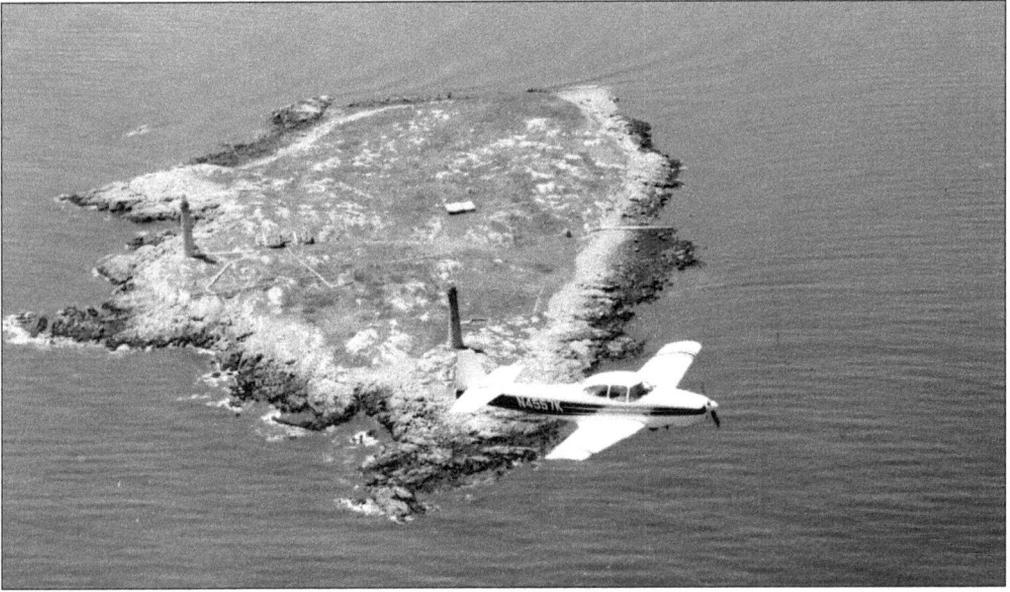

Snow was the author of over 100 books about the sea. Here he is flying over Thacher Island in the late 1960s. For the last few years, he used a Bell Jet Ranger helicopter to deliver his gifts. (Courtesy Dolly Bicknell.)

CAPE ANN LIGHT STATION
THACHER ISLAND
HAS BEEN DESIGNATED A
NATIONAL HISTORIC LANDMARK
THIS SITE POSSESSES NATIONAL SIGNIFICANCE
IN COMMEMORATING THE HISTORY OF THE
UNITED STATES OF AMERICA

THE ORIGINAL 1771 TOWERS WERE FIRST TO MARK
A "DANGEROUS SPOT" ALONG THE COAST AND THE
LAST STATIONS BUILT UNDER BRITISH RULE. THESE
TWIN LIGHTS STAND AT A HISTORICALLY PIVOTAL
LOCATION, JUST SEAWARD OF ROCKPORT, MASSACHUSETTS.

2001

Cape Ann Light Station at Thacher Island was designated a National Historic Landmark in 2001, 1 of only 10 lighthouse stations to be so designated as of 2009. The twin lighthouses of Thacher Island were the first to mark a "dangerous spot in the ocean," whereas all previous lights had been erected to mark harbor entrances only. (Courtesy Thacher Island Association.)

BIBLIOGRAPHY

Claflin, James, *Lighthouses and Life Saving along the Massachusetts Coast*. Charleston, S.C.: Arcadia Publishing, 1998.

Copeland, Melvin T. and Elliott C. Rogers. *Saga of Cape Ann*. Freeport, ME: The Bond Wheelwright Company, 1960.

D'Entremont, Jeremy. *Lighthouses of Massachusetts*. Boston: Commonwealth Press, 2008.

Garland, Joseph. *Guns off Gloucester*. Gloucester, MA: Essex County Newspapers, 1975.

Gott, Lemuel. *History of Rockport*. Rockport, MA: Rockport Review Press, 1888.

Holland, Francis Ross. *America's Lighthouses*. New York: Dover Publications, 1988.

Lewis, Winslow. *Description of the Lighthouses on the Coast of the United States*. Boston: Thomas Bangs, 1817.

Morison, Samuel Eliot. *The Maritime History of Massachusetts 1783–1860*. Boston: Northeastern University Press, 1979.

National Register Nomination form for Cape Ann Light Station, Thachers Island, listed October 7, 1971.

Parsons, Eleanor C. *Thachers: Island of the Twin Lights*. Canaan, NH: Phoenix Publishing, 1985.

St. Germain, Paul. National Historic Landmark Nomination for Cape Ann Light Station, Thacher Island, listed 1999.

Snow, Edward Rowe. *Famous Lighthouses of New England*. Boston: Yankee Publishing, 1945.

Swan, Marshall W. S. *Town on Sandy Bay*. Canaan, NH: Phoenix Publishing, 1980.

Thacher's Woe and Avery's Fall. Gloucester, MA: The Press Room, 1985.

Walen, Harry I. *The Role of Thacher's Island in the American Revolution*. Reprinted from the *Bulletin of the Order of the Founders & Patriots of America*, spring 1985.

ABOUT THE THACHER ISLAND ASSOCIATION

The Thacher Island Association is a nonprofit 501-C3 organization dedicated to restoring and maintaining the Cape Ann Light Station on Thacher Island in Rockport, a National Historic Landmark. Its charter is to raise funds for this effort. The author's proceeds from the sale of this book go to the association. Volunteers work on the island during the summer months, maintaining the scenic trails, campground, and picnic area. They also work to preserve and restore the island's historic structures and unique natural attributes, making them accessible to the public free of charge. For more information, check the Web site at www.thacherisland.org. Anyone interested in joining or donating to the association can send checks to Thacher Island Association, Box 73, Rockport, Massachusetts, 01966. Membership fees are $25 for individuals, $50 for families, $75 for corporate, and $250 for lifetime.

Visit us at
arcadiapublishing.com

··

www.ingramcontent.com/pod-product-compliance
Lightning Source LLC
Chambersburg PA
CBHW050604110426
42813CB00008B/2456